THE LANGUAGE OF WOOD

WOOD IN FINNISH SCULPTURE, DESIGN AND ARCHITECTURE

MUSEUM OF FINNISH ARCHITECTURE · FINNISH SOCIETY OF CRAFTS AND DESIGN · MUSEUM OF CONTEMPORARY ART · ASSOCIATION FOR CONTEMPORARY ART

Exhibition to mark the 70th Anniversary of Finnish Independence
Museum of Applied Arts 21.8.—4.10.1987

Exhibition committee	Salme Sarajas-Korte, chairman	Museum of Contemporary Art · Association for Contemporary Art
	Tapio Periäinen	Finnish Society of Crafts and Design
	Aarno Ruusuvuori	Museum of Finnish Architecture
Exhibition arranged by	Museum of Finnish Architecture	
Exhibition work group	Simo Heikkilä	(applied arts)
	Juhani Pallasmaa	(architecture)
	Kain Tapper	(sculpture)
Exhibition design	Juhani Pallasmaa, Jyrki Ylä-Outinen	
Exhibition catalogue editor, themes	Juhani Pallasmaa	
Graphic design	Juhani Pallasmaa, Jyrki Ylä-Outinen	
Exhibits photography	Rauno Träskelin	
Picture texts	Juhani Pallasmaa, Hannele Jäämeri	
Editorial secretary	Eija Rauske	
Translations	The English Centre (Sarajas-Korte, Pallasmaa)	
	Michael Wynne-Ellis (Suhonen, picture texts)	

Printing	Oy Kirjapaino F. G. Lönnberg, Helsinki
Litho reproduction	Offset-Kopio Oy, Helsinki
Binding	Kirjateos Oy
Paper	Ikonorex special-matt 170 g, Phoenix Imperial 300 g, Tampella Fluting 110 g
Typeface	Helvetica light

ISBN	951-9229-52-3
Copyright	Museum of Finnish Architecture 1987

C O N T E N T S

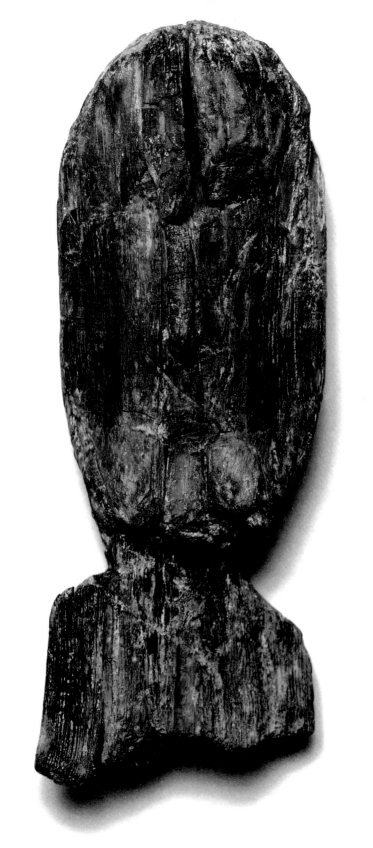

wooden god

SALME SARAJAS-KORTE

When the ancient Egyptians came face to face with life's problems, they seized upon the idea of permanence, eternity. They made images of their rulers — that is, their gods — in stone. They mummified their bodies and entombed them in pyramids. Stone was their fortress against the ephemeral, against death.

At that period, the Finns living on their granite bedrock were a long way from the level of development achieved by more southern cultures. Their technical skills were not so advanced. Objects made laboriously out of stone served only to ensure survival. There were millstones or stone axes, club heads or weapons in the shape of animal heads, arrow tips for hunting game or waging war.

Cult artifacts were usually in clay or wood.

One of Finland's oldest wooden objects is a little 'Wooden god' from the parish of Pohja (picture on page 6). It is made of pine and is about 4000—5000 years old. It was found at the end of last century in a layer of black sludge about 8 metres deep; it was in the peatlands and sludge strata that wooden objects defied time, surviving for thousands of years. The cult figure was made of a round piece of pinewood, but the weight of the earth has flattened it and given its expression an age-old power. An ancient tradition that was part of the cult helped to prevent rotting: during the ritual sacrifice the cult object was coated with grease, blood or some other substance that strengthened the wood.

The 'stone eye god' of Lake Ladoga and the wooden 'fish gods' of the north have also retained their magic power to our day. They are isolated messages from ancient times, from a past wood culture whose products have been destroyed over the centuries. The winds have worn them fragile, and water has damaged them; what might otherwise have survived has often been destroyed by fire.

This culture existed amid forested wilds. There is an old Finnish saying, ''The woods give back what they get.'' Man, who has had to adjust the rhythm of his life to a constant fluctuation between the long dark winter and the dazzling brightness of summer, who sees the life of nature extinguished in the decay of autumn and covered up in the all-embracing snow and ice, and who also experiences its tremendous re-awakening in spring, has naturally projected the profoundest movements of his own mind into the forests, and into wood:

conception — ''Oh hear / how the pine cones rain from the trees / tirelessly, innumerably, fervently.''*

birth — ''I wonder at wood, and at all the green shooting that wood must bear, / a dry log: to live / the wood assumed the task of shooting, and the shoots made it shudder. . .''*

surrender — ''The trees surrender the burden of September / and travel distances / (oh, such perception). / Light, dark forest, desolation / and under it all a bottomless sadness.''**

* Paavo Haavikko
** Eeva-Liisa Manner

Wood is a living — and perishable — material. But it also renews itself, like life. In Finnish society wood's life cycle has been present, more or less, at every stage. As the setting for life, as 'leafy groves' or 'sturdy conifers'. As a useful material for implements and houses, churches and cult artifacts. From wood, man has gained warmth and thus light. And as farming spread, the woodlands submitted groaningly to be felled for burning over — only to rise again from the ashes as new sprouts of grain, like a phoenix. When the earth had given strength, the cycle of wood's life began again: the shooting earth first produced a soft grove of deciduous trees, fast followed by hardy conifers.

Into the pagan idyll of Finnish life came western civilization in the form of Roman Catholicism. The church won sway here, too, by the sword and the cross. But it was unable to absorb the local pagan tradition. The creativity of the ordinary man found expression in the old log joints of the wooden churches, but most of the cult images, though wooden, came from the West — mainly from northern Germany and the Netherlands via Gotland. Confronted by their wonderful craftsmanship the simple Finn was overwhelmed by a pious devotion, as if faced by a strange god.

Only a few of our surviving mediaeval church sculptures were made by Finns. It is difficult to distinguish the work of a Finnish craftsman from that of foreigners, some of whom may have worked here. In the items that can reliably be called Finnish, the work has an expressive piety and simplicity of form, and sometimes, as in the image of the Virgin Mary by the 'Master of Lieto', a shy charm. Sometimes, indeed, the angular forms produced by the Finnish woodcarver have a compressed power produced specifically by the difficulties of working the material, something that one would like to describe using the familiar art history term terribilità.

There were as yet no professional carvers producing skilful church sculptures in mediaeval Finland. The few craftsmen were local talents, a fact expressed by the names given to them later — 'Master of Lieto', 'Master of Sääksmäki', and so on. Not a single one is known by name.

The Reformation cut off the budding Finnish art of church sculpture. Images connected purely with Catholicism were removed or, if the locals could not bear to relinquish them, given a role connected more generally with Christianity. St. George was felt to be a universal symbol of the continuing fight between Good and Evil, and the St. Christopher placed in an honoured and conspicuous place in a Catholic church was moved under the Evangelical creed to the most important spiritual element of its interior, the pulpit. St. Christopher, who bore the Christ Child and offered salvation from 'sudden evil death' was now given the task of carrying on his strong Samson-like shoulders or head the place where the Word of God was pronounced, the (often highly decorated) pulpit.

When an image of an outsize saint was not already used in the church for the purpose, the church builder or local carver satisfied his urge to make images by incorporating human forms into the bearing construction of the pulpit: Often, an ordinary carpenter carved out with his rough hands a large-headed figure of frightening deformity comparable only to the wildest figureheads used on ships or the pauper sculptures set up outside churches or bell-towers.

The pauper sculpture tradition originated and was most vigorous in Ostrobotnia, where shipping and overseas trade were important livelihoods. The wood tradition connected with seafaring took its own forms, lake traffic adopting less rigorous varieties. Even so, the maker of both types of image could well have been the same craftsman — a carpenter. In the figureheads, the head of a classical Aphrodite could be combined, almost in a grotesque fashion, with the flowing robes and fluttering forms inspired by winds and sea, in a combination of blue, black and white. These carvings speak of the northward progress of cultural influences.

The world picture of a seafarer engaged in the tar and fur trade was more adventurous and livelier than that of the sturdy inland peasant. As far as making human images was concerned, neither could be said to have practised a trained skill, not to mention any relationship with an established civilized style. But all in all, these vernacular sculptures did much in the 17th, 18th and even 19th centuries to fill the gap left in sculpture after the ecclesiastical art of the Middle Ages and before wooden sculpture was consciously adopted as an art form by National Romanticism at the end of last century. These unusual creations express in an almost magical way the experiences of the folk soul, and it is irrelevant that the magical quality is often the result of an outright lack of skill. To the simple ordinary folk, they certainly acted with the same power and

caused the same terror as the mediaeval church sculptures or wooden gods.

The pauper sculpture begging box was a unique early form of social art which existed within the sanctified protection of the church. These sculptures served the needs of the surrounding community. They were instruments of charity, meant to assist the most needy members of the parish.

Church sculptures which had lost their original function were sometimes used as pauper sculptures. On the other hand, the pauper sculpture inherited its function from the old collection chests used earlier to sell indulgences and acquire money for the church.

The Greek Orthodox ikon has never been a rarity in the easternmost parts of the country, for Finland lies between two temporal powers and two rival cultures — the Byzantine and the Western. As a result, the country was impoverished by constant wars. It is characteristic of the pragmatic Evangelical Lutheran church that the pauper sculpture on the wall of church or bell-tower, or standing beside the churchyard gate, was often made to look like a wounded soldier. They were stiff and solemn beggars, these, but their very primitive quality makes them evocative examples of Finnish folk sculpture.

In the era of National Romanticism and growing national awareness at the end of the 19th century, wood served as the interpreter of burgeoning national feeling. The nation were 'the juniper folk': they bent but did not break under outside pressure. The tall pine was seen as a symbol of national self-awareness and strength. The forested wilds reflected the profundity of the arts, the hazy fell landscapes the free movement of the spirit.

The northern artist had a proclivity for mysticism and tended to combine National Romanticism with the profundity of contemporary symbolism, seizing on its pantheism and giving material shape to the 'spirits' of the forest in a way that derives straight from the folk poetry tradition. Axel Gallén's (later Akseli Gallen-Kallela) artistic credo of 1894 speaks of links with international symbolism. The trees in Charles Baudelaire's 'Forest of symbols' whisper to each other secretively in the shape of pillars in ancient temples. To Gallén, art was the infinite greatness of the wilds, where flashing-eyed witches and other forest sprites are all part of the magical fascination:

"Art is a huge primeval forest where the trees can grow as sparsely or thickly as one wants. The moon, sun and the glittering stars rise and set as you wish, and when you reach the shores of the forest pool, it can be bottomless if you wish, and glorious plump yellow water lilies and lovely red-feathered water fowl swim in the black water. If you wish, the sun rises behind the crag at the other end of the lake and its golden rays shimmer through delicate spiders' webs suspended between the ancient pines. If the fancy takes you, the birds can start up their concert of piccolo flutes and beyond the hill the wood sprites accompany them on the organ."

The period of marked symbolism in Gallén's work soon passed, as in European art in general. However, even at a later stage, the magnificent 'Broken pine' was still to interpret a sense of individual defeat, and during another period of anxiety he compared himself to a tree with its top cut off and its growth thus stunted.

For a long period while Finnish art was becoming more international, wood was a rare material in sculpture. It was used to some extent during National Romanticism, but even then, often directly or indirectly to decorate architecture. Marble, bronze and granite were more esteemed materials for sculpture than wood. Emil Halonen was aiming at a monumental work when he produced six reliefs in pine for the Finnish pavilion at the 1900 Paris world fair. One of the specific roles these had to play was to represent Finnish national art.

When wood was used as a material for sculpture later, too, it was often for works on folk themes, like the wooden reliefs that dominate Hannes Autere's output or the little sculptures in Ben Renvall's early period. His cheerful and lively 'Polkka', with its grotesque swellings, is a fine example. Artists were obviously aware of the folk heritage behind their work. The clearest example of the continuing tradition is precisely Hannes Autere, a self-taught 'folk master' who started to produce wooden sculpture in his home region of Saarijärvi, an area well known for its folk heritage. The themes of his humorous reliefs are amusing village stories, though there is often some serious fear of evil spirits or devils mixed up with the joking.

Our old sculptures, their soft wood worn smooth by time, now seem to us to embody many layers of feeling and experience, as does other old wooden ware. We see in them the flow of the

centuries, the half-fearful piety of our forefathers, their fight against original sin, their gratitude to the Mother of God and her Son, the 'Man of Sorrows', whose suffering freed the simple soul from the agonies of Hell.

This tradition is strangely vital still in some of today's work, freed from any ethnographical deadweight. Kain Tapper's pupil, the young sculptor Jaana Heikkilä, has a nearly conceptual form in giving expression to the theme of the suffering and death of the Man of Sorrows inherited from the Middle Ages — the same theme that brought the mediaeval sculptor to depict a Christ lowered into his coffin. From Heikkilä's rough coffin grow spikes worked smooth by suffering. What is dammed up and dumb in the soul is released in the therapeutic process of creativity. The 'Way of the Cross' ends in harmony, taking its form from the profoundly expressive material of wood.

In some respects, Heikki W. Virolainen's wooden sculptures go back to the painted wooden sculpture of the Middle Ages, though their themes alone express the sculptor's spiritual links with old Finnish, and thus international, mythical tradition. The sculpture series 'Ilmatar', 'Väinä-möinen', 'Marjatta' and 'Son of Marjatta' are a modern Finnish version of the 'Twilight of the Gods'. Ilmatar, who gave birth to Väinämöinen in Finnish mythology, foresaw in pagan myth the birth of Christ, Son of God, of Marjatta, the Virgin Mary. The basic ideas shared by all the great world religions are still a challenging reality to today's sculptor.

Even today, bare wood used as a material for sculpture embodies something that the sculptor tends to react to as if to a living thing. Marko Tapio watched his brother Kain Tapper working at the end of the '60s:

"Before seven, he had already been to the woodshed, where — and I remember this very clearly — there were some enormous lumps of pine. He sawed off a piece about a metre long, brought it out and kicked it around among the chips. 'I'm going to put an iron hoop round this,' he said. 'It has to be so tight that it bites into the wood. It has to be put on hot so that it contracts. Father knows how to do it. It'll be a Pietà.' But it never was to be a Pietà. Kain cut it in two, cut another log the same length, and then split that in half. He set the three pieces upright on the remaining fourth split half — and there was the title work, 'Cortège', of his famous 'wood block art'.
. . . When he was working on 'Cortège' I remember the axe swinging and the wood splitting and that Kain said, 'Good Good, it's a coffin!'"

When Kain Tapper was working on the altar relief for Orivesi church, the experience suggested by the splitting of wood was repeated, but now converted into a process more consciously creative. The awe at Christ's suffering shown in mediaeval sculpture lived again, as if atavistically. Tapper took one moment in Christ's Passion, the climax in which the whole of nature is disrupted: "And behold, the veil of the temple was rent in twain from the top to the bottom; and the earth did quake, and the rocks rent."

Finnish wooden sculpture is inevitably always linked with both experience of nature and folklore. This fact finds expression in both a rough and an extremely refined way, though wood as a material always endows its own emotional warmth. The extent of the experience finds its finest expression equally in building and the applied arts, and in pictorial creation. That is why wooden art tends to blur the boundaries between different artistic disciplines. Two very different examples are Alvar Aalto's wood bending experiments and Mauno Hartman's sculpture. Alvar Aalto's wooden reliefs can be viewed as almost pure abstractions. A sense of the powerful force of nature's own bending of wood was a vital prerequisite for them. However, the many forms that Alvar Aalto's wooden Functionalism took derived from the initial insight manifested in them.

In Mauno Hartman's wood sculptures we find infallible pointers to old log joint, the traditional notching method, and the patina on old log walls. Hartman usually takes real logs from old buildings as his starting material. He preserves the tactile and emotional aspect of the material. The original purpose is banished, or is present only as a remote feeling. He creates space, but only for the mind to visit. He makes steps, but they do not lead anywhere, a seat round which is a mysterious construction, an artisan's table without a single recognisable tool — or finally a sturdy fence, which he unexpectedly calls by the title of the national anthem, 'Our Land'. . .

However, it is totally understandable that Mauno Hartman does not wish to give his work the stamp of a 'national art'. What links his work with tradition goes deep and is self-evident. By categorizing, we must not ignore the uniqueness of the individual artist's objectives, either. One

experiences this particularly clearly with certain modern artists, whose work has a lucidity and delicacy of line that sometimes links them almost more firmly with international minimalist trends than with the Finnish tradition.

This is particularly true of Esa Laurema, whose art avoids emotional romanticism and attains the remote sophistication of mathematics and top technology — their pureness of form and harmony of proportion. "The idea of a work comes from thinking. The first hints of an idea almost come by accident. . ." The language of the wood 'bends' to express in the cool purity of this art, too, just as it does in the practically intangible constructions that Martti Aiha makes out of thin bamboo. The wood in these is not Finnish or even Scandinavian; indeed, I would go farther and say it is not even Western. Does meditative expression here lead towards the idea of still remote sources, towards still thinner and higher strata, so delicate that the slightest breath of wind could blow them away?

But what is it that brought the Hungarian-born Zoltan Popovits and the Polish Radoslaw Gryta into the ranks of Finnish wood users? Popovits' working of wood has an architectural clarity. Gryta's 'Path to Heaven' combines in our imaginations a constructivist structural clarity, a colour as intangible as the fragmentary layer of worn colour in a mediaeval church sculpture, and a rising form which strives ever up towards the unattainable, like Jacob's ladder. Each uses light, industrially produced, pure wood. But when we again find an almost kindred language in the sculpture of Kari Cavén, achieved through a sensitive combination of worn, everyday bits of planking, we have come right back to our starting point:

Wood is an inherently living material. It has its own message to put across. It has its own inscrutable language.

wood and everyday aesthetics

PEKKA SUHONEN

The vast majority of Finland's five million people experience summerhouse life, often every year. This significant, yet sociologically neglected phenomenon, has been explained by the survival of a predominantly rural society as late as the 1960s and today's return to the land and search for roots. Or let us consider the Finns' original, nay primitive feeling for nature, which expresses itself as much in the products of an advanced society as in the way leisure is spent. There is undoubtedly the same feeling and love for nature elsewhere in the world, something often exaggerated here, but one cannot help musing on our culture's special relationship to nature.

Psychologically and culturally, although the summerhouse life is a regressive act for the modern town dweller, it is something which can be programmed and subjected to commercial pressure. At its best man experiences it as a return to some golden age, like childhood, and at the same time as he forswears electricity, piped water, even TV, he takes a step into a past world of self-sufficiency and the natural, functional nearness of nature. Obviously, not all those forced to endure summerhouse life consider themselves lucky.

To most Finns the summerhouse means a positive contact with the four elements and the material with which he masters and binds them together: wood. The true urbanite's world is filled with billets and brushwood to burn, broomsticks to brush with, the wood-rich sauna, its vihta *of birch twigs, the* puukko *knife and axe to shape and conquer. The forest, or for that matter a piece of driftwood, is in a way nearer to man and possess greater meaning. It has an aesthetic quality, though for the townsman its nature and content is more acquired than natural, but it also has more functions: the birch branch becomes a* vihta *and the juniper a small boy's bow.*

Just over a century ago Aleksis Kivi in his 'Seven Brothers' romance created the character, Lauri, whose practical skills made him the artist of that small band. He fashioned clay animals for the amusement of his brothers and had a special communion with the forest where he spent much of his time. The village lads made up a ditty about the brothers in which:

> *Lauri-lad the forest searches*
> *With an eye to twisted branches,*
> *Nosing the woods like a weasel.*

Many wood carvers since Lauri have searched for sources and materials in the same way. The aesthetic and the practical meet at different levels in the milieu described by Kivi. The relation to wood is also reflected in language. Kivi has Lauri, exceptionally, quite drunk on the Devil's Rock, to explain a familiar saying among the brothers concerning the artful Eero: "But, see here, I know the sort of tool to compare them to. Tuomas now is an axe, noble, solid, upright, manly and stern, but young Eero is a small, sharp, smart whittling knife. Yes, he 'whittles' away, carving most craftily, twisting around him little tricky words, the blackguard."

Once the Finnish axe had developed by the end of prehistoric times into an effective instrument for clearing forests and dealing with wood, it assumed a shape that has remained virtually unchanged. If forging the axehead belonged to the blacksmith's art, then fashioning the handle was the work of many a farmer and his labourer: the carver took note of grain and knots, unlike

the modern machine-made version which nevertheless owes its shape to past generations of handle hewers. The whittler of axehandles was such a common scene in peasant cottages during the winter months spent in handicrafts that he became a figure of fun and proverb, yet none could doubt the importance of his labours.

Centuries of development and refinement have given the axehandle its functional shape, and this, plus an acquired veneer of culture, has given it its aesthetic value. Kustaa Vilkuna has described the time factor behind its shape as follows:

"The shape of tools are extremely simple, but in function or task often very advanced. Thus they endure the passage of time better than many other products of a culture. . . . The hammer, axe or crochet hook of our time have been used by countless generations irrespective of nationality or language. Generally speaking, basic tools are quite international and long use has made them practical. As such they are beautiful, perhaps not pretty, but beautiful in their practicality. Originally they were but extensions of human hands, nails and teeth, additions to their power, possessing the same naturalness."

Functionality appeared, in the final instance, in the act of using the tool, thus contradicting the 19th century belief that Finns, or at least some of them, were slothful and sluggish. A Finnish craftsman or rural jack-of-all-trades could use tools with agility, deriving from them their energy and skill. Kustaa Vilkuna has said: "When you see an old carpenter standing in the yard all gnarled, hunched and misshapen, he appears awkward and helpless, but once he takes hold of his hatchet be becomes another man. It is a revelation to behold the confident sweeps of the blade, the even shape of flying shavings and the beautiful mark left on the wood. Not one faulty move, not a fraction out."

A skill becomes an object of aesthetic interest when the outcome conveys an aesthetic message to the beholder and this must have been subconsciously in the mind of many craftsmen here in distant Finland long before the concept of aesthetics had been invented. Sakari Pälsi writes: "The hatchet marks of a skilled carpenter can be seen from afar on the timbers of a house cleaved in unbroken lines from gables to stone foundations. They are rough, even careless in appearance, but their munificence and impeccable straightness place the master in the leading echelons of his trade and proclaim him more than any panegyric."

An equally good, if not better, example could be the puukko sheath knife. Although this too is international, probably having reached Finland from Germany, it is here that it has acquired its reputation for both good and evil. The use of the axe in its modern meaning ranged from architecture to interiors, but the more objects and utensils were intended for everyday use or Sunday best, the greater role the puukko played.

Skill in woodcraft has even earned a special name for part of historical Finland: Vakka-Suomi. It was given to an area in West Finland famous for the production and export of handicrafts in the sixteenth century. An old proverb: "Better quite smooth than badly decorated" well illustrates vernacular everyday aesthetics, something which could well be borrowed by those modern applied arts influenced by Functionalism. However, 'decorated' was quite in order for festive occasions. Craftsmen were not so unskilled and the more advanced carvers and painters were quite able to transfer to furniture and utensils their own interpretations of mainstream European styles.

The vakka, after which this area was called, was a prized object; a box fashioned from thin planed boards of aspen in which people kept their valuables. They were thus carefully and beautifully made and may even be associated with rituals and beliefs: in Mikael Agricola's list of the Finnish gods the vakka owned by Ukko, the God of Thunder, was brought each spring to the orgies.

One of the most prized surviving wooden objects is the Rusko kousa, an ornamental cup, fashioned from a fir root, with open-work and painted decorations dating from 1542 — about the same time as Agricola wrote his list. Some dozen such kousas have been handed down as heirlooms in titled Swedish families. They were used at weddings, though the Rusko one was owned by the whole village and used to celebrate the end of the parish catechetical meeting. Ritual both demanded craftsmanship and gave it due recognition. Many a young man in former times would try his skill at carving bridal gifts, either a modest love spoon or something more ambitious like a distaff that required mastery and a sense of style.

But like human life, wood also has its mundane side, yet still associated with important rituals. The dairy of an old farmhouse was the goodwife's sanctity. Here she made the butter and cheese in churns and frames of wood. This was the most hygienic and well-cared for area on the farm because the success of the process had to be guaranteed. "Nobody was quite sure what went on in those tall wooden receptacles where the cream soured by the heat of the hearth, the pungent aroma penetrating through the burlap, awaiting the moment when the milk would be reborn. Then the farmer's wife wished to be alone with her secret processes"

If new technology superseded the farmhouse dairy and its wooden vessels, wood still surrounds Finns in another everyday institution linked to a most unique sanctification: the sauna. Sakari Pälsi imagined how people from a more developed society would view the traditional Finnish Yule sauna: on Christmas Eve, a whole nation and its folk, armed with vihtas of leafy birch twigs, stepping as one at almost the same hour of the clock into a dark, unpleasantly sooty, infernally hot log lean-to, there to produce a quite unbearable heat and in uniform rhythm, with all their strength to flagellate the naked flesh with these same birch switches. To Finns, the architecture, interior and few sticks of furniture of the sauna are perfectly natural. The sauna not only reflects the hygienic function of washing, but also the now lost sacred tasks of childbirth and curing sickness. The sauna was an ancient form of hospital and is just as simply furnished as a modern one (it was Alvar Aalto who wished to reintroduce the simplicity of wood into his Paimio Sanitorium).

Traditional saunas, built near by but not on the water's edge, sent up the Saturday smoke signals indicating the social customs and rituals of the end to the working week. The visual meaning was an integral part of the old sauna. The need to protect waterlines has compelled modern legislation to regulate what can be built, but even now smoke rising from a sauna may well be a factor in the landscape. It is then that the sauna becomes more than mere wood, water and fire to range from the magnificence of lakeside vistures to the proximity of people on a bench in some hot corner.

Another system of interaction in human culture concerns everything associated with moving on water and boats which, until recently, like even summerhouse boats, were of wood. The most exciting aspects, related to rapids, long boats, shooting the rapids or even the extensive tar trade, have now passed into ethnography. Its heroes were the sharp-eyed, daring shooters of rapids, faultlessly steering their long pointed boats past the jagged rocks concealed beneath the foaming waters. Anyone who has ever journeyed in one of these boats will appreciate the dangers as well as the alurement. However, one should also give a thought to the silent heroes oaring their boats back upstream.

Behind these glorious deeds is always a boat builder who knows each rib and dowel and blows life into them: for such a boat must ride the boiling waters, it cannot be inflexible. Even the builder of the ordinary, practical lakeboat can achieve great artistry. In the national epic, the 'Kalevala', Väinämöinen is ordered by the Maiden of the North to build her a boat otherwise she will not wed such an old man. But even his wizard's arts fail, he becomes flurried and strikes his axe into his foot. This episode is by way of illustrating the tremendous importance of boat building in Finnish culture.

When Vuokko and Antti Nurmesniemi designed the small Finnish section at the 1964 Milano Triennale and made a Savo rowing boat its prime exhibit, they were undoubtedly aware of its national aesthetic origins. But even they could not have guessed just how universal was its beauty: the Italians gently stroked its pale wood surface, shyly adored its graceful lines, whispering, as if to a beautiful woman, "barca, barca!".

In the late thirties the legendary cameraman Eino Mäkinen, who died this spring, filmed the making of an aspen dugout in the way passed down from antiquity: a hugh aspen of a kind that no longer exists was hollowed out like the Stone Age ones found in bogs. Alvar Aalto came to the studio to see the film and was convinced of the utility of the apsen dugout: with a depth of only twenty centimetres it could take a load of 400—500 kilos. Aalto took Mäkinen to film the Paris Exhibition thus marking the beginning of their fruitful collaboration.

If the aspen dugout reaches back to Neolithic times, then the wigwam-shaped kota with its simple wood, hide and bark parts is the result of an equally long development, "one of the world's oldest utilities, paling even the pyramids in age". But its antiquity is perhaps not the kota's

most interesting feature, rather its simple nobility and social functionality among the different Fenno-Ugrian races and its ties to mythology. This protective and healthy shelter was quite easy to erect, women could do it unaided, and thus its care became their task. Perhaps that is why it has something of the snug nest or womb about it: wee babes could lie naked and snug within its fur-lined walls despite a numbing frost outside. The central post of the kota, around which taut hides protected these Arctic people, was related to the tree in some sacred forest or sacrifical glade in whose shade people lived and which they workshipped. When the age of the kota passed in the Savo district, folk still left an old tree standing in the yard, the god's tree, a sacrifical pine, and gave to it the first milk from a mother's breast. In the same manner Horatio had sacrificed the sacred stone pine of Diana, the helper of those in childbirth.

The concept of tuohi birch-bark culture became much despised by Finnish modernists in the 1930s and 1950s. It is, however, a question of a cultural system built around one product of the birch and which has well served Finnish hunters, anglers and gatherers. Plywood is tuohi's industrial equivalent: although the basic inventions behind the production of plywood were made in France and Russia at the end of the 1890s, the best raw material for plywood is Finnish birch. Plywood first became used in interiors and for making utility articles in the early years of this century and later played a vital role in Alvar Aalto's furniture. Plywood, and the possibility of bending wood, combined mass production and the psychologically, warming effect of wood within the framework of the Functionalism.

The sculptor Tapio Wirkkala found in plywood the material of moving and plastic form. In his huge 'Ultima Thule' sculpture he transposed the post-glacial Lappish riverscape and its transcient, spring turbulence into a modern industrially produced material which still retains its primitive warmth and intimacy.

Although the names of Aalto and Wirkkala can be connected with other aspects of wood, let us now take an example of how symbolically, and also now historically, one can study the relationship of Finns to wood — surprisingly from Paris.

The Finnish writer Juhani Aho admired the then revolutionary iron constructions at the 1889 Paris World Exhibition but he also found the 'psychology' of wood in the pavilion devoted to wood. "In beholding this building, undoubtedly the work of an artist, it struck me that it was just like the temple to the forest spirit Tapio, his kingdom of Metsola. . . . The hall of machines was the realm of iron and there you felt yourself at the hub of the world, in the factory of factories. But here was the smell of soft wood whose age had long since passed. Whereas in the former ones nerves were racked and incensed, here they were calmed and gentled as in a forest."

In the World Exhibition, wood, its processing, its 'sociality', concentrated on influencing the spectator, and when one of these happened to be a Finnish writer it was bound to succeed. Aho's thoughts flew to his homeland, its forest industry and mythology, just as on that same trip to Montmartre he wrote one of the most lyrical descriptions of Finnish nature 'Kosteikko, kukkula, saari' (Morass, hillock, isle). Almost mirroring this are Alvar Aalto's ideas for the World Exhibition in Paris 1937 — where they were not completely carried out — and New York 1939. He wished to show wood processing "not as an export, but the focal point of a national economy". In New York the theme succeeded so well that even its lyricism was immediately recognized. Aalto recreated the spirit of Tapio's Metsola as a pavilion in a world exhibition. Countless Finnish designers and artists have since continued to work the theme of wood and its myriad variations.

There is a Finnish word, yöpuu (literally night wood), whose meaning many no longer know. It is not the perch upon which chickens spend their nights, but a simple yet skillfully made slow-burning fire the hunter or some other forest camper builds against the night, to sleep alongside, to "lay down by the night log", and so listen to the forest sounds until overtaken by sleep. The fire burns quietly, steadily, independently of the surrounding forest from which it draws its fuel. The sleeper alongside his slowburner illustrates in all primitive simplicity the trustful and natural relation to forest and wood Finns still achieve wandering in the forest and fashioning wood for work or art.

architecture of the forest

JUHANI PALLASMAA

Finnish life in the old days meant living in communion with the forest. The forest was the Finn's world; it was there that he cleared land to farm and caught game, and from it he took the raw materials for his buildings and implements. The whole of life was wood: buildings and means of transport, tools and traps, furniture and children's toys. Naturally, then, skill at handling wood was one test of man's estate.

The forest was also a sphere for the imagination, peopled by the creatures of fairytale, fable, myth and superstition. The forest was a sub-conscious sector of the Finnish mind, in which feelings of both safety and peace, and fear and danger lay.

The same symbolic and unconscious implications continue to live on in our minds. The memory of the protective embrace of woods and trees lies deep in the collective Finnish soul, even this generation. The strong smell of the primitive, smoke-blackened farm kitchen, a wooden womb, fills our hearts even now with an inexplicable feeling of happiness as experiences forgotten generations ago struggle into our consciousness.

Peasant buildings and objects exude a satisfying harmony, the noble beauty of economy and practicality conferred by an unerring feeling for material and proportion. Rabbe Enckell had good cause for writing in his 1931 collection 'Vårens cistern' of the simplest of country buildings, the grey haybarn, comparing its fine templelike proportions to the Acropolis.

The single material surrounding the countryman speaks to us of an unbroken unity and balance. And it is perhaps precisely a longing for this unity that makes us touch the veined surface of wood smoothed by long wear, dig some little implement out of the woodshed as a monument to this sense of balance, or seek the lost coherence of life in what is often an artificial 'forest life' at summer cottages.

Students of the meaningful relationship between environment and behaviour have shown that each culture has its own way of using space. The articulation of our material and mental space follows principles which also reflect the unconscious system of space use peculiar to that culture. Whereas, for instance, the French organize their surroundings in a radial hierarchy — whether a national road network, school system or personal space arrangement — the Americans base their use of space on a rectangular network, and this finds expression in everything they do.

We can assume that we Finns base our use of space on some kind of 'forest geometry'. However, this is not the place for further speculation on this secret organization of the Finnish mind, interesting though the possibilities are that it opens up for interpretation of many of our behaviour characteristics.

•

The main thread that runs through the history of our architecture is the conversion of stylistic features that have developed in more southern climes and more urban cultures into a form of building peculiar to our forest culture. This development is equally visible in the wooden

churches of our 18th century 'folk builders' as in the Post-Modern regionalism to be found in Finland today.

Continental stylistic forms are taken out of their original context and transferred into a different material, wood, taking on a naive folk interpretation which has an appealing honesty. The paths taken in the arts by influences and models are often surprising, we all know. Buildings considered genuine manifestations of the original Finnish vision, like the wooden churches of the folk masters, have been shown to display stylistic links with developments in European art. After all, even the enclosed farmyard complex that seems such an integral feature of the old Finnish farm in fact derives from Renaissance ideals.

The stylistic impulses provided by the 'great architecture' of Europe had to be adjusted both technically and aesthetically to the horizontal log-building method used in the north. The result was that the stylistic motifs were simplified and made more archaic. The basis of the building style that took shape in the skilled hands of the folk builders was the proportional geometry of the carpentry tradition, dating back to the Middle Ages, and well-established forms of corner joints, though these varied from province to province and among different groups of carpenters.

The most impressive wooden church produced by a folk builder is Petäjävesi, built in 1763—64 by Jaakko Klemetinpoika Leppänen. This has log vaults that touchingly emulate stone vaulting, a pulpit carried by St. Christopher, and wooden chandeliers designed to look like metal, producing a blend of many outside influences transferred into wood. But the instinct for beauty and the devoted commitment of the folk builder to his demanding task are expressed in every mark of the axe. The use of a single material and the lack of surface treatment create an overall impression of being inside the wood, in a wooden cavern, that appeals to all the senses.

•

Another distinctive adaptation of universal stylistic ideals was the Finnish wooden town. This was a combination of urban and farming communities where trading and the crafts lived side by side with farming and animal husbandry. This Finnish type of town was based on the grid plan model that developed during the Renaissance. The single and double storey log-built houses, set lengthways along the streets, and their wooden fences marked out a clear street area, while the various outbuildings formed a more intimate yard complex. The public buildings giving character to the townscape stand on market squares.

The wooden towns were a constant fire hazard, and lines of trees and bushes were planted to act as a firebreak. These in fact gave the wooden towns a green and parklike look. Because of repeated fires, our wooden towns date mostly from the 19th century, when the outbreak and spread of fires was better controlled.

The architecture of wooden town buildings was Classicism transferred into wood — sometimes 18th century, or Gustavian, sometimes Empire, or late 19th century.

Like the wooden towns, the Finnish ironworks milieu was a combination of two opposite lifestyles: industry and farming. Many of the ironworks of the early industrialization period, and their workers' housing, are particularly appealing wooden complexes. Distinctive wooden environments, with large timberyards, developed later round the sawmills and wood processing mills.

In the latter half of the 19th century, more ornamental Neo-Gothic, Swiss-style and 'eroded Classical' forms emerged side by side with Classicism proper. The invention of the frame saw meant it was possible to make complex ornamental boards and the publication of pattern books promoted the spread of the ornamental wooden style. The streamlined ideals of Modernism made post-war generations scornful of the ornamental woodwork of the end of last century, but today these products of the carpenter's craft and the joy of working in wood have won the appreciation they deserve.

A chapter of their own in the development of the ornamental and eclectic wooden style are the 19th century railway stations. The basic style of early railway architecture both in Finland and elsewhere in Europe derived from the Italian country villa, a type of wooden house aiming at a picturesque effect in which elements of several styles were combined in one building.

•

At the end of the 19th century many countries in northern Europe were developing a national wooden architecture based on the folk tradition. The concept of a 'Finnish style' was first adopted in the art handicrafts, when the Friends of Finnish Handicraft founded in 1879 under the influence of the English arts and crafts movement strove to raise the standard of crafts and industrial arts products and to develop a national form. The debate on a Finnish building style arose somewhat later, as a result of this crafts movement.

At the end of the century, architects, too, wanted to revive the Finnish tradition, and were provided with some important stimuli by the Karelianism that had begun to flourish earlier in literature and art. Inspiration was sought in the characteristic building tradition of the 'forest folk' to counterbalance Continental influences. Inspired by the Karelia expeditions of certain leading artists — Axel Gallén (later Akseli Gallen-Kallela), Louis Sparre and Emil Wikström — Yrjö Blomstedt and Viktor Sucksdorff made their famous expedition to Russian Karelia in 1894, their declared aim being to seek the ingredients of "the indigenous Finnish building style". The outcome was a report with numerous drawings called 'Karjalaisia rakennuksia ja koristemuotoja' (Karelian buildings and ornamentation), which brought the living Karelian wooden building tradition to the awareness of architects.

Several leading artists literally moved into the forest. Their ideal was the stern wilderness landscapes of National Romantic mythology, and the products of their enthusiasm were several logbuilt wilderness studios. Axel Gallén's studio home in Ruovesi (1894—95) looks as if it has jumped straight from the canvasses of this great Kalevala painter, merging perfectly into the rock formations and soaring pines of its setting. The building is a free combination of various sources of inspiration, as is true of most of the buildings of the National Romantic era. The obvious sources are the Central Finland storehouses often depicted in the master's paintings the previous decade, which inspired many other buildings in that era. This collage-like architecture, based on loans and references, has aroused new interest recently with the development of Post-Modern referential architecture. For instance, the works of the present school of architects in northern Finland often contain echoes of both folk architecture and of late 19th century National Romanticism.

There are less Kalevala features from eastern Karelia in the sturdy, manly log buildings designed by Lars Sonck for his home region of Åland than in the villas built in the wilds of the Finnish mainland. Despite their hardy Finnishness, Sonck's log buildings are closer to the pan-European wooden style than to the romanticized Finnish folk building heritage.

The architect trio Herman Gesellius, Armas Lindgren, and Eliel Saarinen built their stone and log studio home (1901—03) on the shore of Lake Vitträsk in Kirkkonummi, where they found a sufficiently Kalevala-like landscape at a bearable distance from the capital. The log-built quality has since been lost in Hvitträsk's exterior; the log walls were covered with shingling, and the north wing and its log tower were burned down. At the same time, the building's national elements weakened and English/American features became much more pronounced. Even so, the log construction of the main room provides an idea of what the whole building originally looked like.

The elevations and interiors of the urban buildings planned by the architect trio were also decorated by imaginary creatures of the Finnish forest, plant ornamentation and fabulous beasts during the years of National Romanticism. On the facade of the 'Doctors' House' built on the corner of Kasarmintori square (1900—01) the task of supporting the corner tower normally allotted to Classical Atlases and caryatids is given to a frog from a Finnish forest tarn.

The log and board interiors, wood sculptures and heavy furnishings of the Pohjola building (1899—1901) in Aleksanterinkatu are in direct conflict with the 'Chicago-style' architecture of the facades. But then, while National Romanticism sought out the presumed sources of 'Finnishness', the style also unmistakably reflected international trends of the day, including the architecture of Scotland and the American Mid-West.

When, after its brief flowering, National Romantic architecture began to give way to designs aimed at deliberate monumentality, use of wood also grew more remote from the Finnish tradition.

•

The Nordic Classicism of the '20s introduced an anonymous building tradition from the Mediterranean area into a new century, the forest context and also often to use of wood as a material. After all, the Classical style had been made part of the Finnish landscape and identity in the previous century, thanks to the productive and high-quality life's work of Carl Ludvig Engel. The contradiction between the lifestyle of this 'forest folk' and the ideals of Neo-Hellenic architecture aroused no amazement at the time. While the National Romantics of the end of the previous century admired the magnificent untouched scenery of the wilds and the wooden building tradition of the Finnish forests, the architects of '20s Classicism were more interested in the farming landscape and rural domestic architecture. The aim was restrained but expressive economy and the use of peasant tones with Classical motifs. In the '20s architects preferred to seek links with the European than with uniquely national characteristics. The motto of the artistic group called 'Tulenkantajat' (the Torchbearers), "Windows open on Europe", at the end of the decade directly expressed this aim.

The finest architectural achievements of the era include Erik Bryggman's and Oiva Kallio's wood-built villas and Martti Välikangas' Käpylä garden city (1920—25). 'Wooden Käpylä' is an extension of the Finnish wooden town tradition which experienced a revival in the late '60s and early '70s. The variation of terrain and vegetation, building types and detail, creates subtle diversity within a rational town plan. The wooden pillars holding up the porch roofs and the sawn ornamentation on the boards are examples of the same economical Classicism as simple peasantstyle detail. The colour schemes used for the buildings are the 'earth shades' of rural buildings, offset by paler ornamental motifs.

The building technique used in Wooden Käpylä was simultaneously traditional and new; the buildings were assembled on the site from prefabricated wooden units. The traditional log-built house was in fact an early form of unit building, and often the log construction was erected, dismantled and moved several times.

•

Following its initial orthodox enthusiasm, Finnish Functionalism also began to get 'forestized' in the mid '30s; Finnish wood began to be used to counterbalance the standard white forms, and buildings were grouped freely amid trees. Alvar Aalto's housing area for the Sunila pulp mill (1936—39) has a row-house for office employees which winds freely through the terrain and illustrates well this transformation in Functionalism. The Sunila housing area and Hilding Ekelund's Olympic Village in Käpylä (1939—40) are internationally unique examples of the 'Siedlung' of Functionalism adapted to the forest setting. The strict geometry and rectangular outdoor areas of the ideal 'Siedlung' housing area are relaxed somewhat, as the buildings are melded with the Finnish terrain and forest. There are wooden details to counterbalance the whiteness and Aalto, specifically, often enhanced the simple building units of the Continental models with detail in wood, as he did in the case of the pole railings of the stepped apartments in Kauttua. The undulating ceiling of the lecture room in Viipuri library had already introduced a new material and form into Functionalist architecture at the beginning of the decade. Aarne Ervi also produced a Functionalism typical of the period, which was softened with wooden detail.

The grand climax of Aalto's pre-war period, the Finnish pavilion at the New York world fair in 1939, gives us a non-tectonic, free-form, multi-rhythm forest space liberated from the restraints of international Functionalism. When he was planning his pavilions for Paris and New York Aalto made a thorough study of Finnish materials and craft skills, and the pavilions and their exhibits were lofty manifestations of Finnish forest and wood culture, a kind of symphony in wood.

The main characteristic in Alvar Aalto's work was his interpretation of the universal urban principles of modern architecture in the context of the Finnish landscape and building tradition. The 'Finnishness' that is often attributed to him, but is so difficult to define, expresses the peasant tradition. The inexplicability typical of creative work can be found in the way in which this timeless, profound Finnishness is fully integrated with Continental avant-garde ideals in Aalto's architecture. But then, where else could a new art obtain its significance and effect other than in tradition?

Aalto reconciled the style, texture and 'graininess' of his buildings with the structures of the

Finnish type of forest, most expressively in the Villa Mairea (1938—39), which is the architectonic counterpart to Finnish forest poetry. The building is a collage-like combination of images from international Modernism and the Finnish peasant tradition, and enthusiastically exploits both wood as a material and a wide range of forest themes. It is a masterpiece of woodworking craft in which the effects given by the wooden constructions extend from the countrystyle ruggedness of the log sauna to the Japanese-like elegance of the interior detail. The many kinds of banded joint, to which Aalto gives a traditional ornamental role, refer equally to the Japanese and Finnish tradition of wood handling.

Just after he completed the Villa Mairea Aalto wrote enthusiastically of the folk building tradition in eastern Karelia (Karjalan rakennustaide, Uusi Suomi, 1941):

"One interesting basic feature is that Karelian architecture uses a single material. . . . It is pure forest architecture. . . In its external colour, a decrepit Karelian village is somehow akin to Greek ruins, where a single material is also a dominant feature, though in this case the material was marble, not wood, right down to the beams."

The reference reminds one of the comparison between a haybarn and the Acropolis in Rabbe Enckell's poem.

The plastic form motifs of Alvar Aalto's architecture, its rhythmical quality and surface textures, link it with the forest aesthetic, and his furniture bends into forms natural to wood. However, it would be one-sided nationalist fervour to fail also to see in his forms links with elements in modern art at the time, especially the collage technique used by the Cubists.

Aalto's bent wooden furniture has connections with the ingenious ways in which the peasant used nature's own forms, in objects ranging from a sledge runner or boat rib to a loom and fishing hook. Aalto himself describes the refinements of this traditional peasant use of wood and the link with his own furniture design as follows:

"Here, too, is an art particularly close to nature.

"Karelian furniture culture, like the building itself, is firmly based on the growing tree. While the building utilizes the standard element of the tree — the trunks — the furniture uses smaller and more richly formed parts of the wooden material for its construction — various branches bent by nature, and strange, often unexpected, formations.

"For beauty, this logical natural complexity is hard to beat . . ."

In his own wood-bending experiments and in his furniture, Aalto created various "artificial natural forms" and combined them to produce a wide range of different furniture, while the original peasant had to seek the exact curve or branch shape he wanted in the forest.

•

In his hour of need, the Finn has always resorted to the forest and to wood. The forest has provided him with a hiding place and with nourishment. During the war, men at the front had to rediscover the primitive lifestyles and building methods of the 'forest Finn' in a multitude of ways. In their leisure wood carvings and the like, they revived woodworking and other crafts of older times. After the war, when the country started reconstruction, wood was the obvious material, especially as there was a shortage of other building supplies. In any case, a wooden construction is the best suited to do-it-yourself building, for at that date almost every Finn still retained something of the carpenter's skill. New houses were built to economical standard plans, all in the same spirit though designed by many different people, and the wood-frame houses of the reconstruction era gave many communities a highly homogeneous stamp. The first prefabricated wooden house system, called the AA system, was produced jointly by Alvar Aalto and the A. Ahlström company.

•

Once again, it was the task of the architecture that rose to world fame after the war to adapt the principle of the International Style to Finnish materials, using an idiom less harsh than its urban models and reflecting our peasant tradition.

From the '50s onwards, Aalto combined wooden constructions and textures with brick surfaces to give the effect of materials both ancient and sensitive. The roof constructions of the

Säynätsalo town hall council chamber and the University of Jyväskylä canteen building, both of that period, are among the finest wooden constructions in our new architecture. Aalto sometimes used very unorthodox combinations of materials; for instance, in Jyväskylä University he set rough white-painted planking and marble side by side.

There is the same feeling for structure and material in Kaija and Heikki Siren's Otaniemi chapel (1957), which is a combination of a rationalist view of architecture and material effects appealing strongly to the senses. The interior, which is divided from the forest backdrop by a wall of glass, suggests associations with the pantheistic world of the 'forest Finn's' thinking.

Our architecture in the '50s generally has great feeling for the material — possibly post-war shortages made architects sensitive to the distinctive idiom of their materials. The wartime life in forest and trenches also brought wood as a material closer to architects. Finnish design in the post-war era shows the same ultra-sensitive feeling for the material — as if the designers, too, were fingering the tangible surface of their objects with profound gratitude after all the years of shortage. The fact that most of the building process was done by hand naturally meant that the builder left his own mark on what he made, while buildings produced a couple of decades later reflected only increasing mechanization and standardization.

In the '50, Aulis Blomstedt, Aarne Ervi, Jorma Järvi and Viljo Revell were also creating clean-lined, delicately expressive architecture articulated with wooden constructions and surfaces. The Kontiontie row-house area (1955) designed by the Sirens in Tapiola, and partly constructed out of prefabricated wooden units, shows the same splendid aesthetic of economy as in Wooden Käpylä. One of the most characteristic wooden buildings of this period is Reima Pietilä's Finnish pavilion (1958) at the Brussels world fair. Pietilä experimented with the building's themes in sculptural form studies made of wooden units.

In the '60s and '70s several wooden unit systems were developed, the basis for which was Aulis Blomstedt's early 'Cell' system, of 1943—49. Inspired by American steel Constructivism and traditional Japanese architecture, Finnish wooden Constructivism in the '60s created an ideological basis for mass production. In the Finnish climate, wood, because it is an all-in-one construction and insulation material, is in fact the only material that permits the Constructivist ideal — a visible bearing structure in both the elevations and the interiors.

•

Post-war building in Finland created a completely new type of town, the 'forest town', the paradoxical aim of which was to combine two contrary ideas and types of environment: town and forest. The principle succeeded best in Tapiola, where the 'forest' often became an intermediary, a 'park' half made by man.

The re-emergence of the wooden town tradition began with Bengt Lundsten's competition entry for the Kortepohja housing area in Jyväskylä (1964). The building frame is stone, but wood is used as a material adding richness to the milieu, as in innumerable other plans in the last few decades throughout the country.

Since the end of the '50s Reima Pietilä has consistently developed the Finnish forest architecture type. In his exhibitions, articles and lectures he has analysed the morphology of the Finnish landscape and on this basis worked out the themes of an architecture tied firmly to its location. Whereas the basis for the pro-Finnish ideals of National Romanticism lay in folk tradition, Pietilä is interested in the Finnish landscape. His drawings usually show conifers and mixed forest, and his architecture is very much the architecture of pine forests, counterbalancing the more southernly models followed by our architecture.

•

During the '80s the idiom and materials of architecture have greatly diversified. Both the 'Northern School', which is developing Finnish regionalism on a basis of themes from folk building tradition, and the Modernists of the south, who add richness to a more purist Functionalist line, often use wood. Compared with how wood was used in the '50s, their surface structures are more intricate and the detail more diverse. Since Aalto's death the wooden surfaces typical of his architecture — wooden lattices and textures — have become the identifying features of to-

day's Finnish architecture. The growing amount of work being done on renovating and restoring old buildings is in turn reviving practically forgotten woodworking skills and crafts.

•

The structural strength of wood, its insulating and acoustical qualities, its pleasant tactile character, its variety of texture and colour, together with the ease with which it can be worked and the many ways its surface can be treated, all make it the most versatile of building materials.

But the tree is also one of mankind's most common and meaningful symbols — take the Cosmic Tree, the Tree of Life, the Tree of Fertility, the Tree of Knowledge, the Tree of the Soul, the Tree of History and the Sacrificial Tree. These diverse associations are hidden in the shape of the tree and even today add dimension to our relations with wood. The tree is man's shape and we feel it is our equal.

Despite the profusion of materials, forms and goods, our industrialized cultural environment seems to be increasingly impoverished in terms of experience and feeling. The warmth of natural materials, the variety of textures, and the enhancing effect of aging have been replaced by homogeneous and timeless man-made materials. It may well be that the experience we most miss in our new synthetic environment is the experience of time. Time is always strongly present in wood, because it speaks simultaneously of its own process of growth, wear and gradual decay, of human craft, and of an object used for generation after generation. Wood is the only material that gets more beautiful with time and use.

"As the main material for the delicate detail of architecture, wood will probably preserve its status, and the artifical materials still being developed out of it have not succeeded in ousting it. A synthesis relying on a chemical process loses some of the most important qualities of the original wood, those of specifically human and psychological importance, and these will probably ensure that wood remains a material of great richness and humanity, with resources that are far from being exhausted." (Alvar Aalto, Puu rakennusaineena, 1956.)

Sources:

Helamaa, Erkki, 40-luku, korsujen ja jälleenrakentamisen vuosikymmen — 40-talet, korsurnas och återuppbyggandets årtionde. Exhibition catalogue, Museum of Finnish Architecture. Helsinki 1983.

Härö, Elias & Salokorpi, Asko, Ruukinmiljööt — Bruksmiljöer — Early industrial milieu. Exhibition catalogue, Museum of Finnish Architecture. Helsinki 1979.

Lilius, Henrik, Suomalainen puukaupunki — Trästaden i Finland — The Finnish wooden town. Rungsted Kyst 1985.

Paavilainen, Simo, "Nordisk klassicism i Finland" — "Nordic Classicism in Finland". Nordisk klassicism — Nordic Classicism 1910—1930. Exhibition catalogue, Museum of Finnish Architecture. Helsinki 1982.

Paavilainen, Simo, "1920-luvun klassisismi ja klassillinen perinne Suomessa" — "Classicism of the 1920's and the classical tradition in Finland". Abacus, Museum of Finnish Architecture yearbook. Helsinki 1979.

Pettersson, Lars, "Kansallisia ja kansainvälisiä aineksia Suomen vanhassa puukirkkoarkkitehtuurissa" — "National and international features of the old wooden church architecture in Finland". Abacus, Museum of Finnish Architecture yearbook. Helsinki 1979.

Schildt, Göran (ed.), Alvar Aalto luonnoksia. Helsinki 1972. (Alvar Aalto Sketches. Cambridge and London 1979.)

Tuomi, Ritva, "Kansallisen tyylin etsimisestä" — "On the search for a national style". Abacus, Museum of Finnish Architecture yearbook. Helsinki 1979.

Valanto, Sirkka, Rautateiden arkkitehtuuri — Järnvägarnas arkitektur. Exhibition catalogue, Museum of Finnish Architecture. Helsinki 1984.

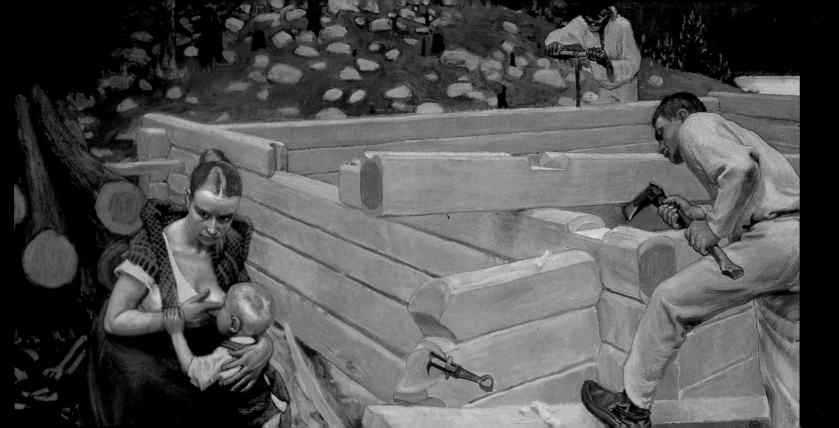

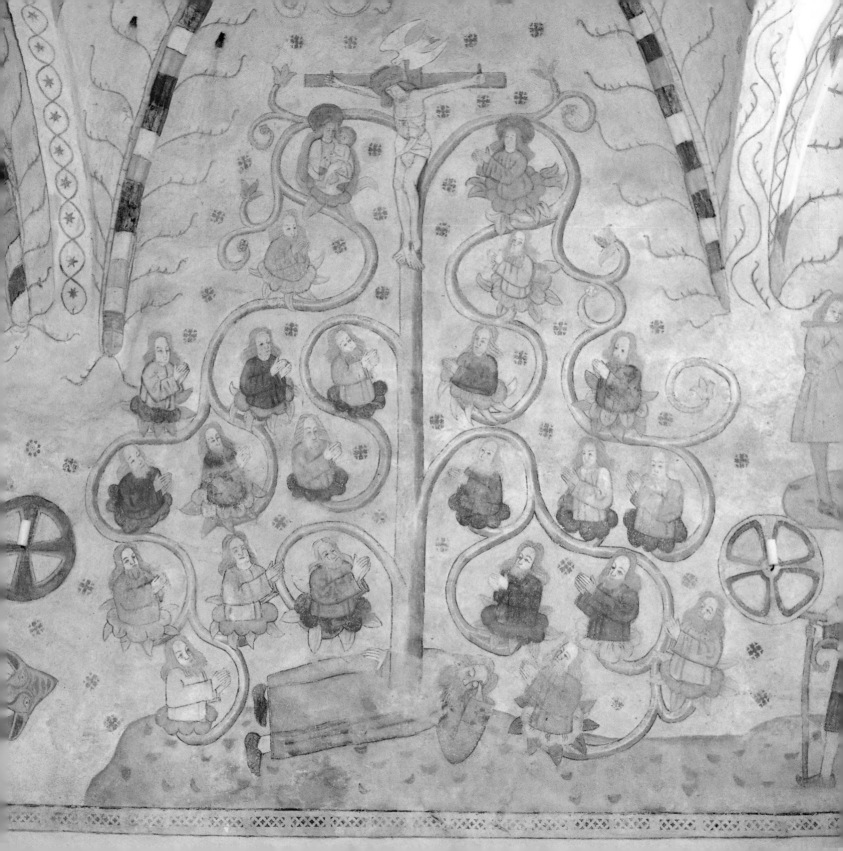

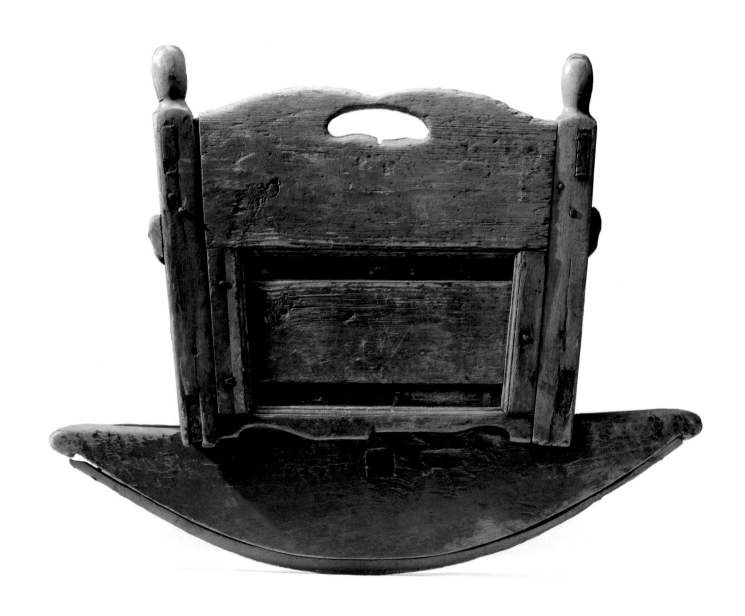

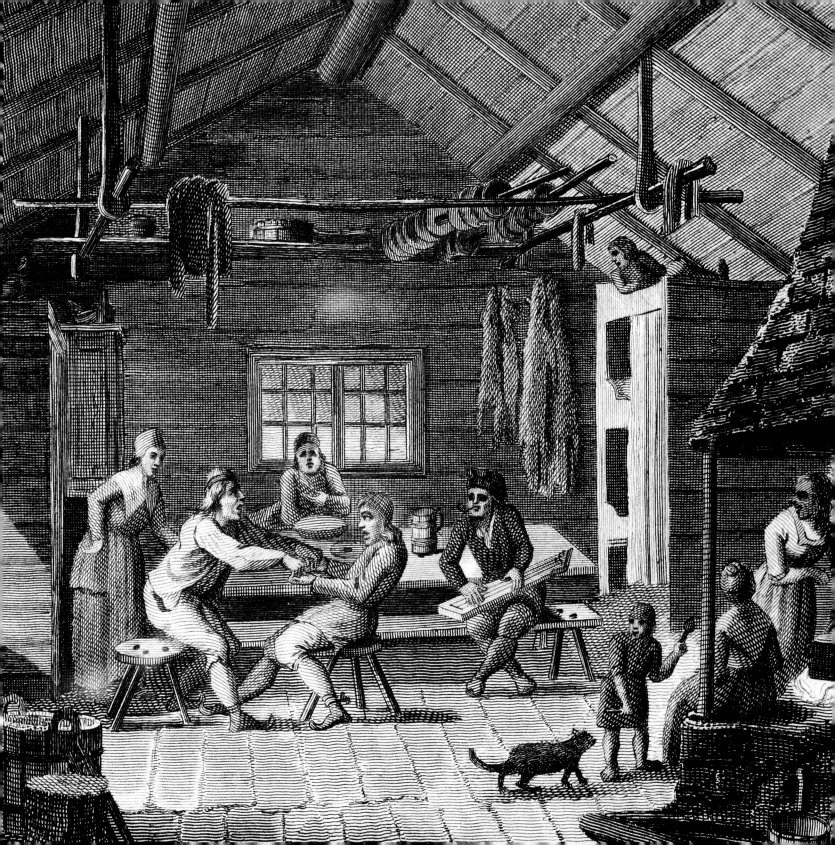

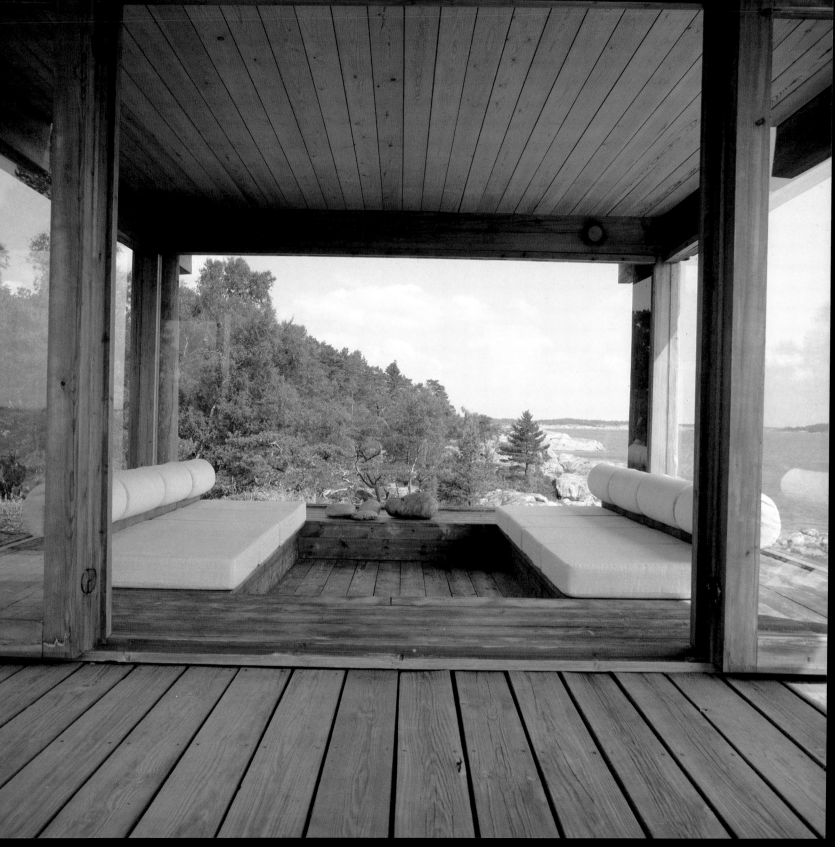

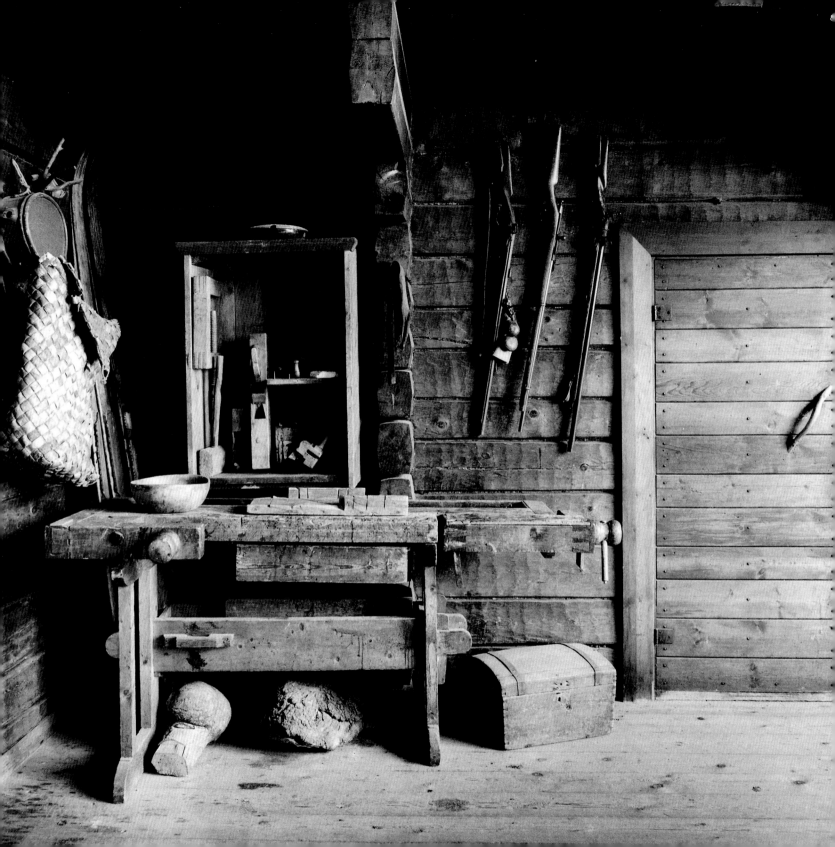

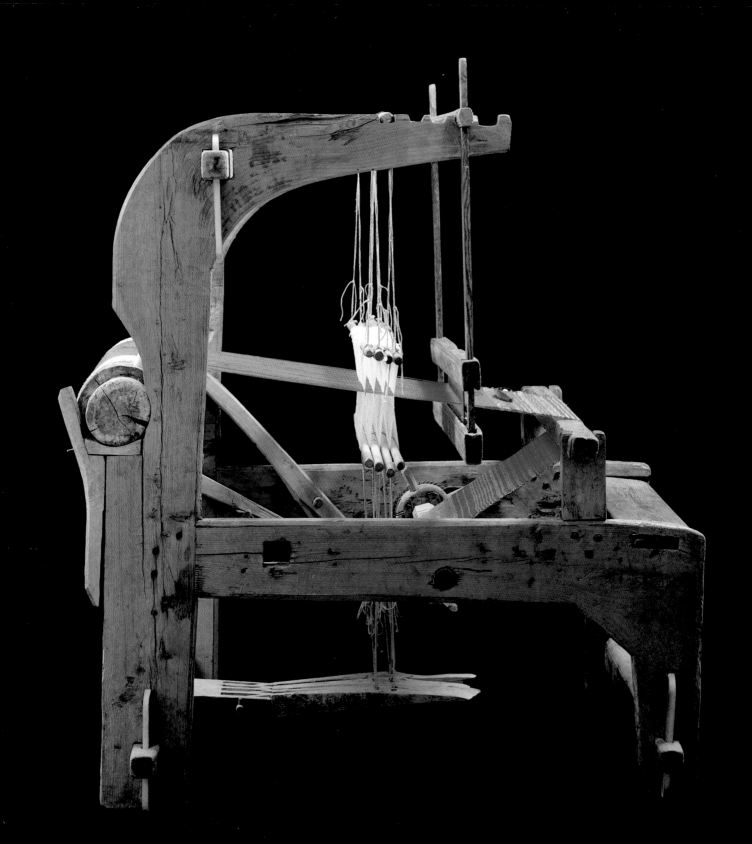

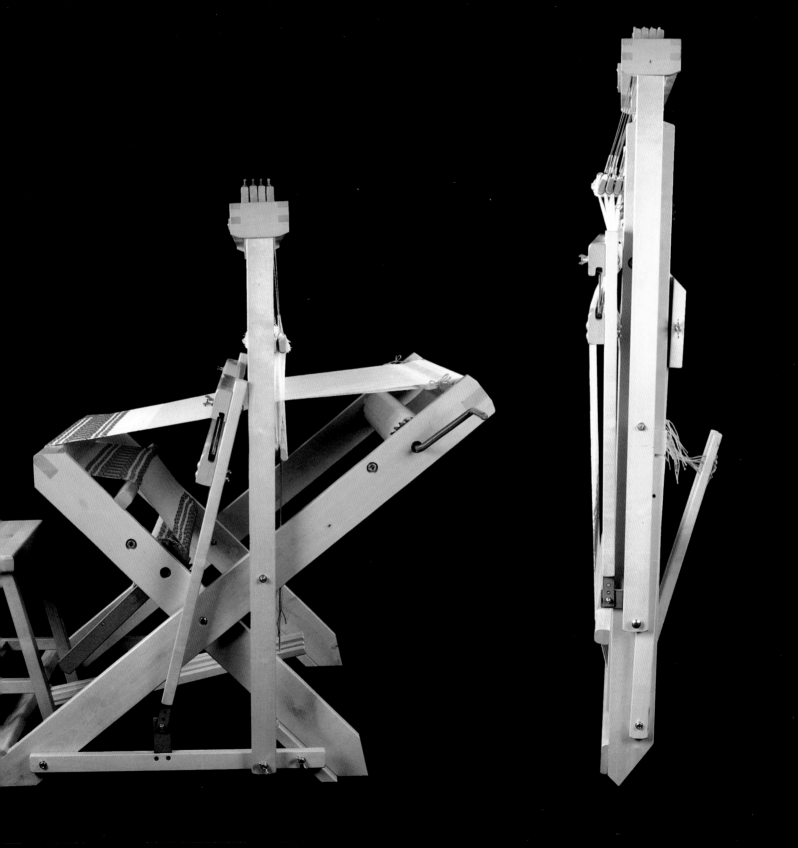

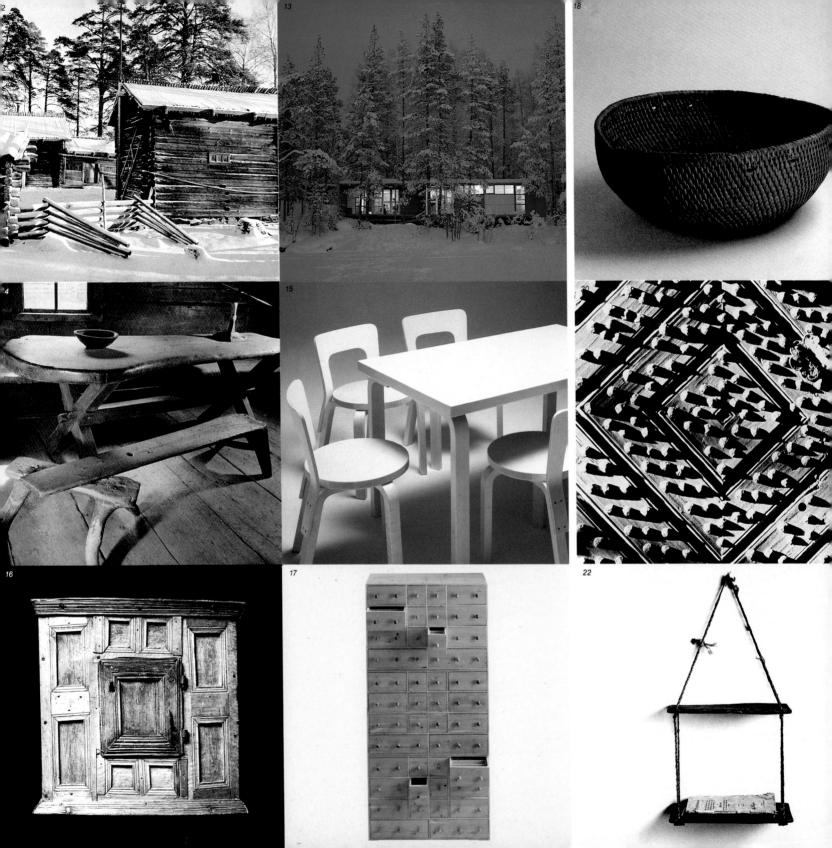

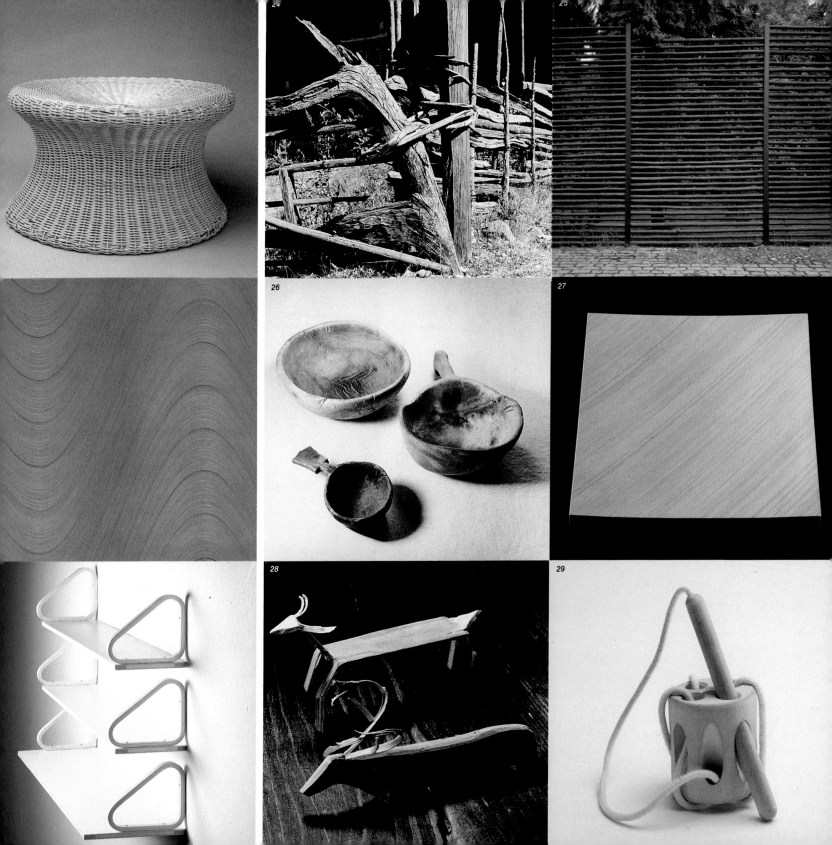

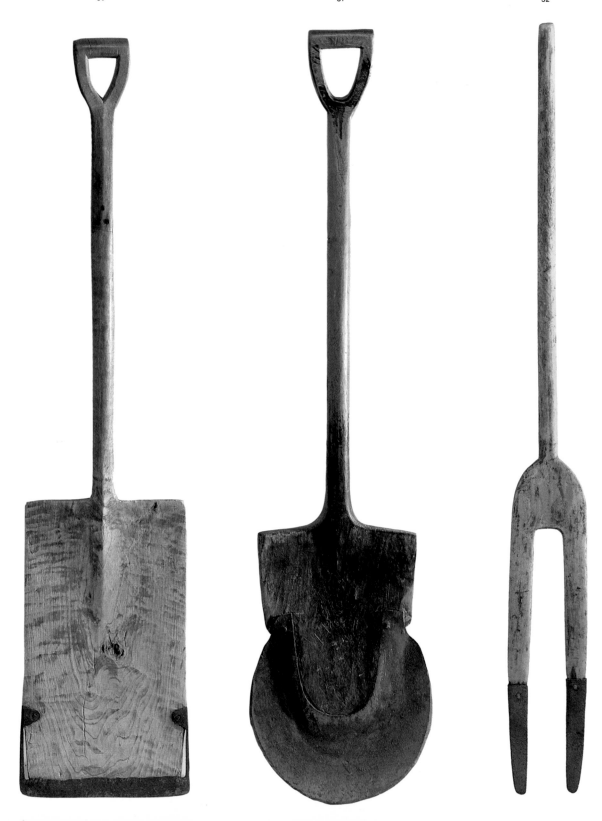

30 31 32

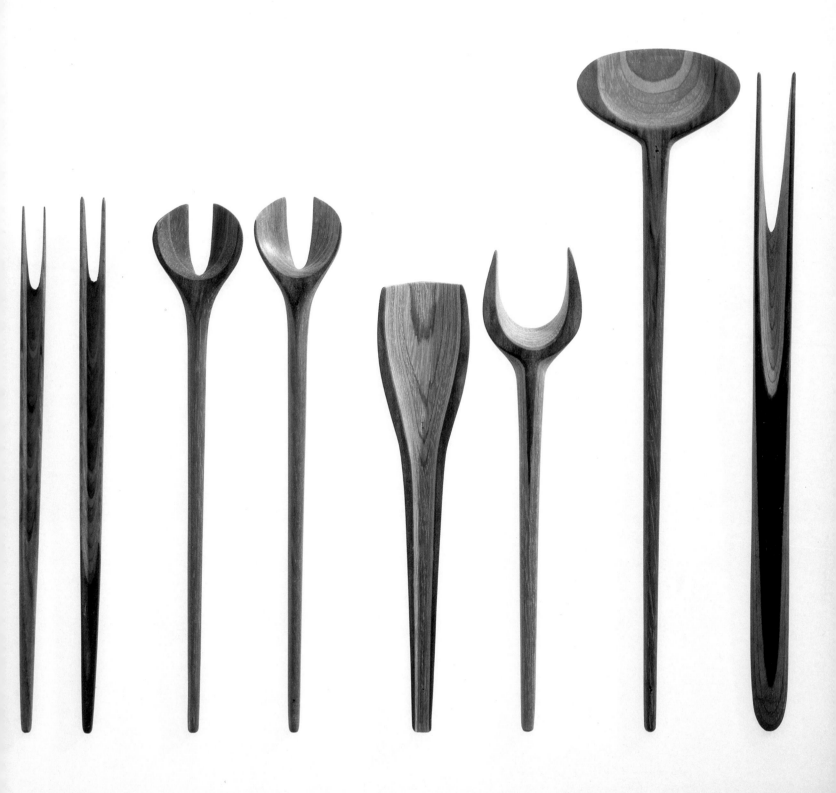

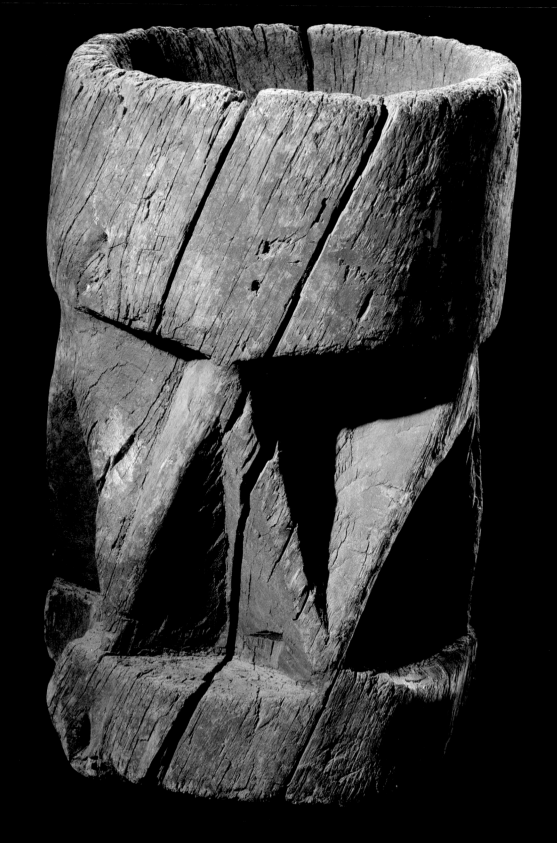

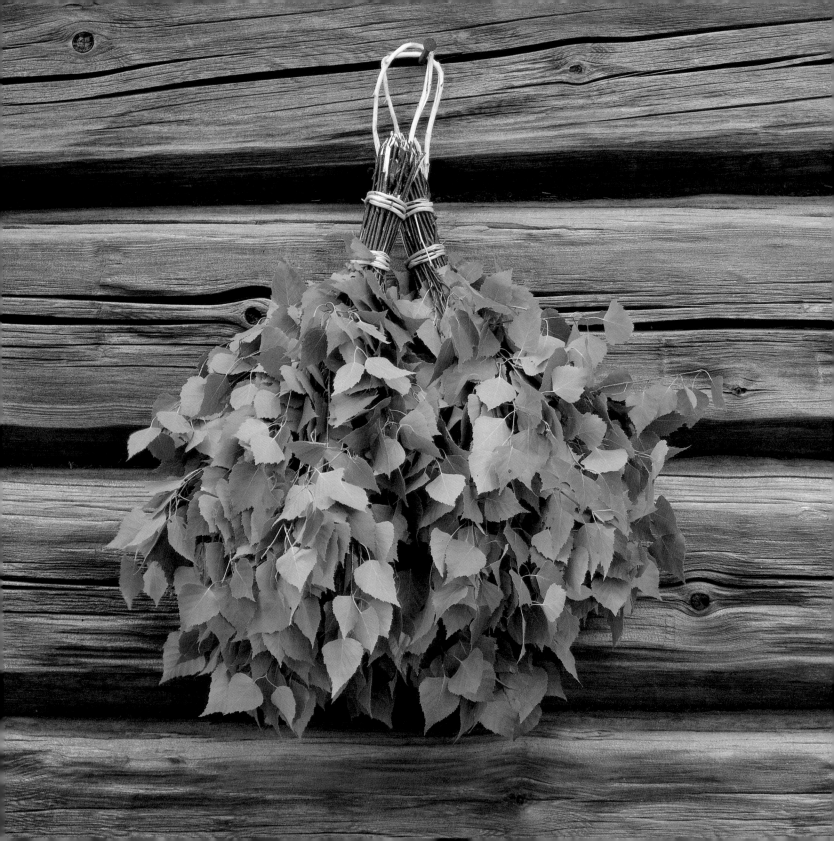

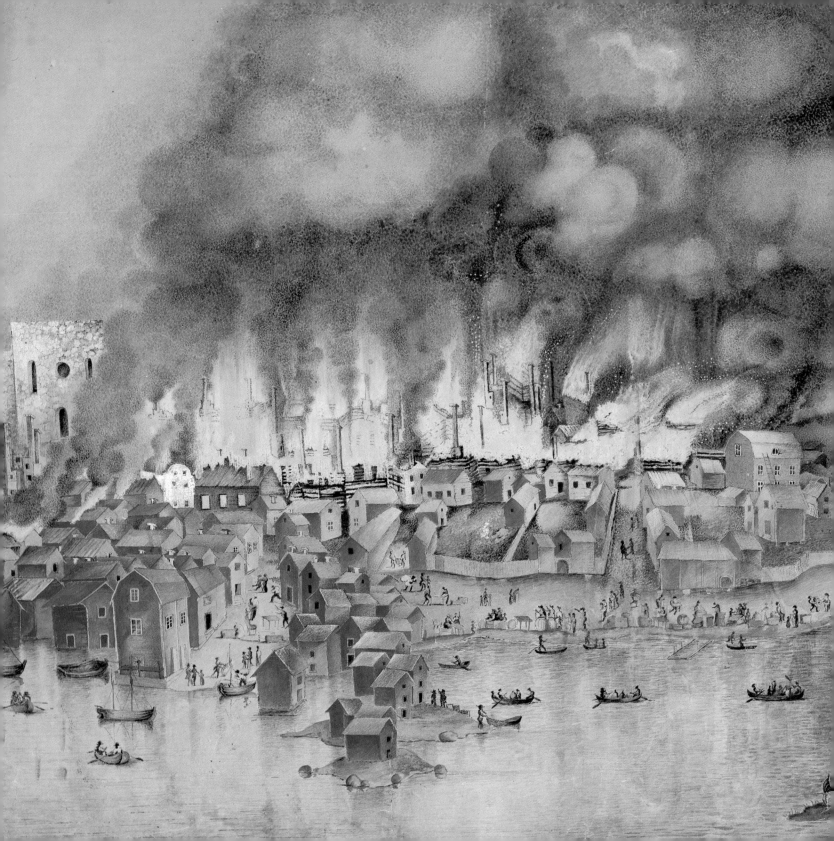

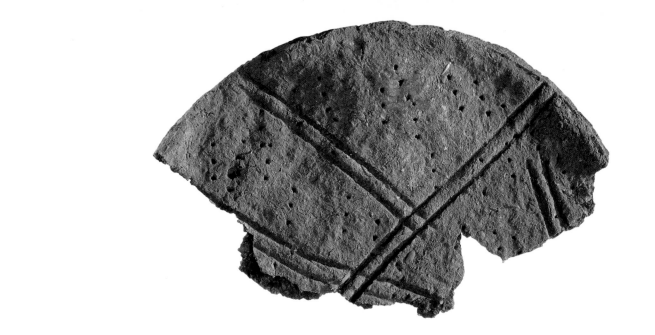

wood shapes

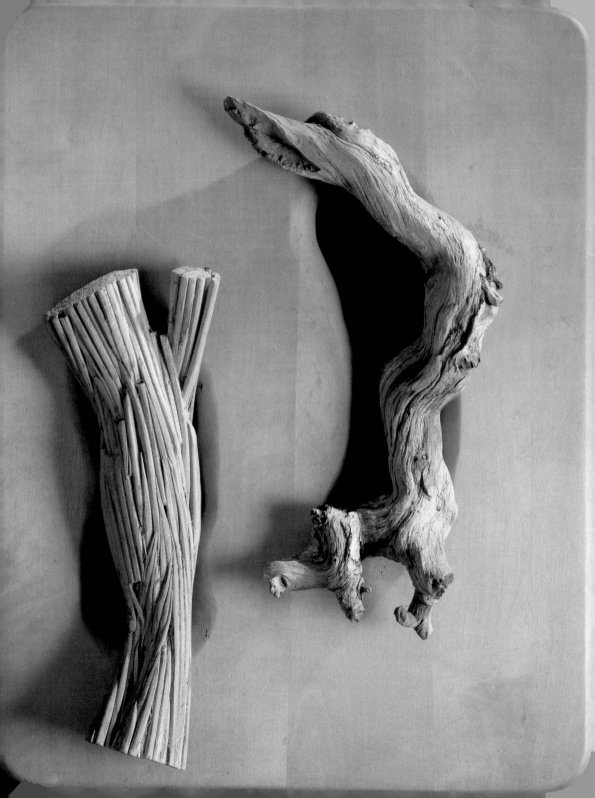

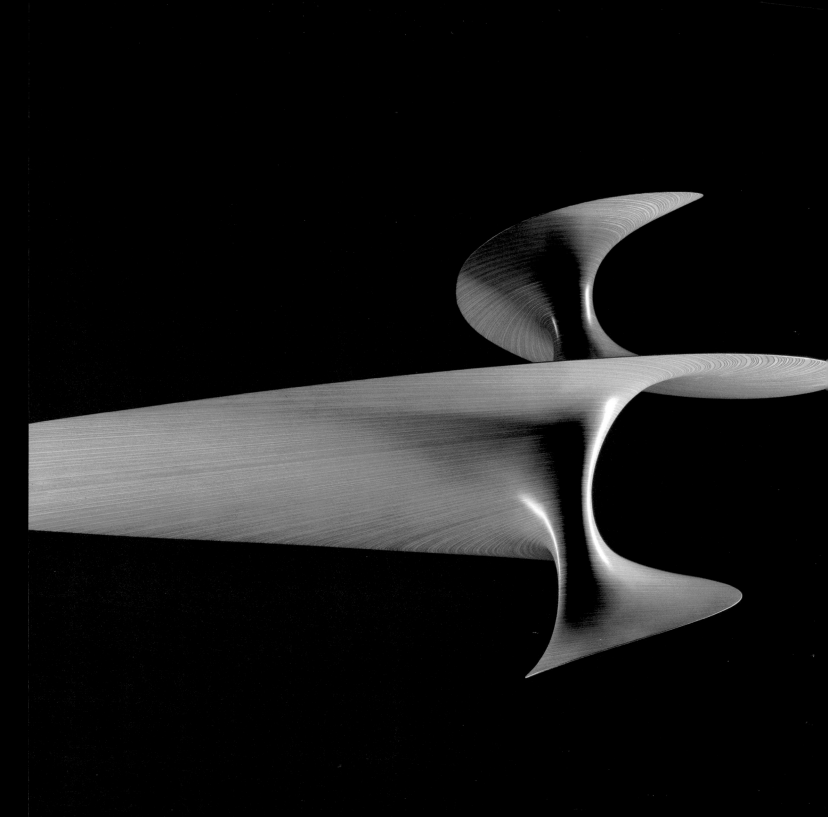

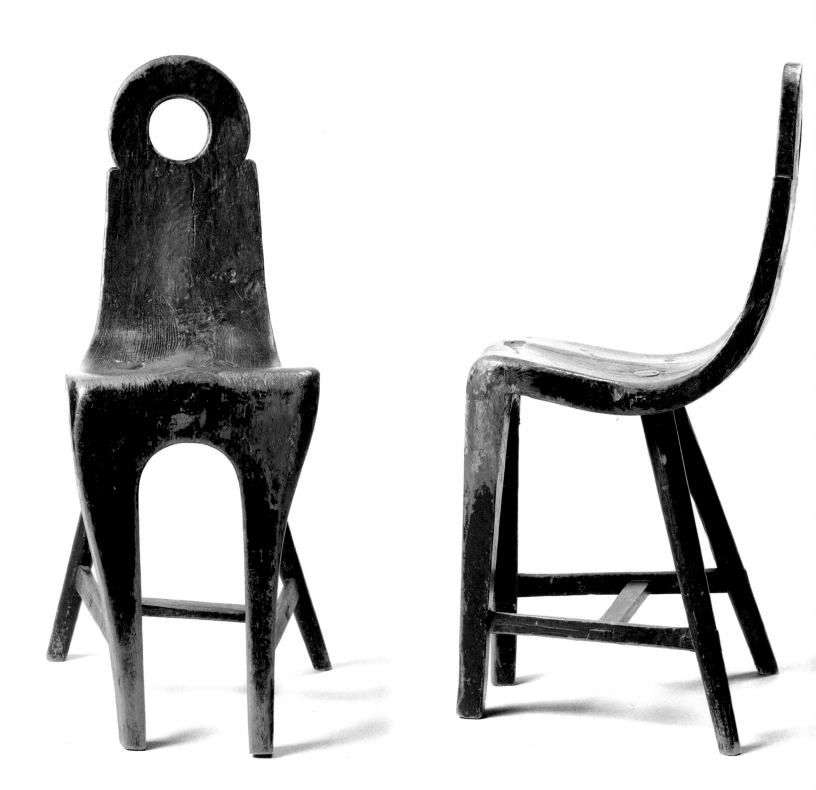

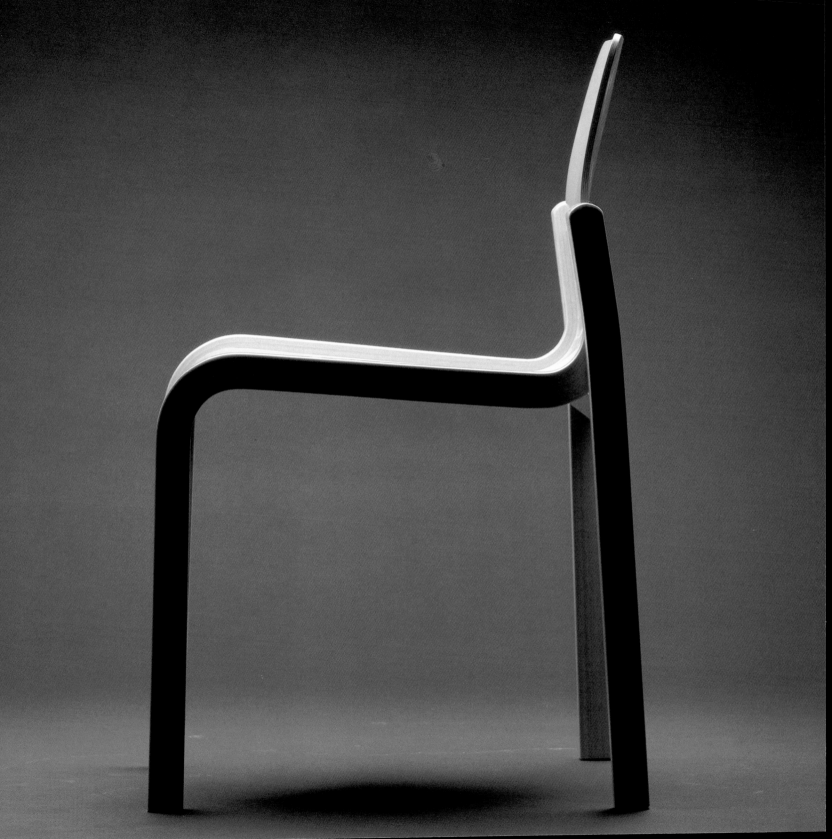

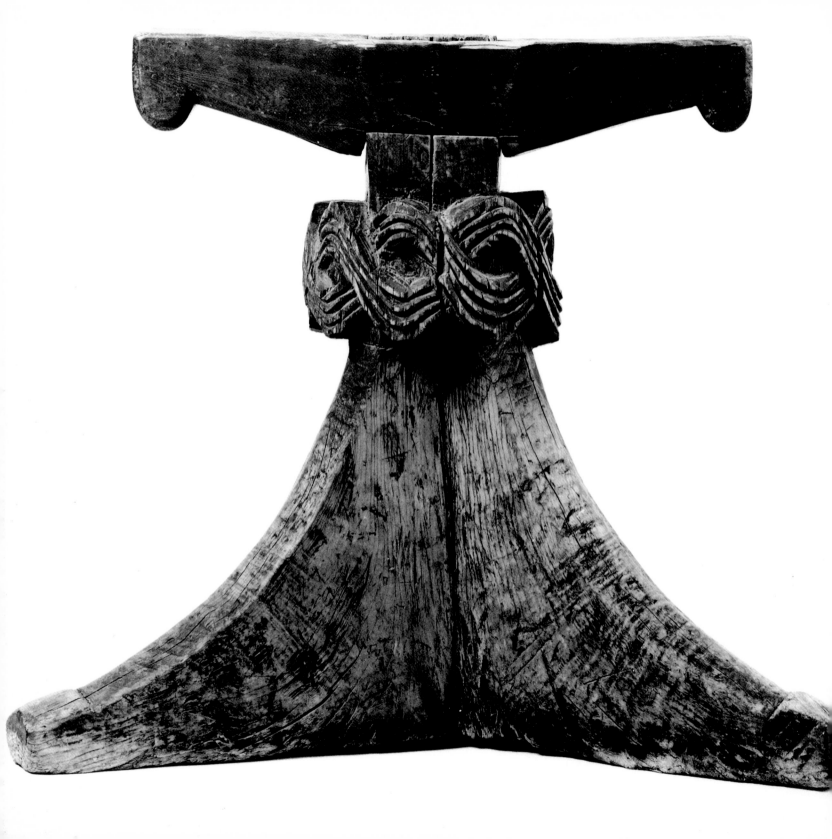

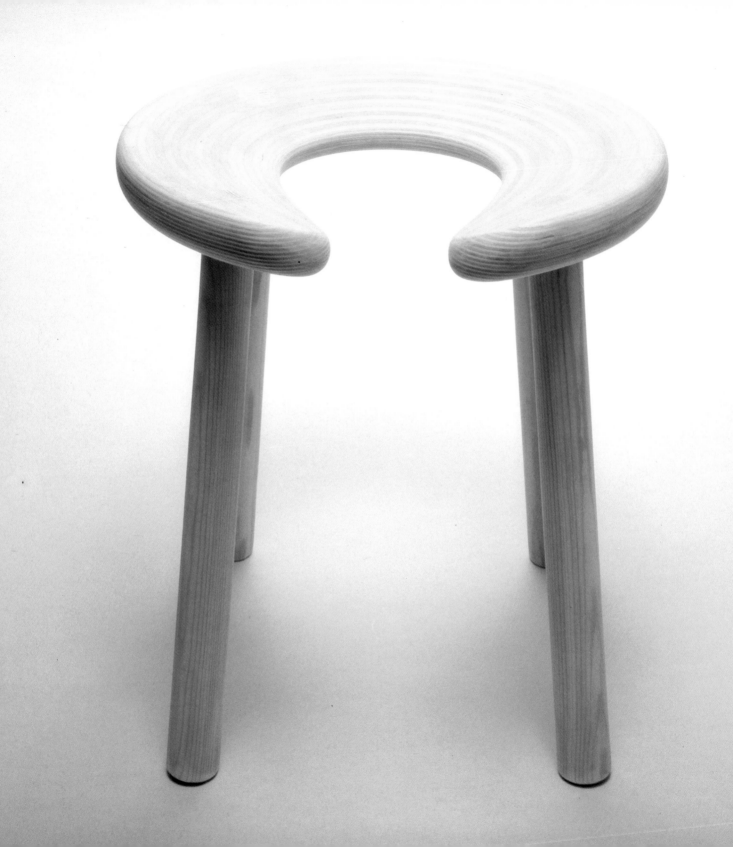

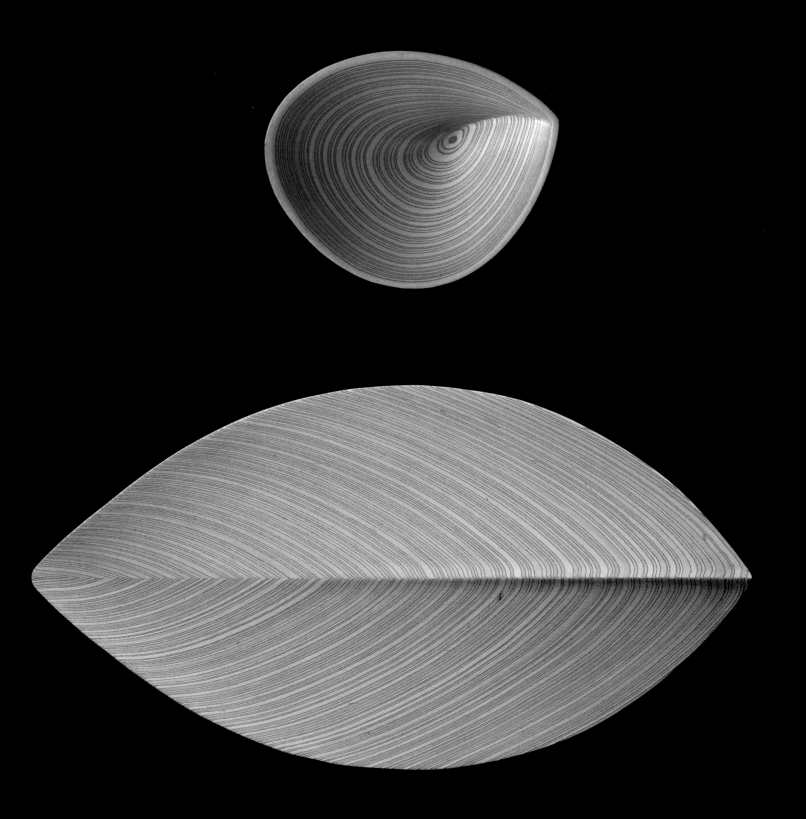

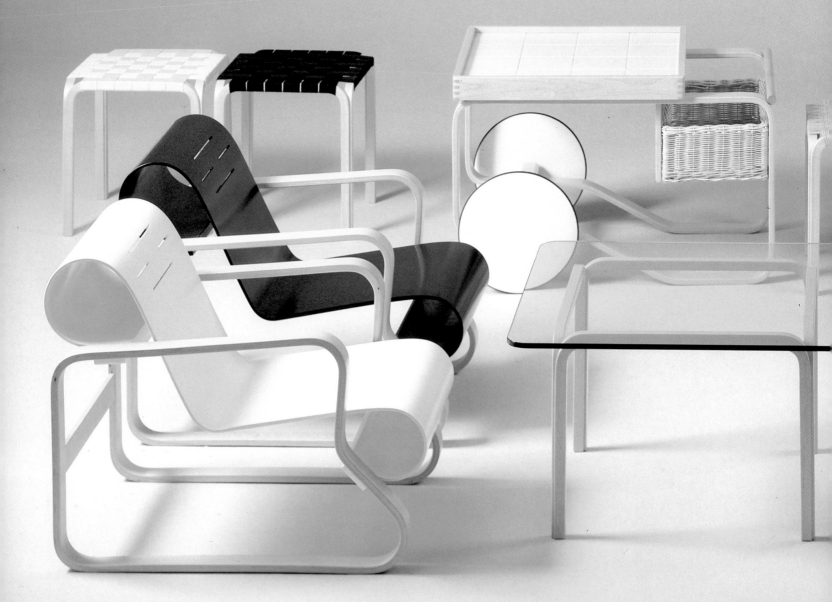

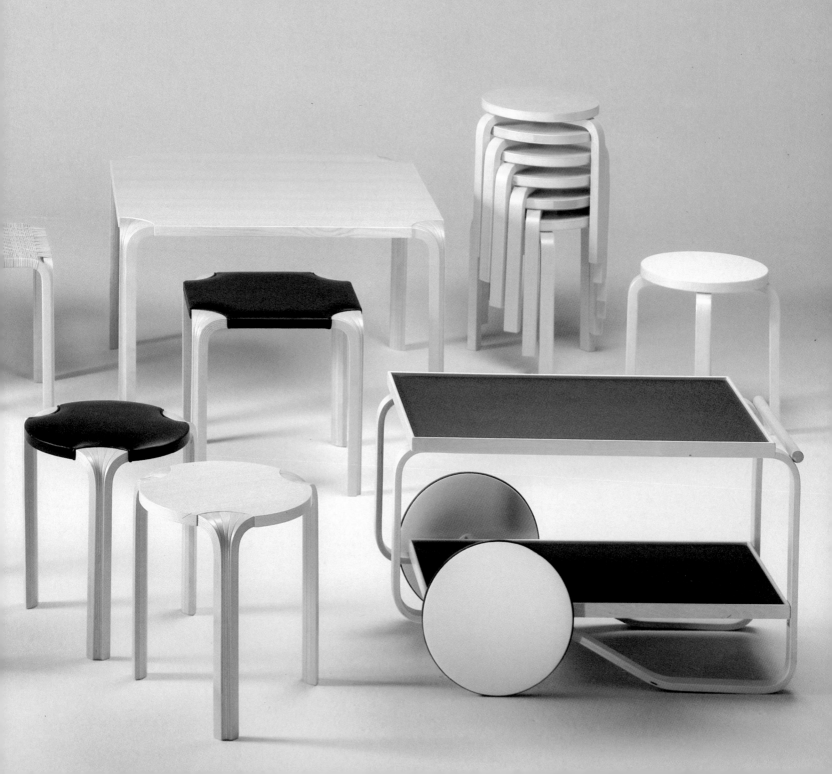

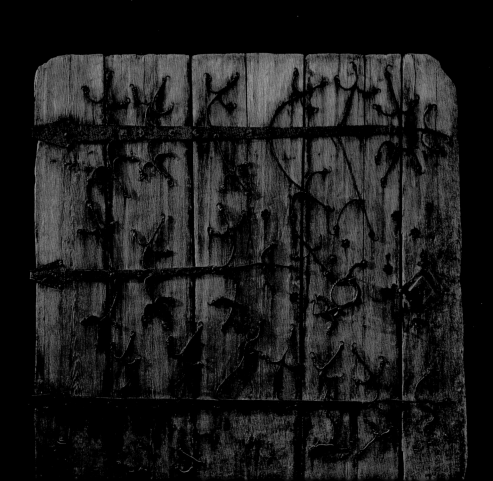

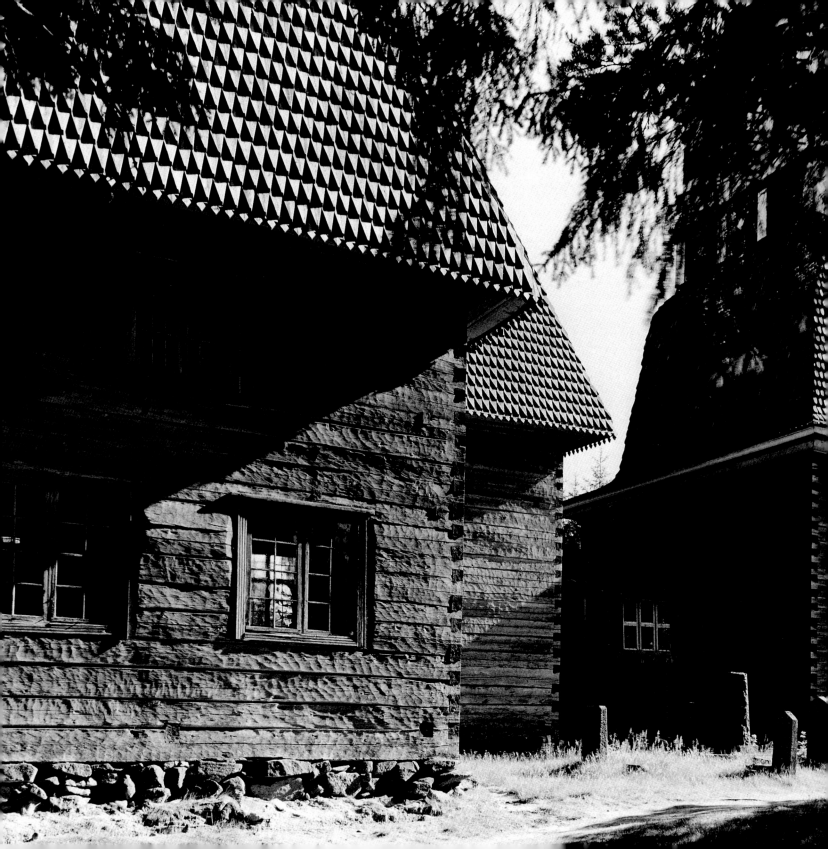

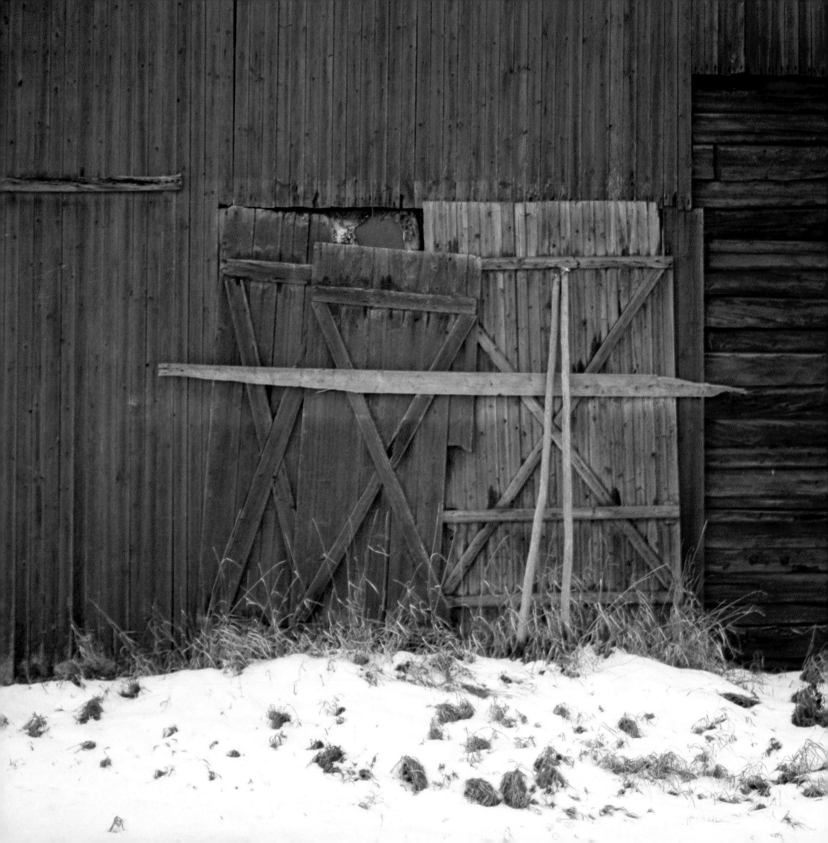

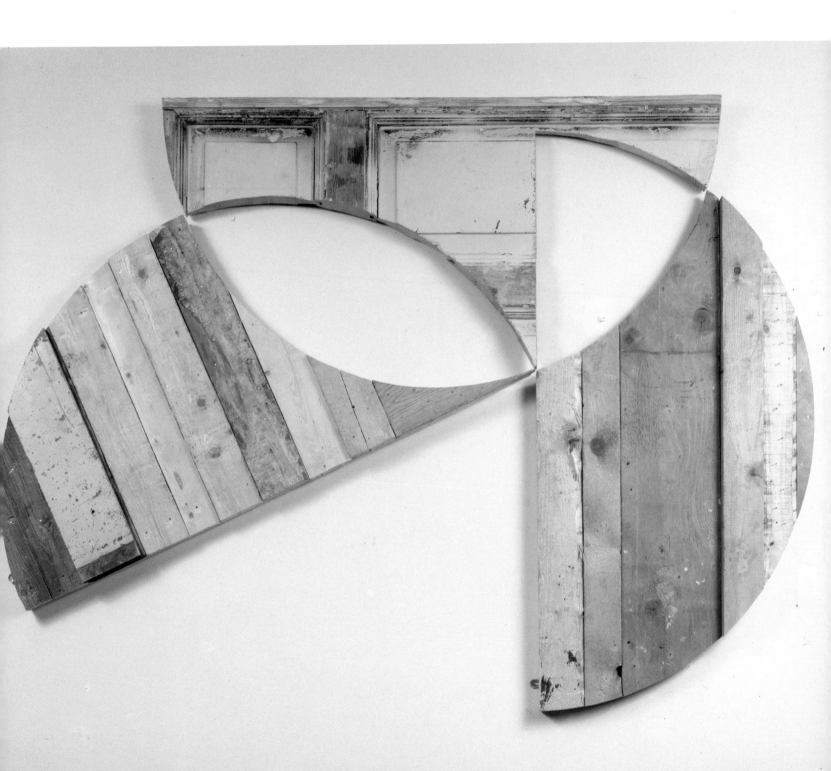

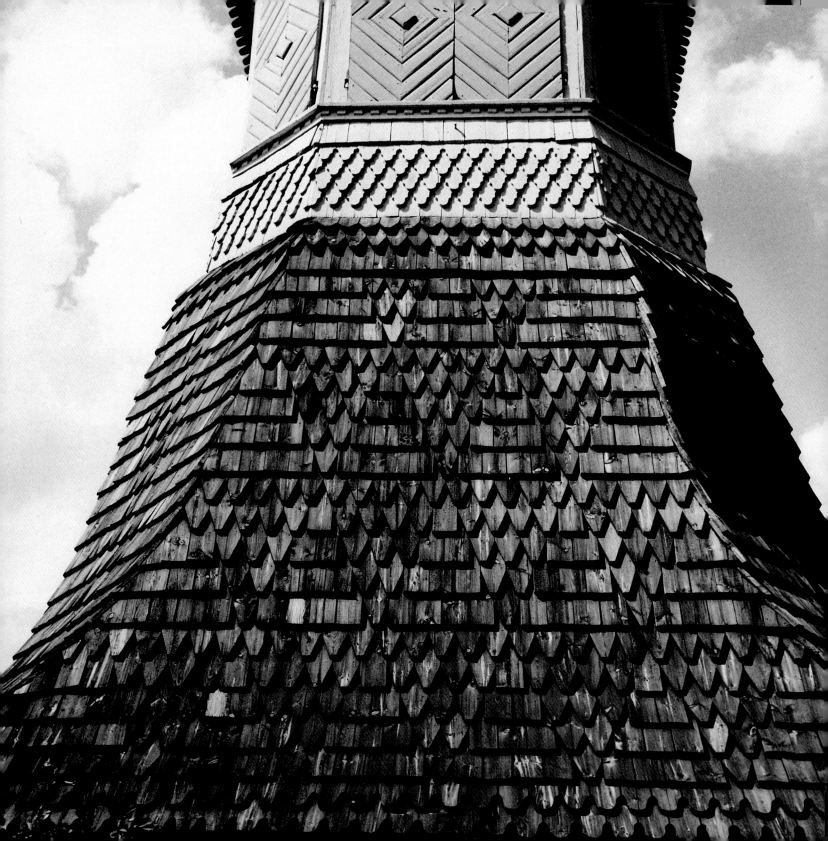

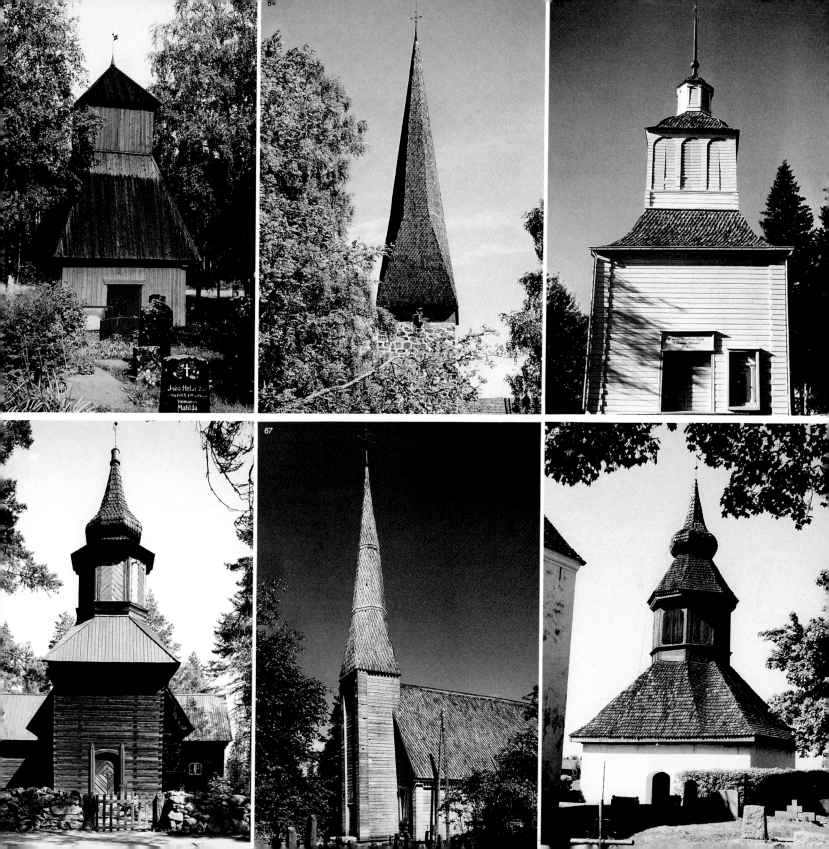

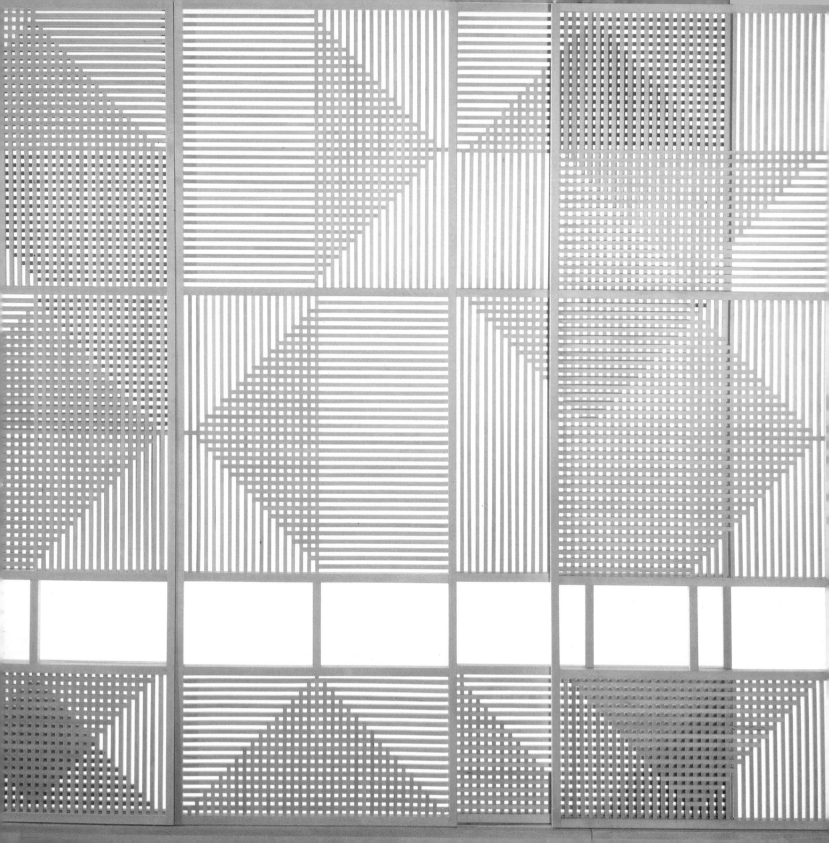

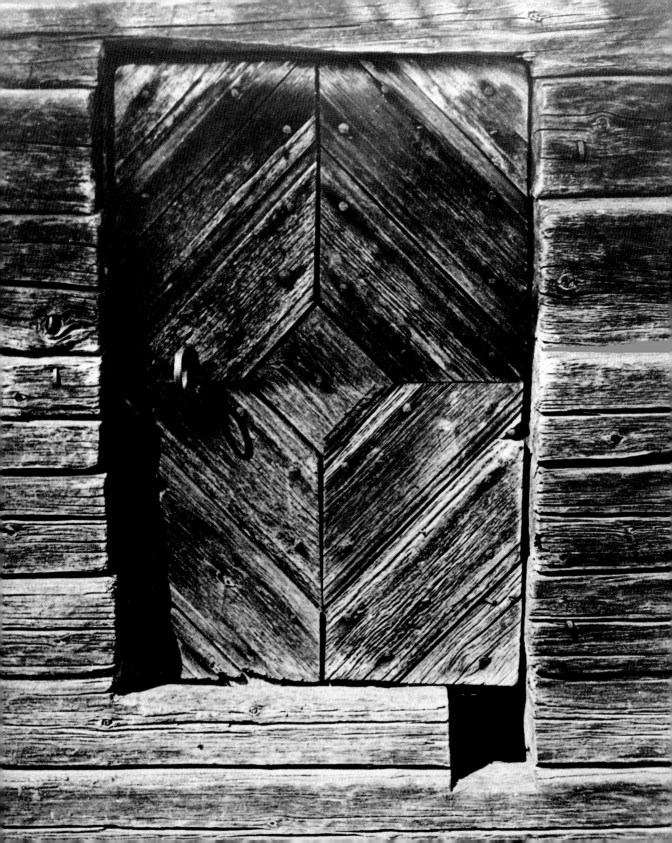

structure

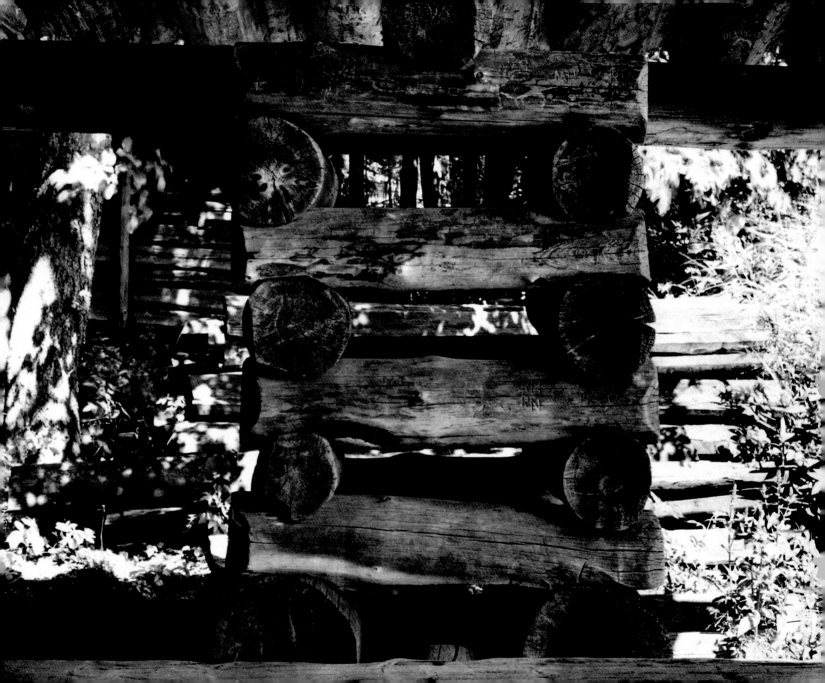

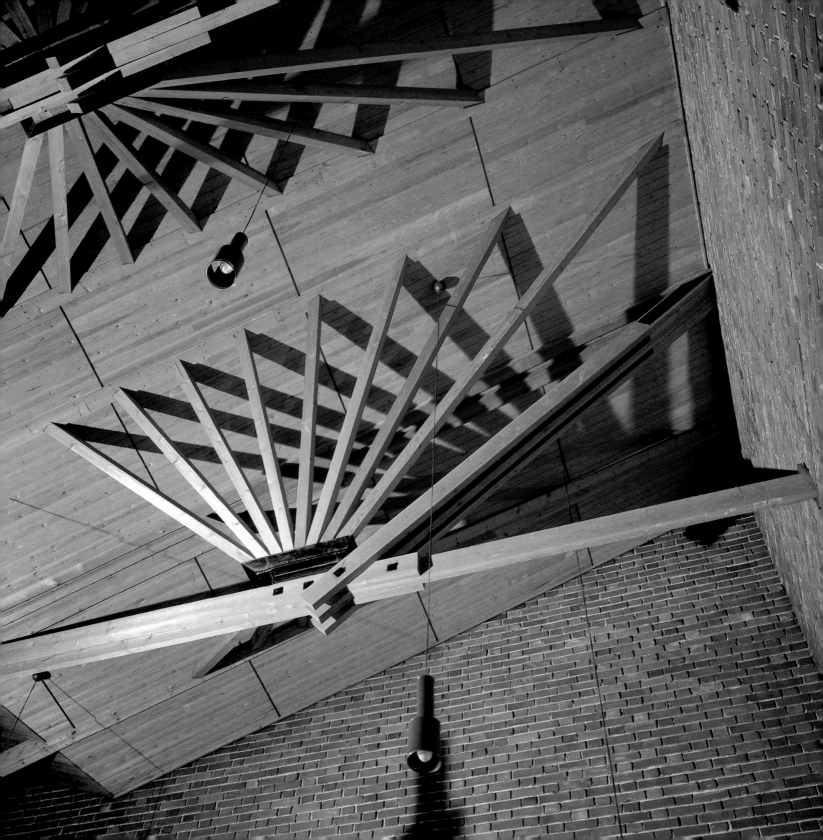

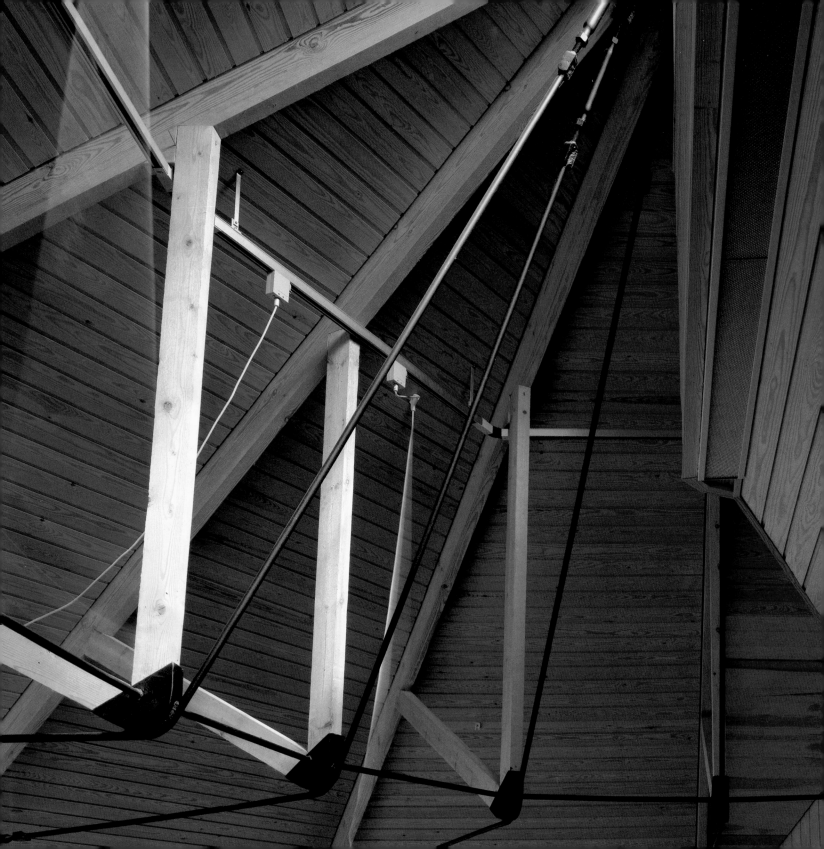

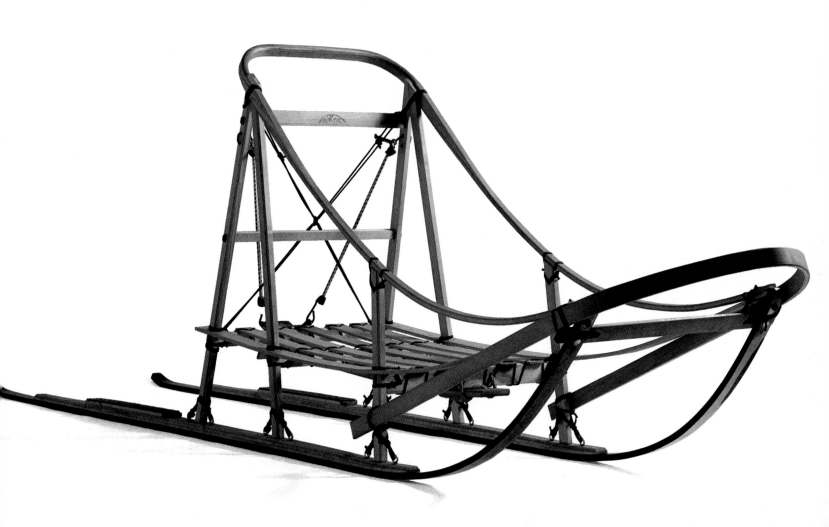

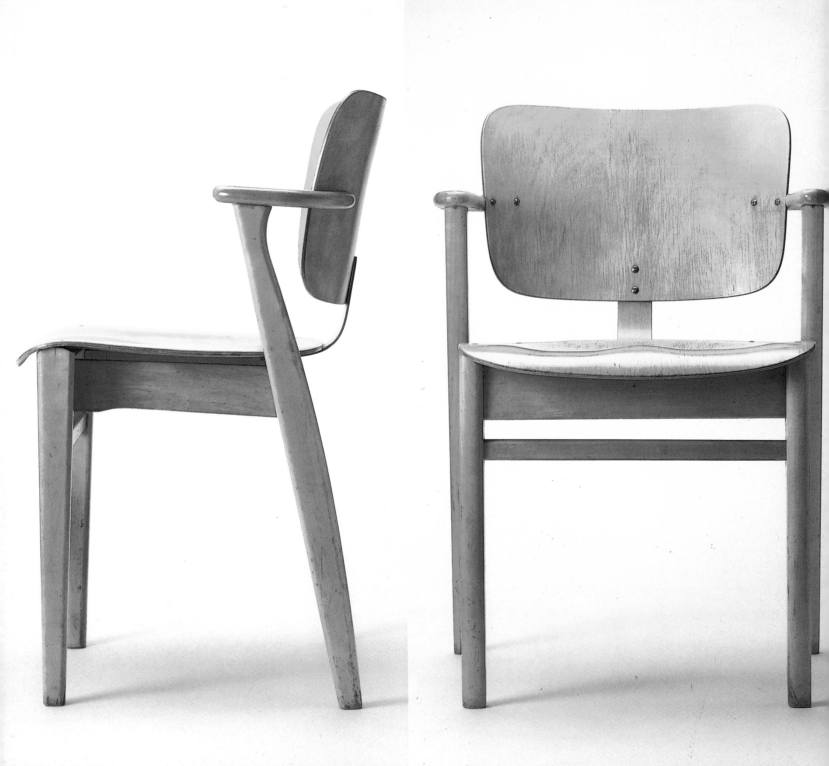

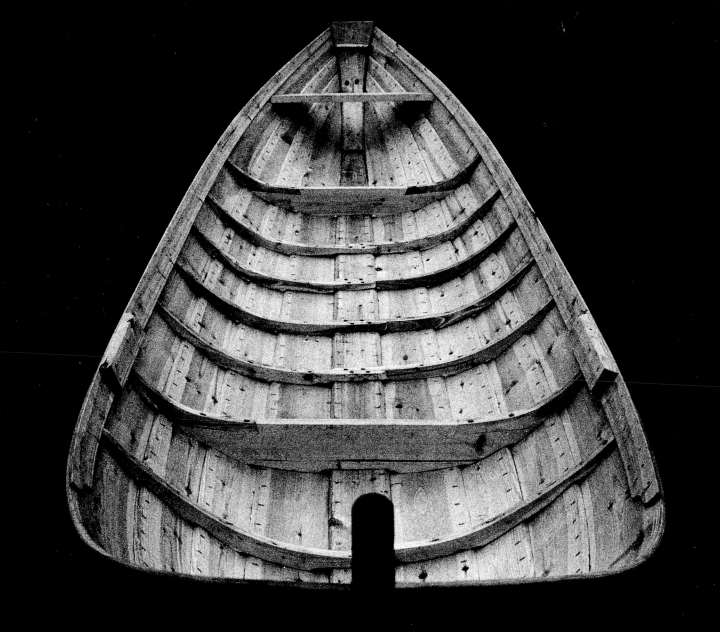

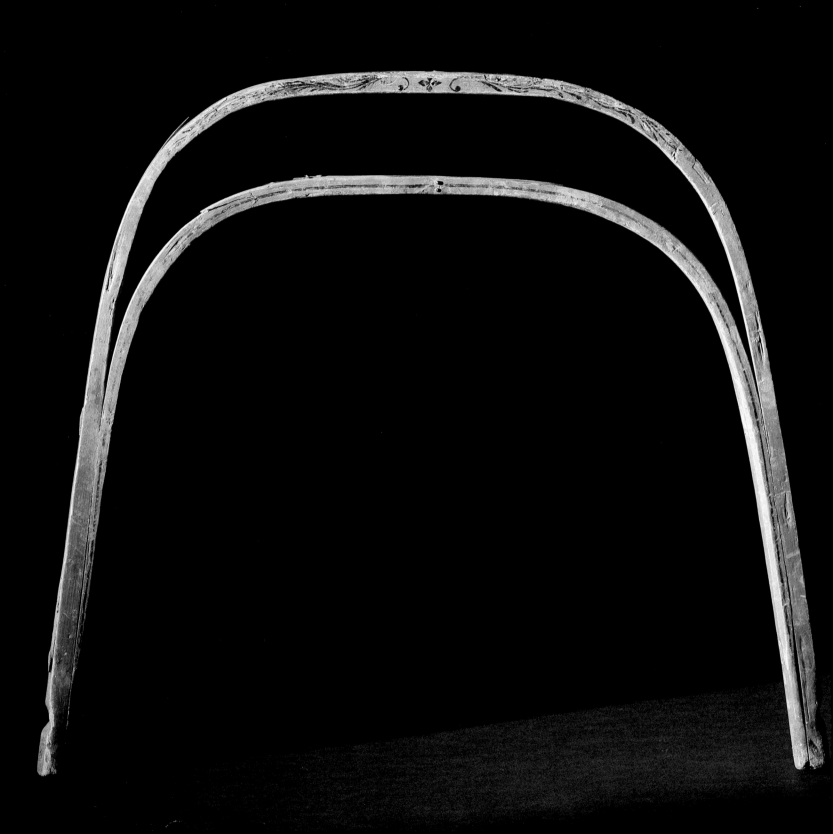

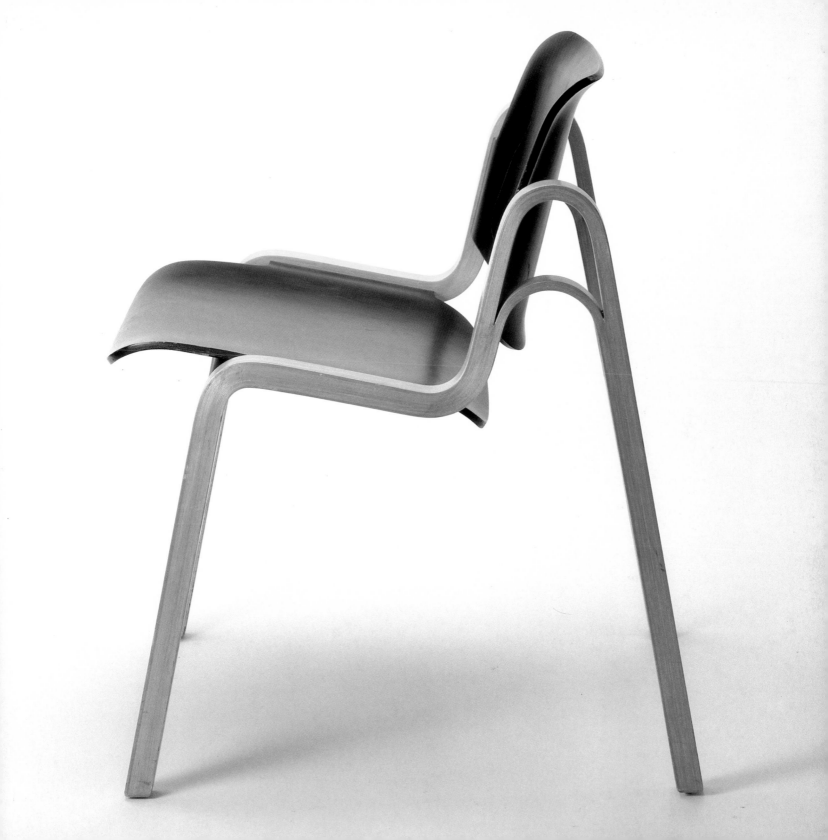

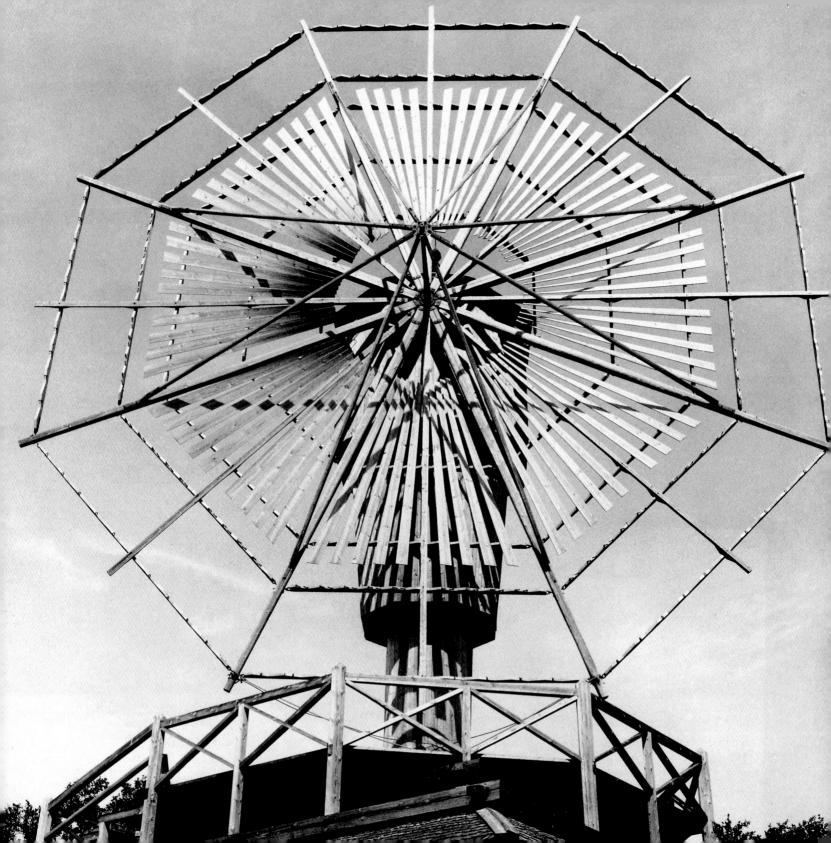

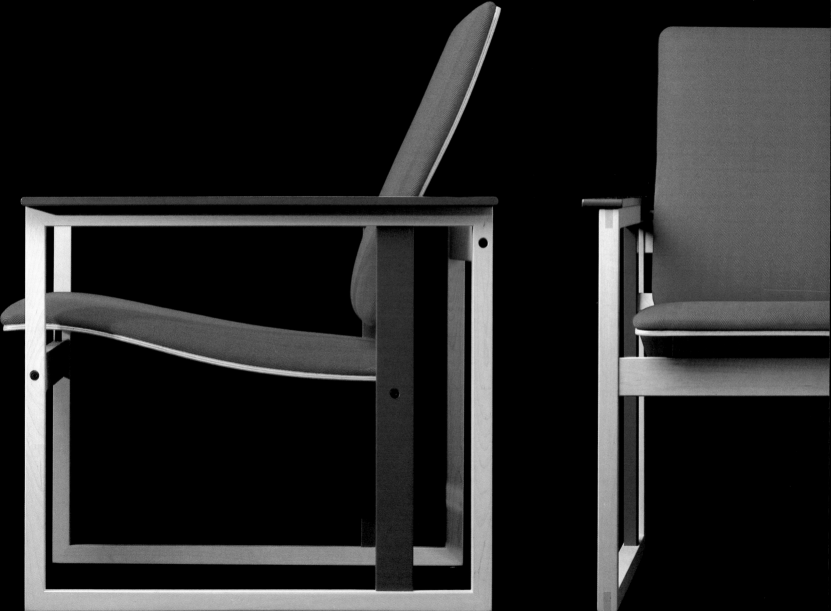

joints

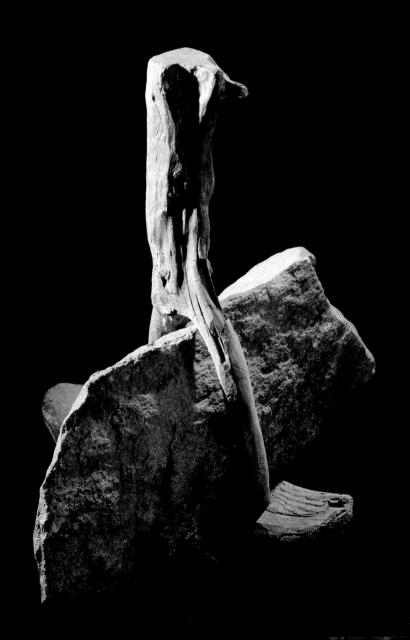

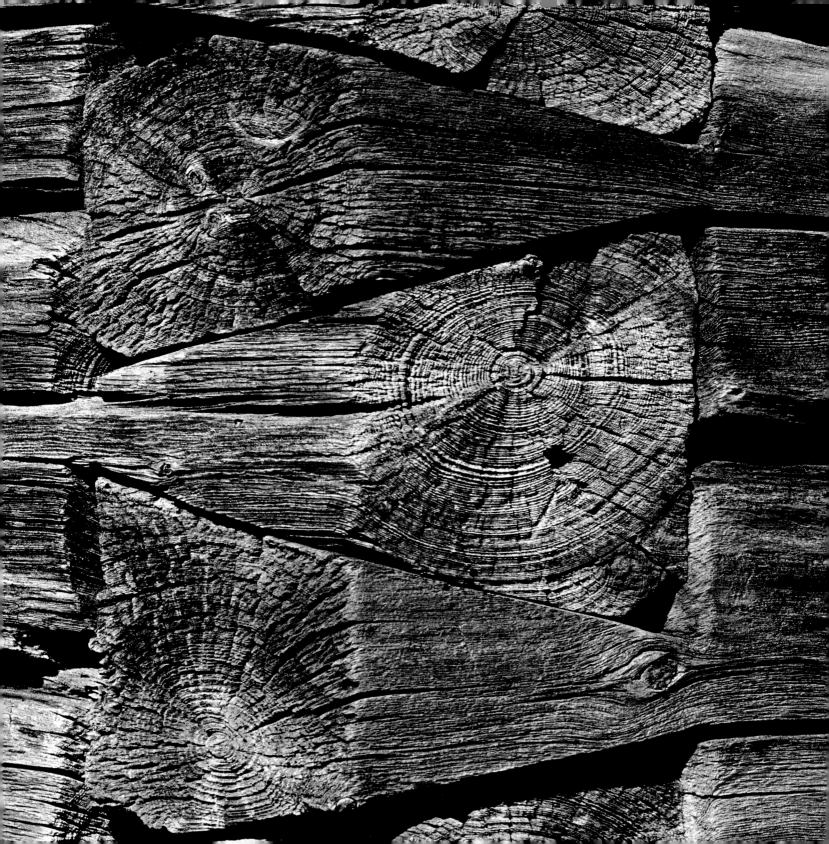

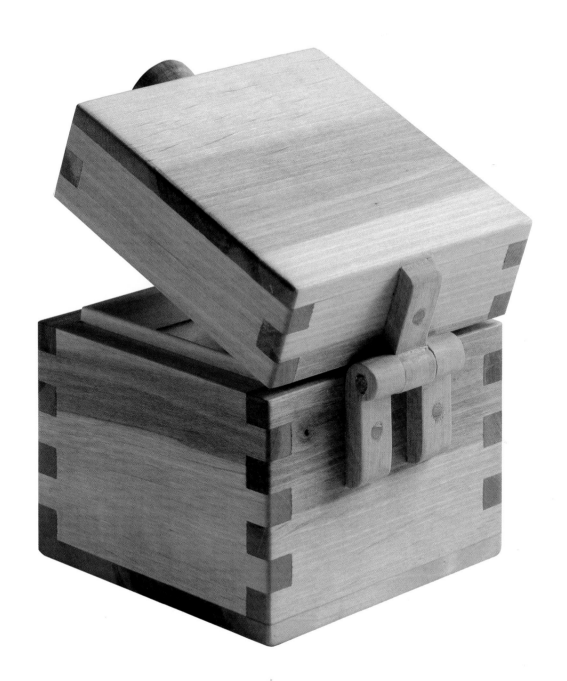

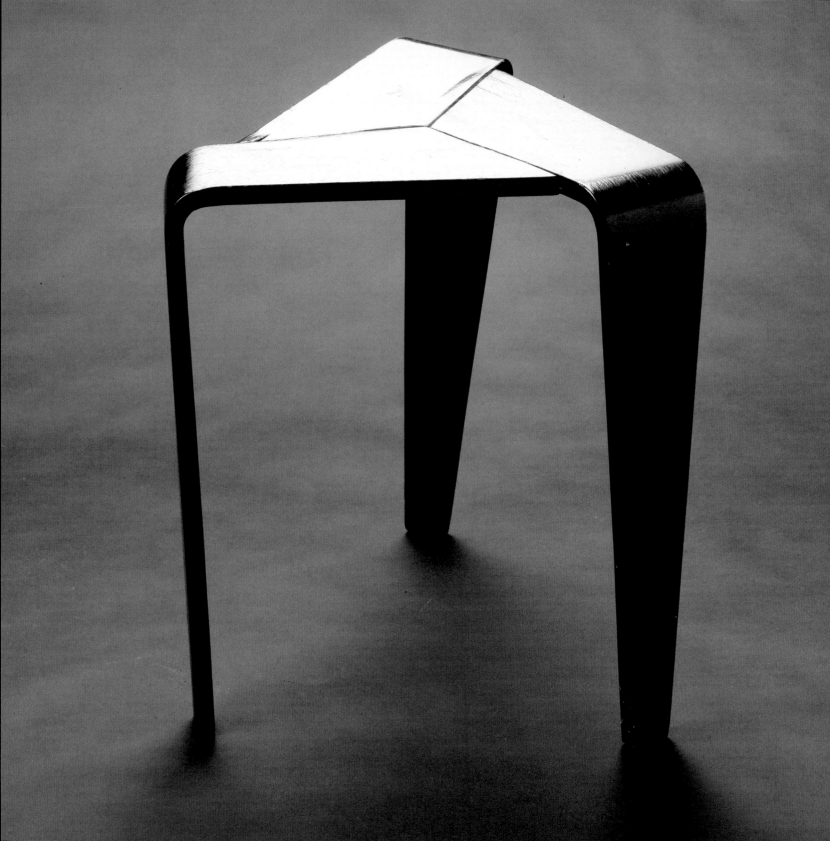

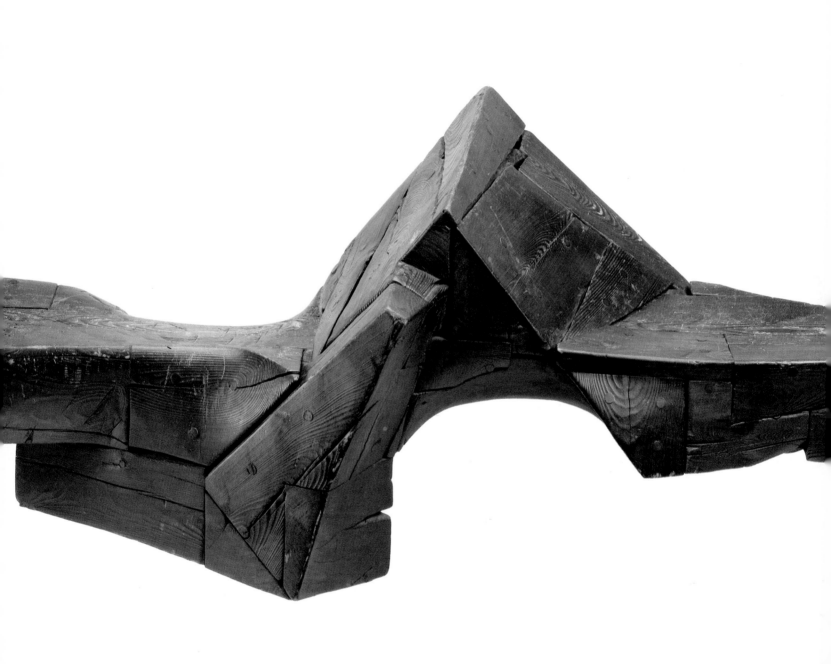

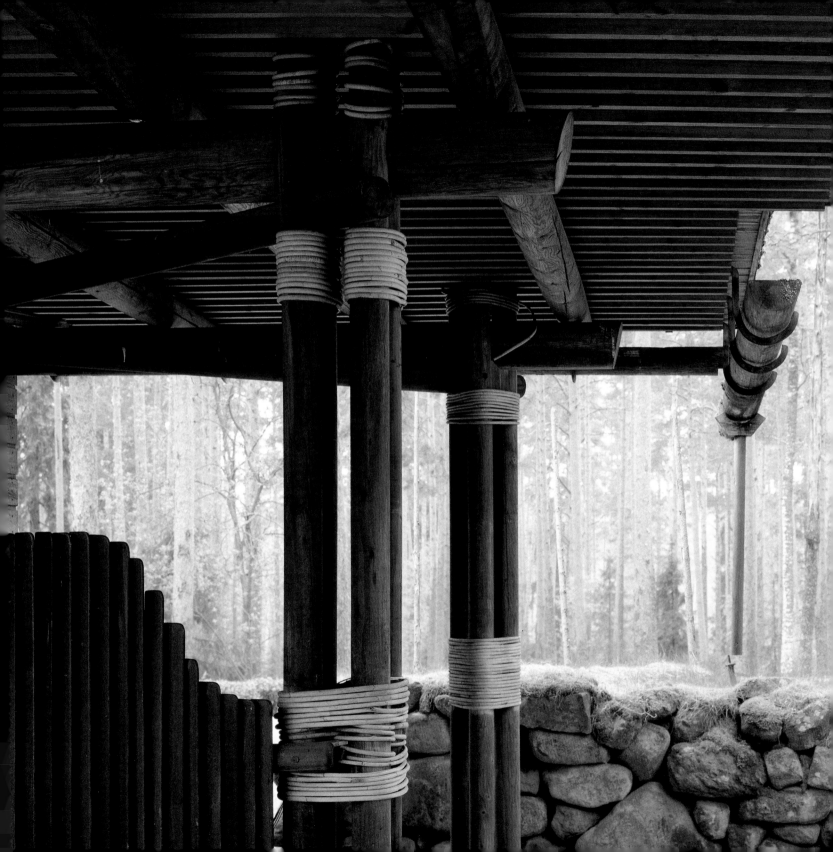

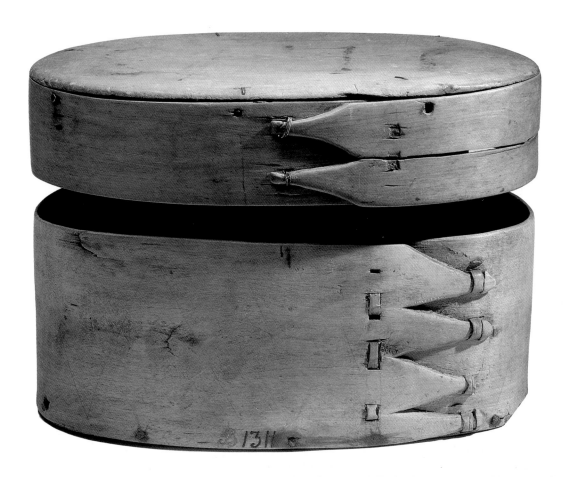

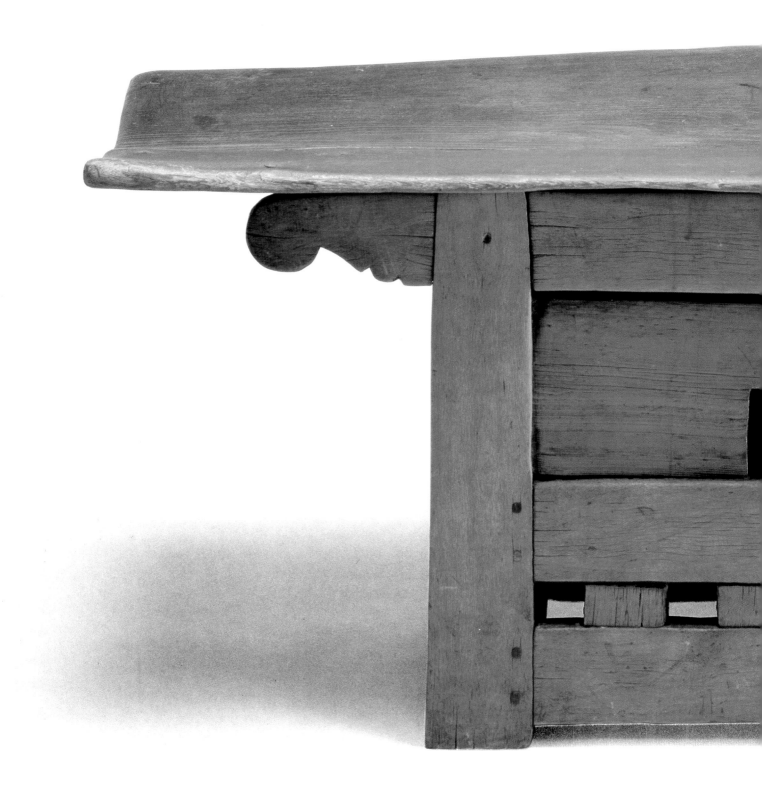

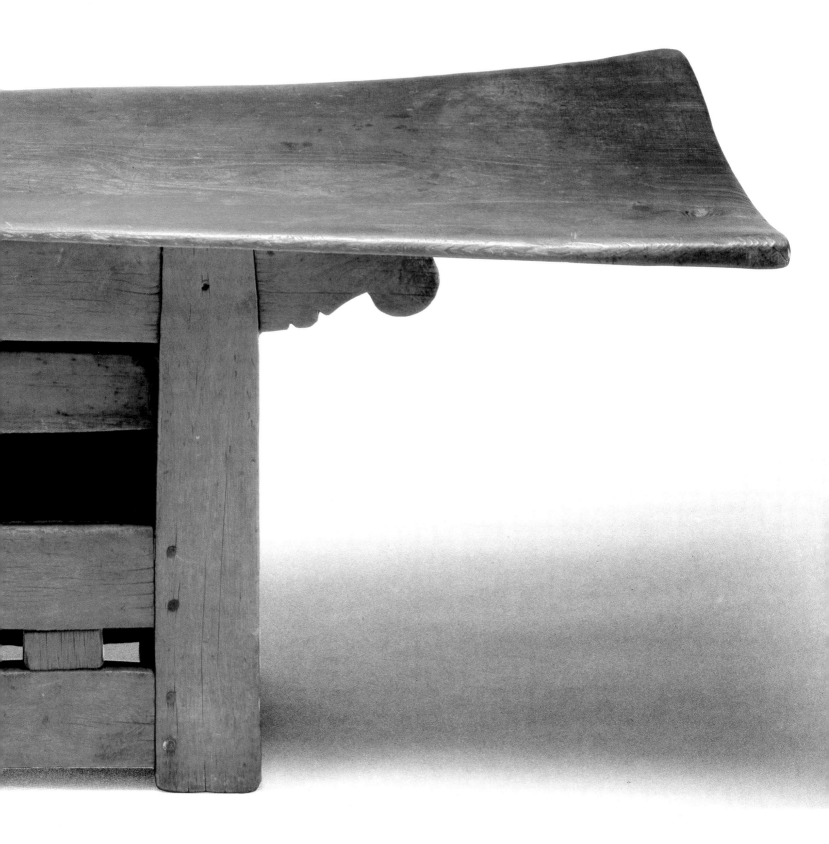

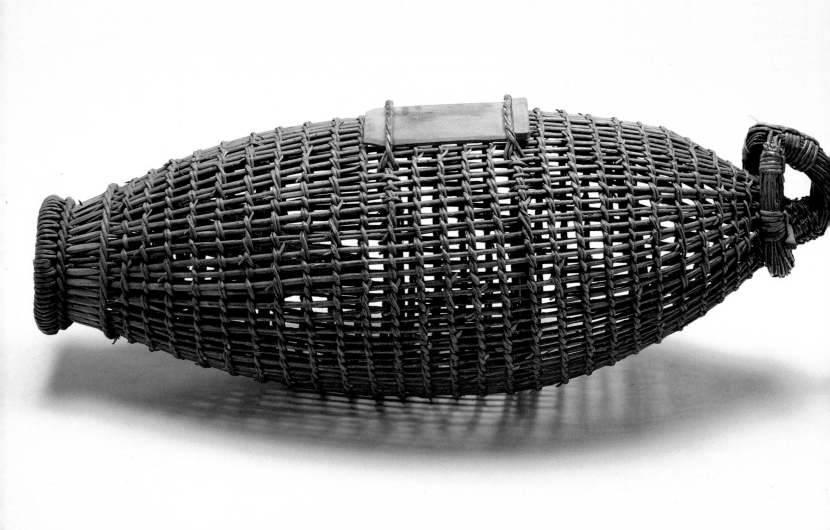

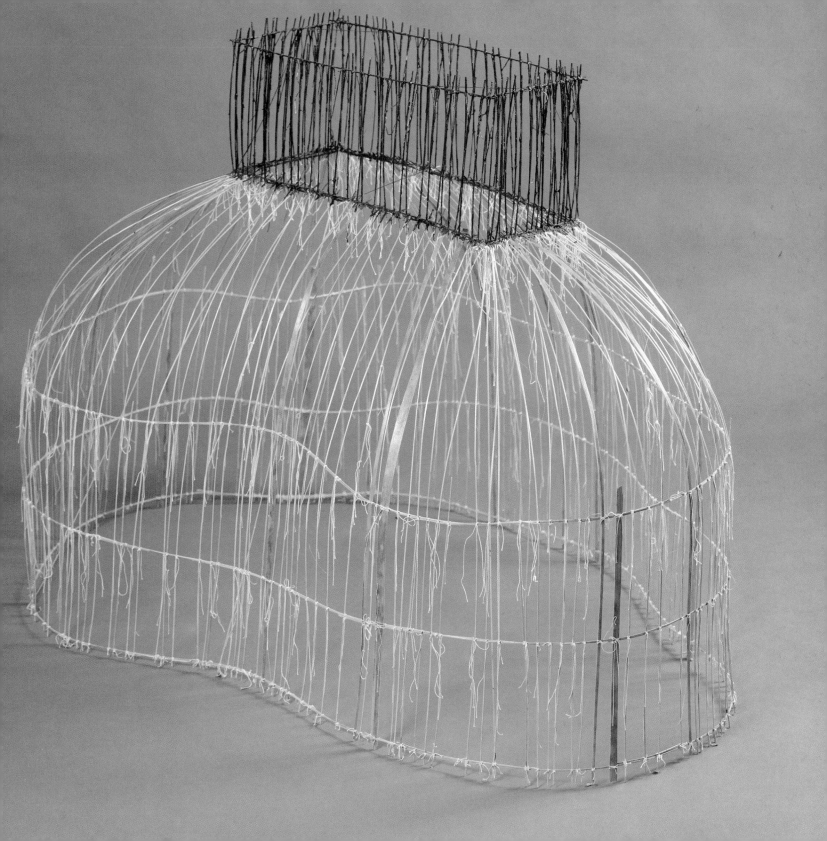

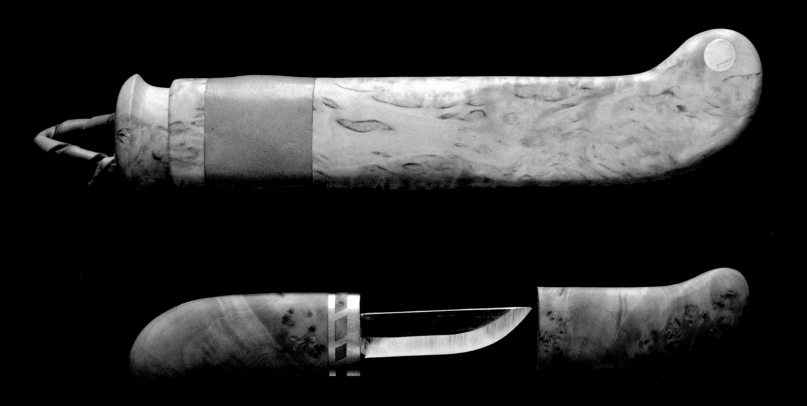

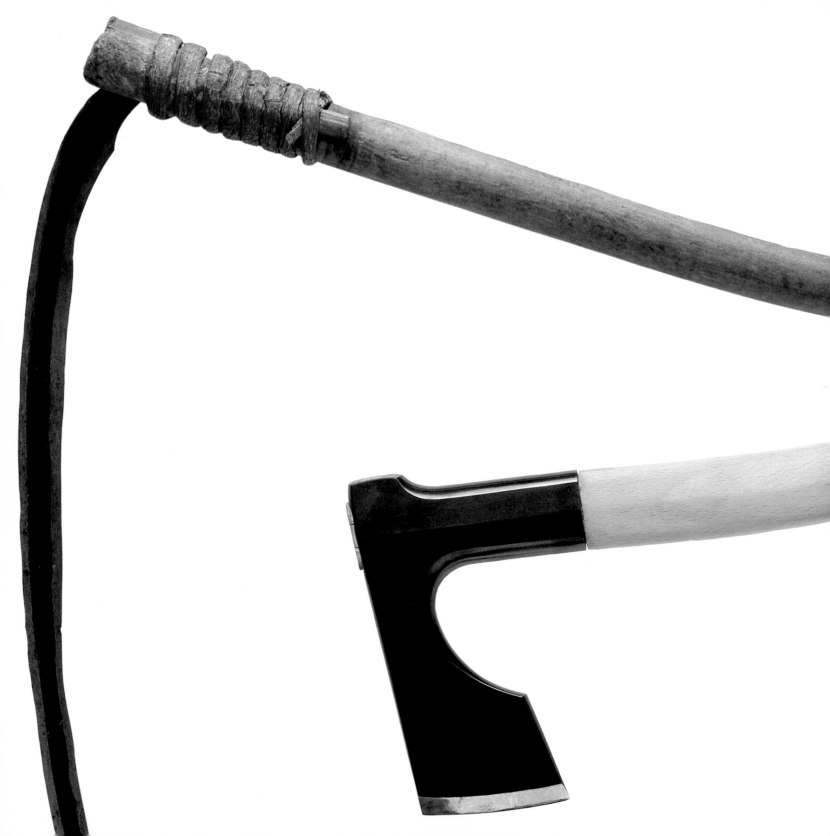

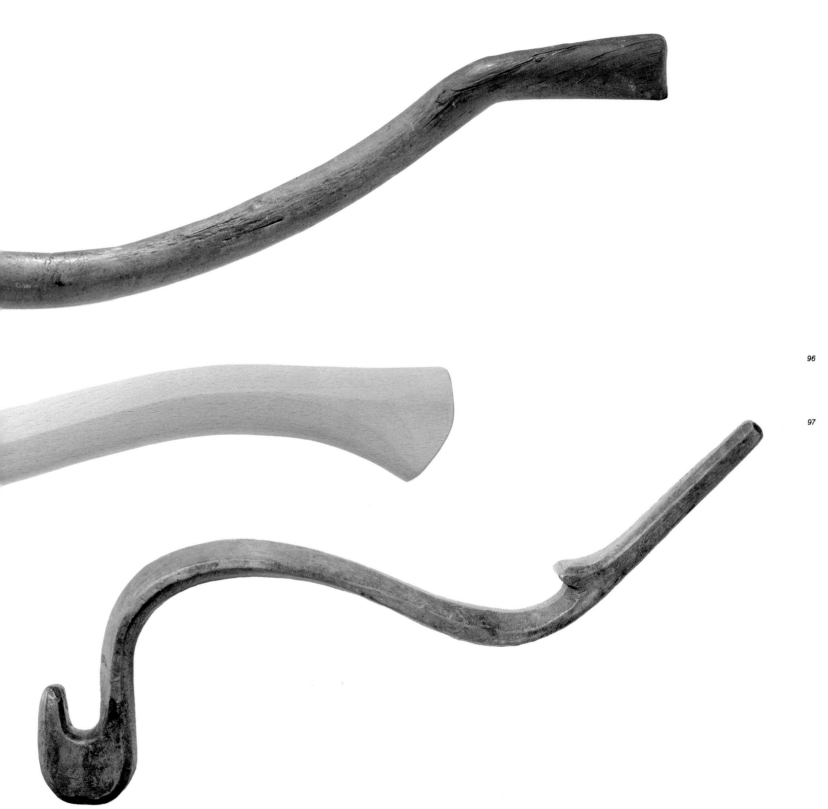

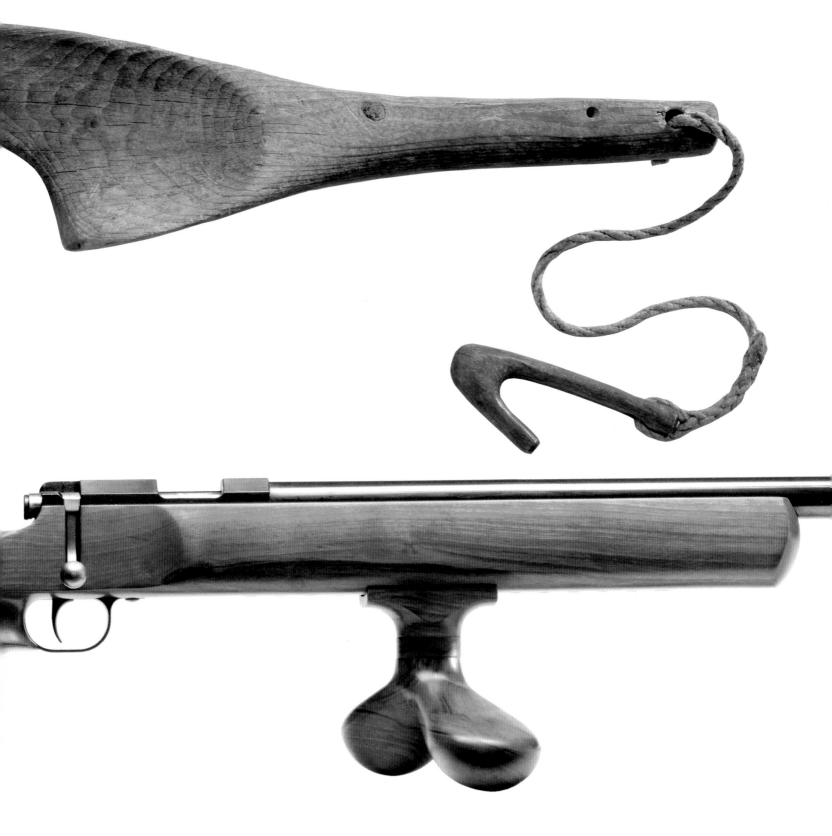

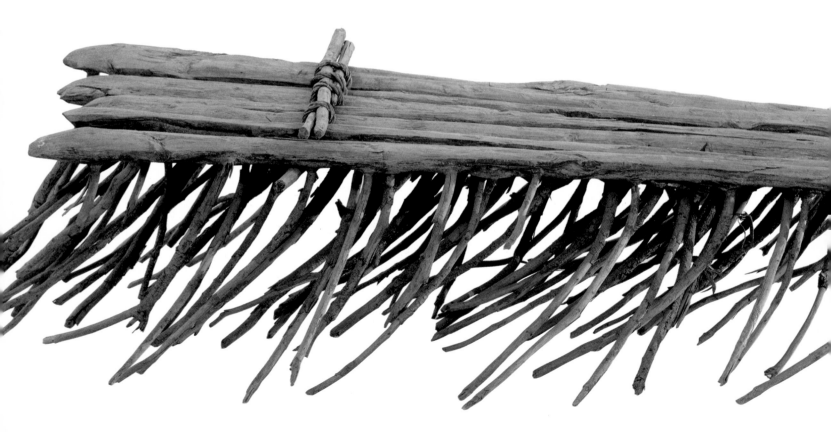

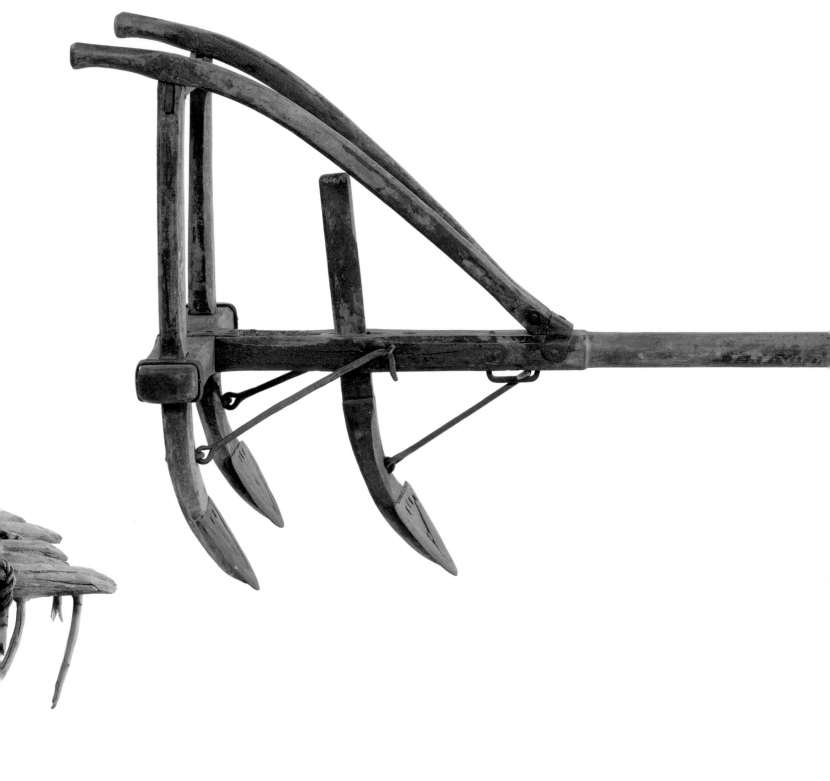

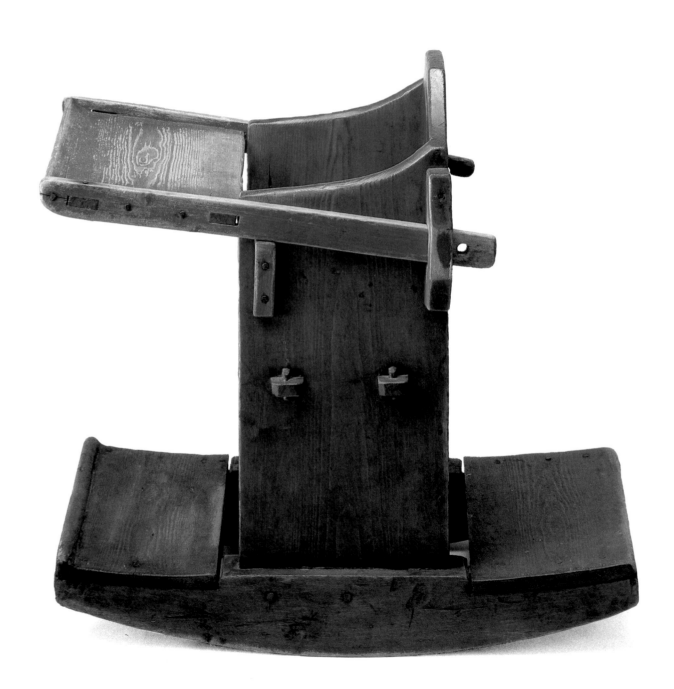

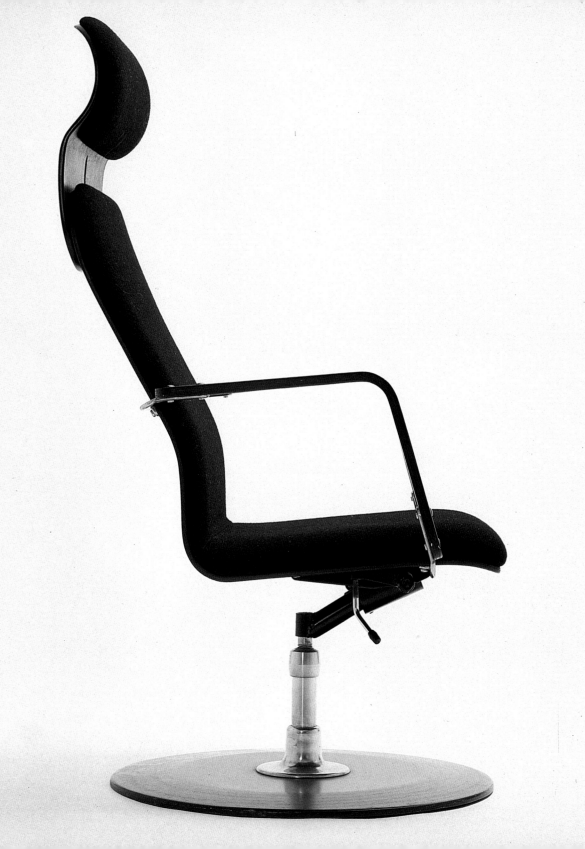

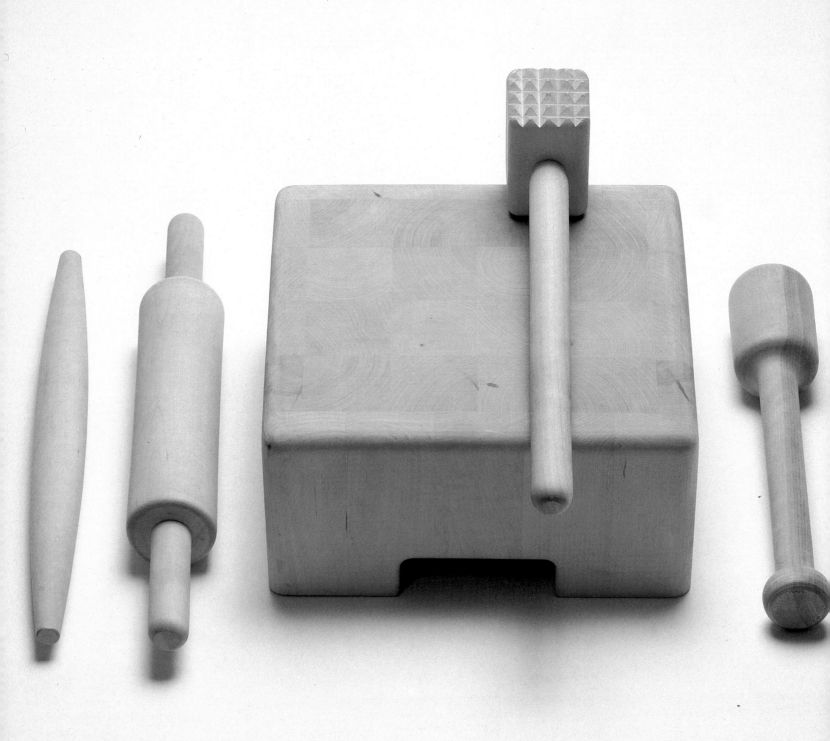

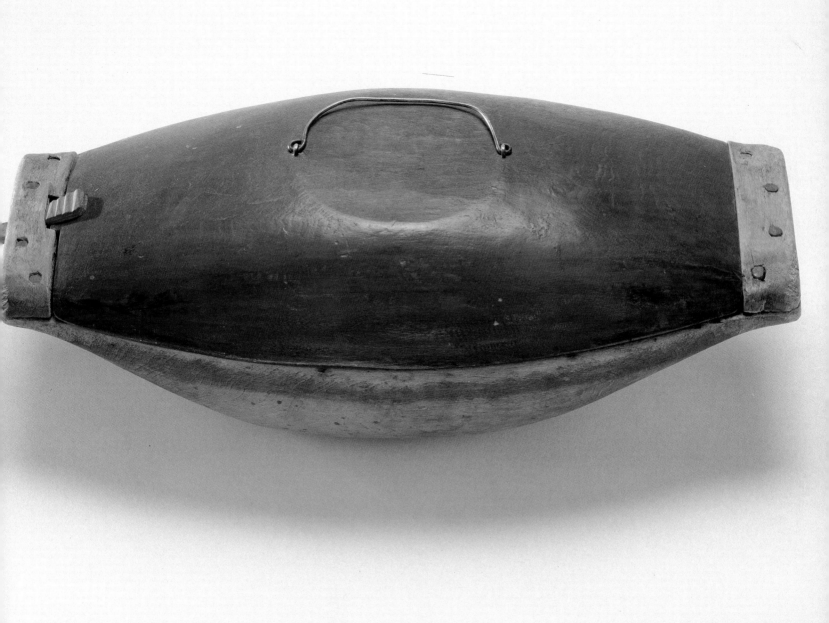

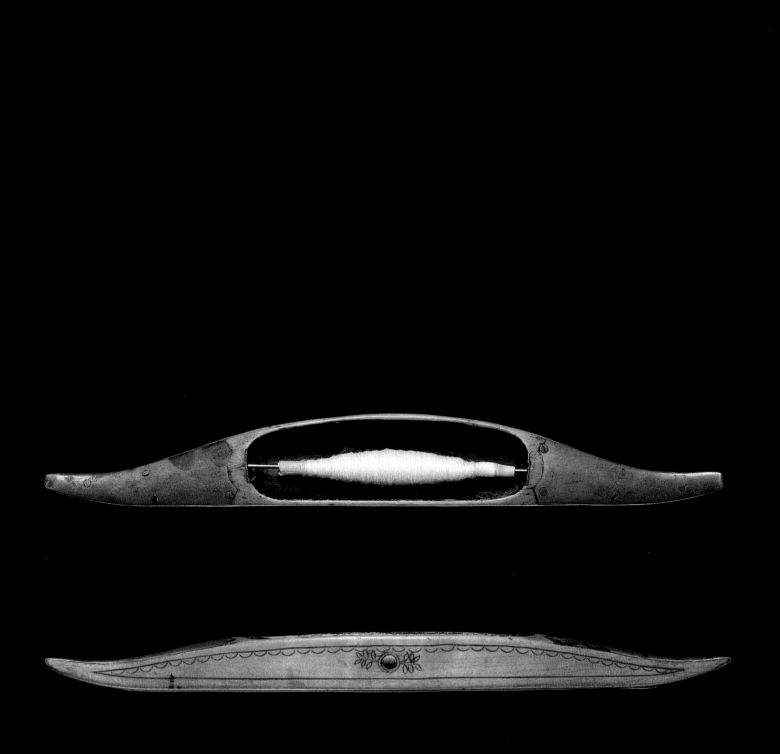

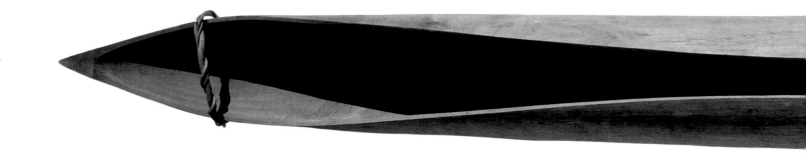

107

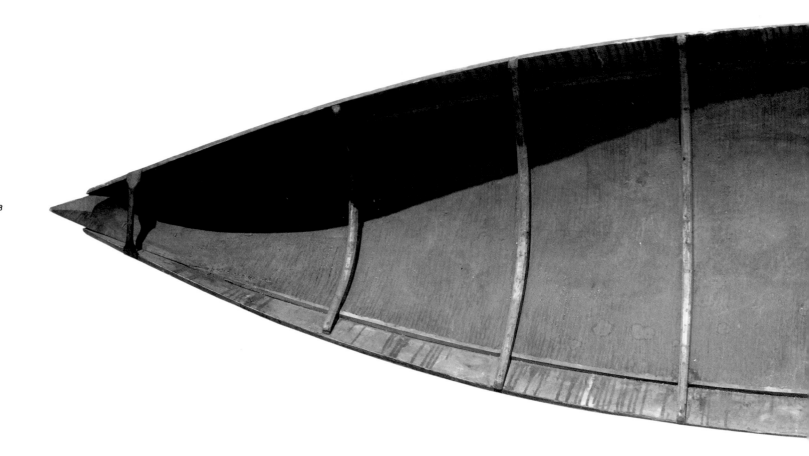

108

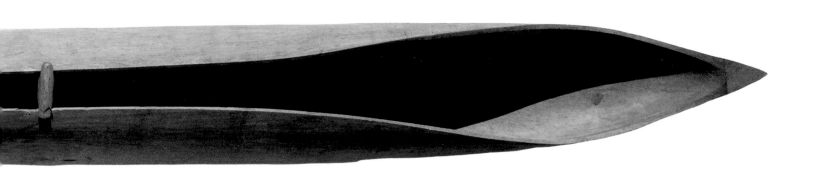

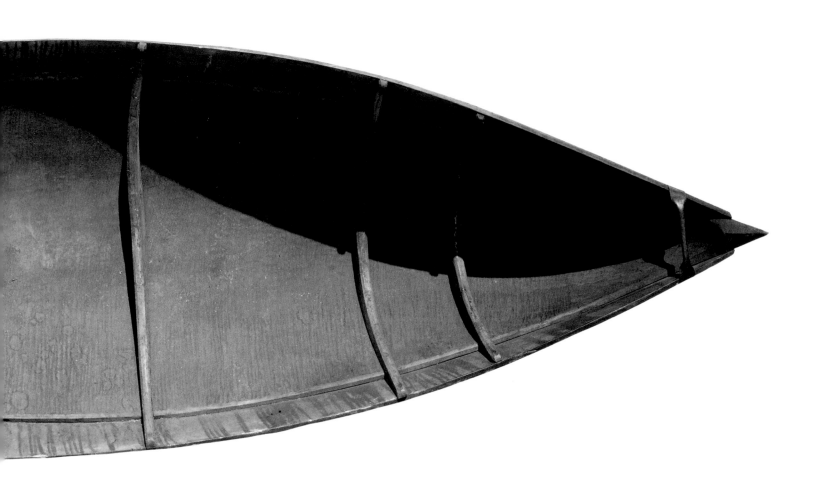

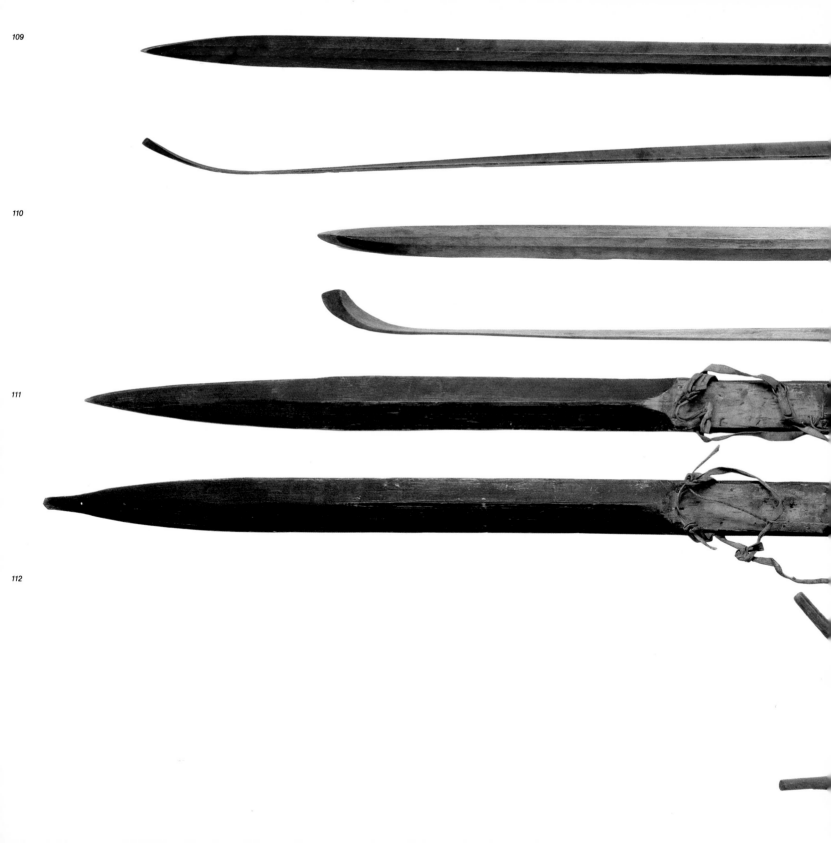

109

110

111

112

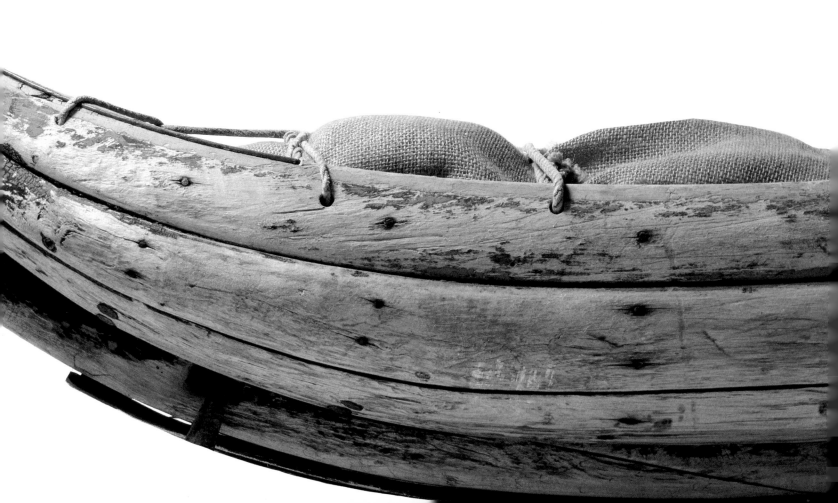

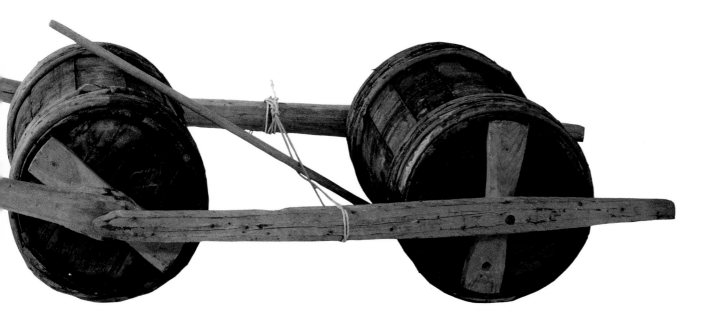

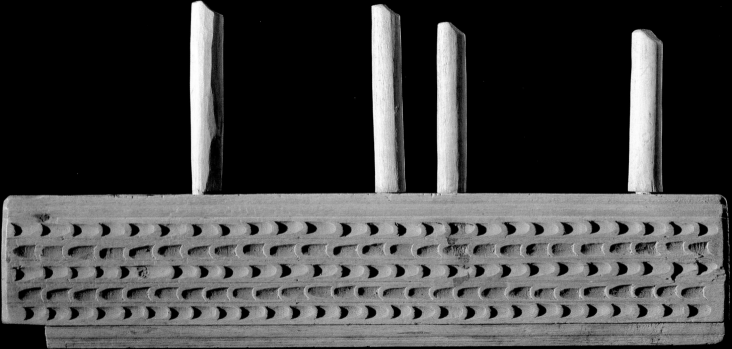

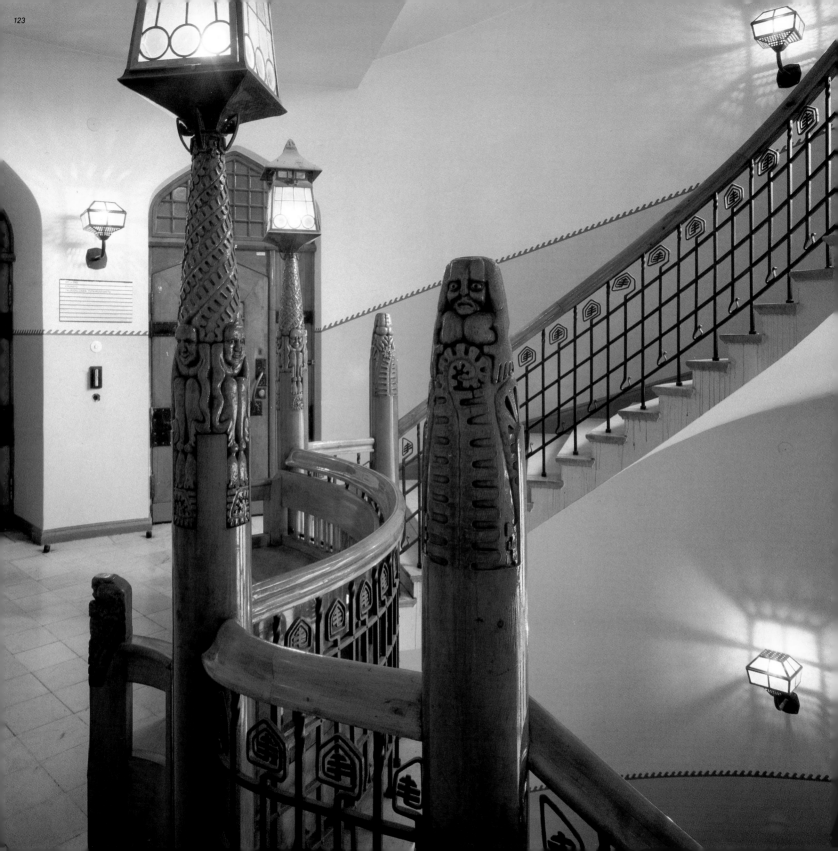

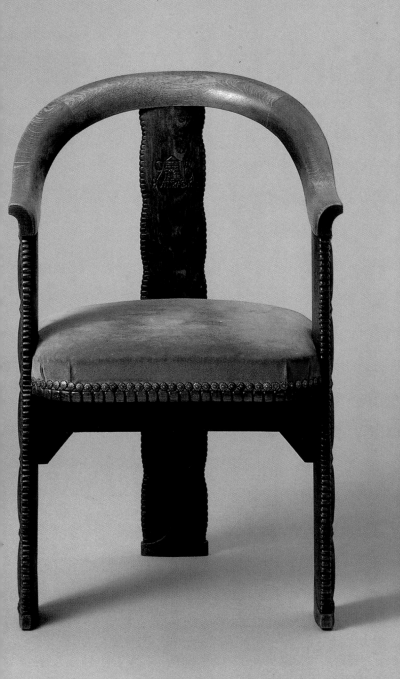

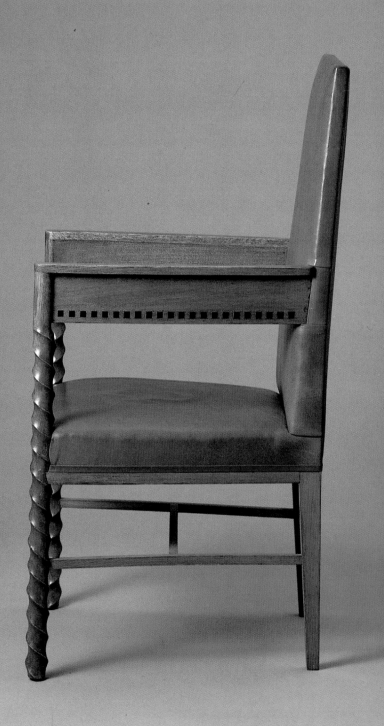

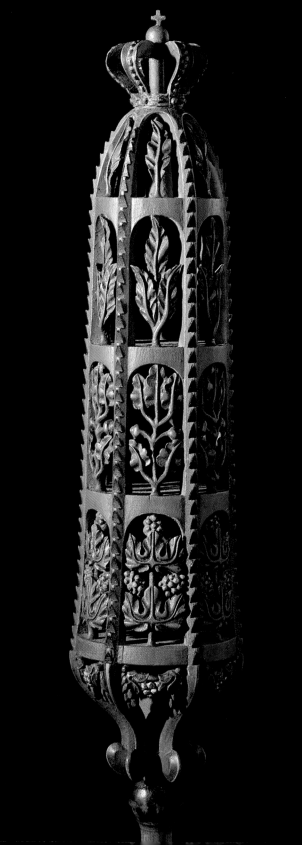

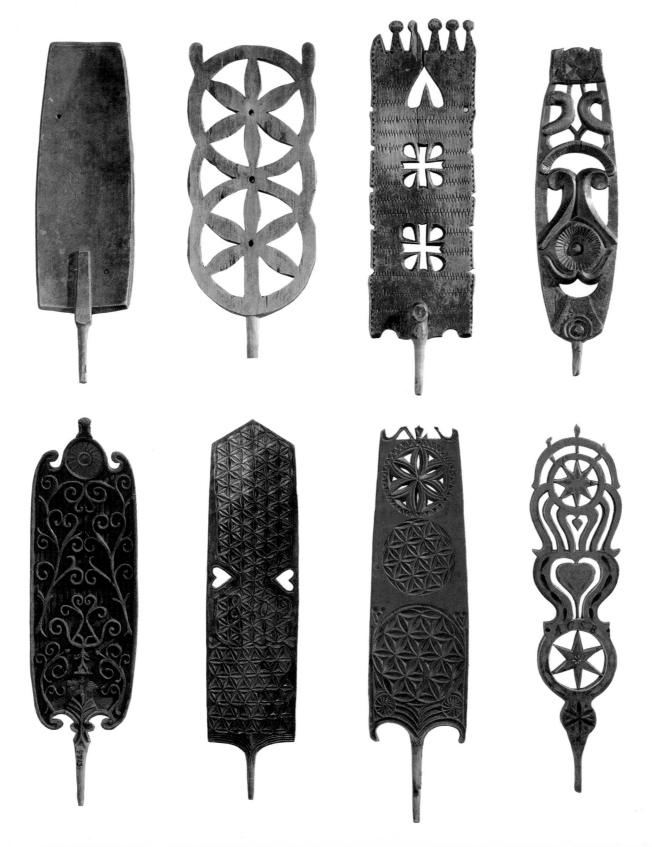

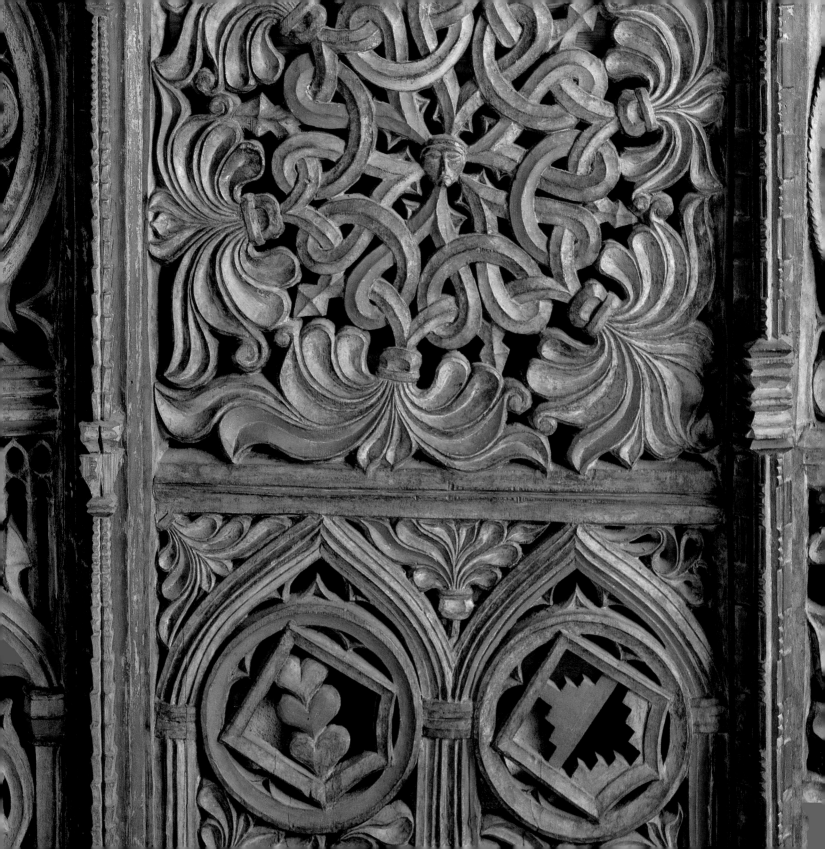

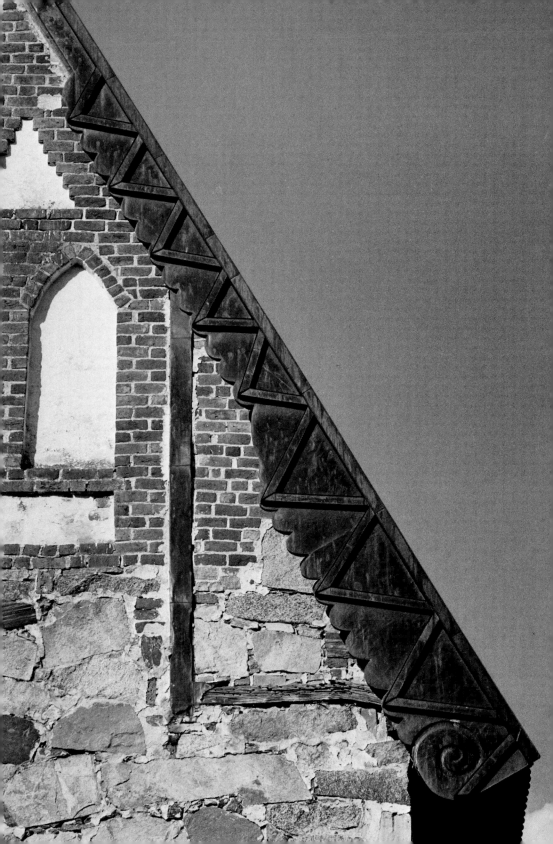

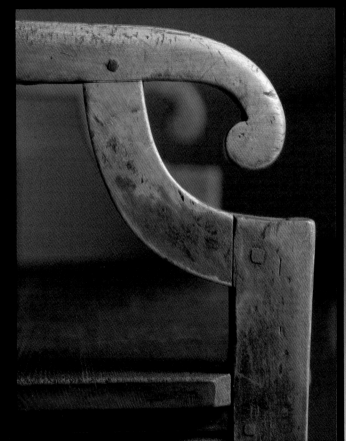

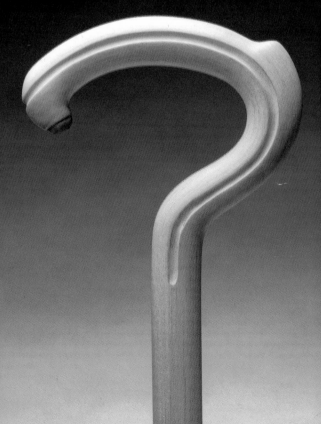

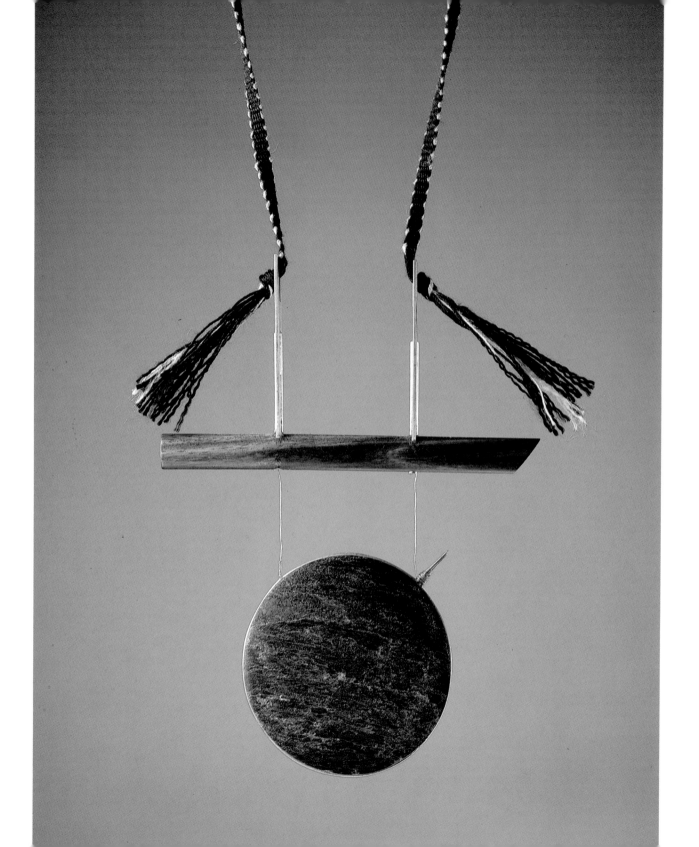

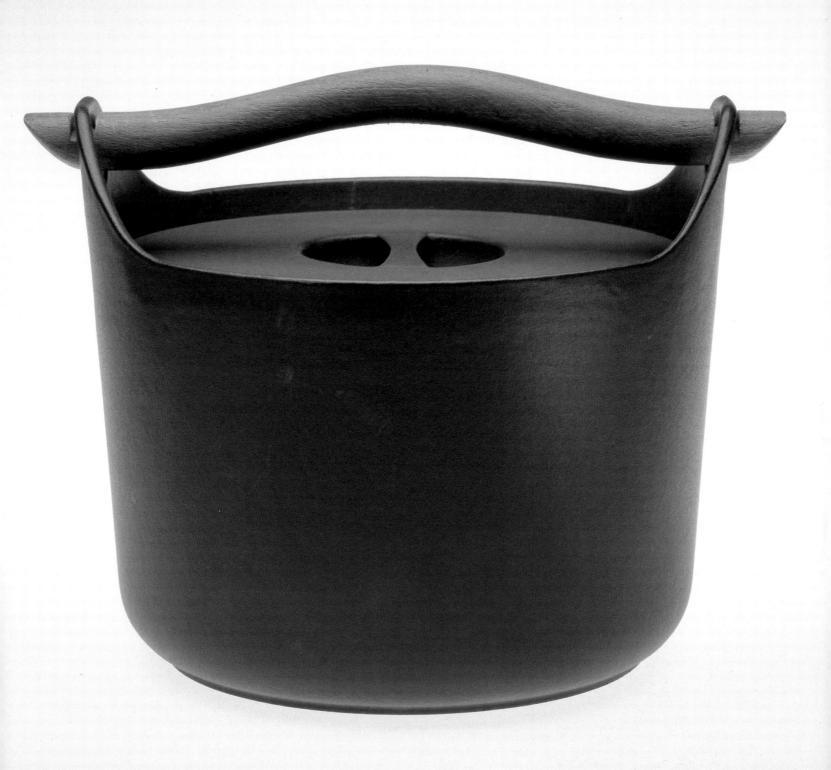

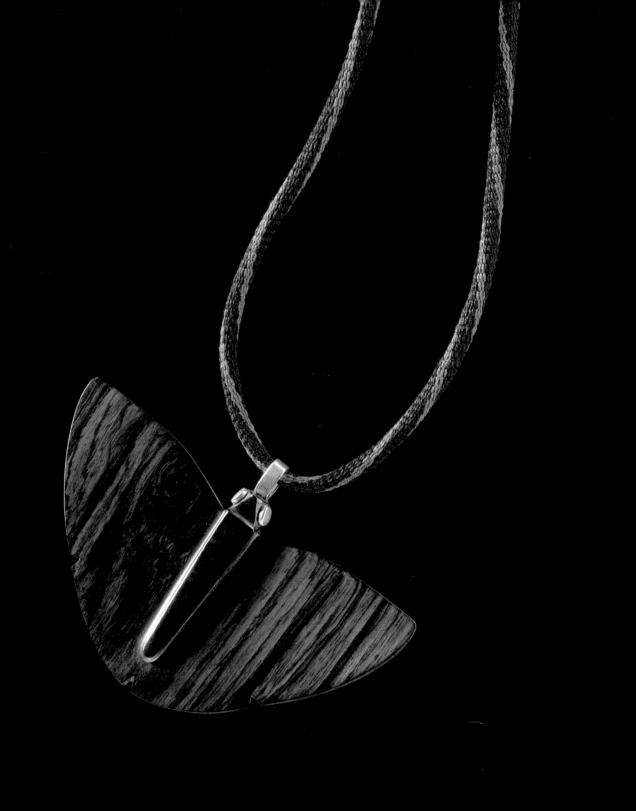

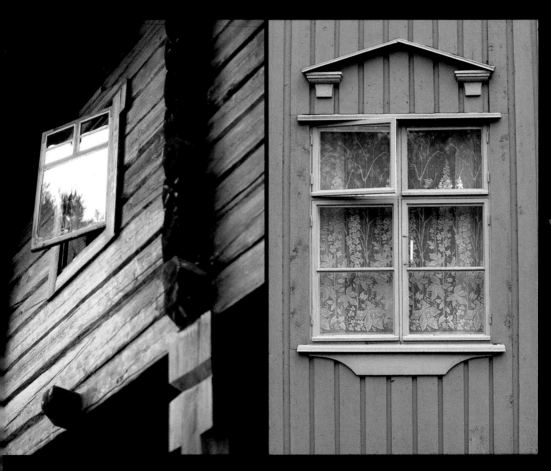
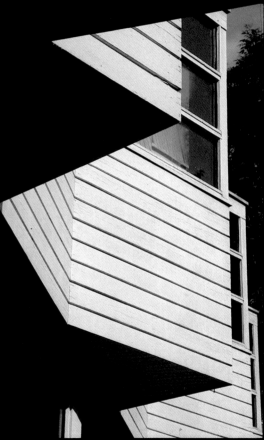

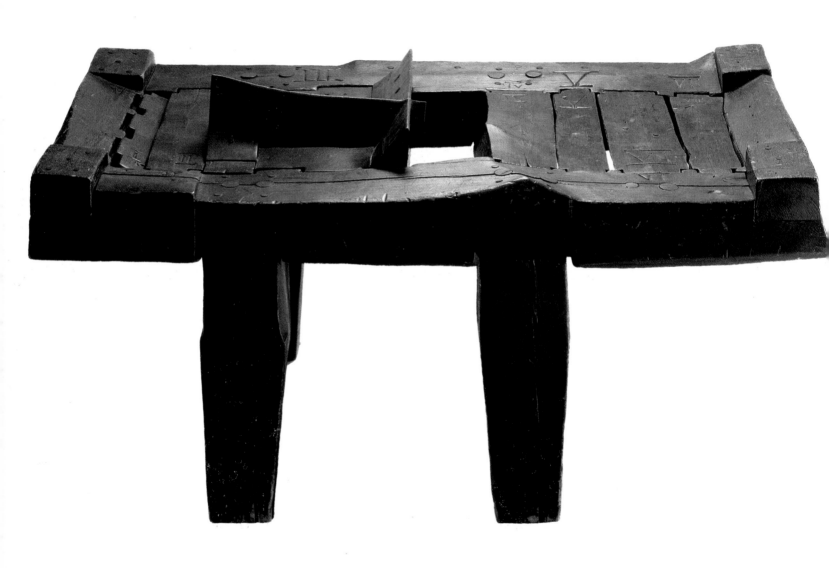

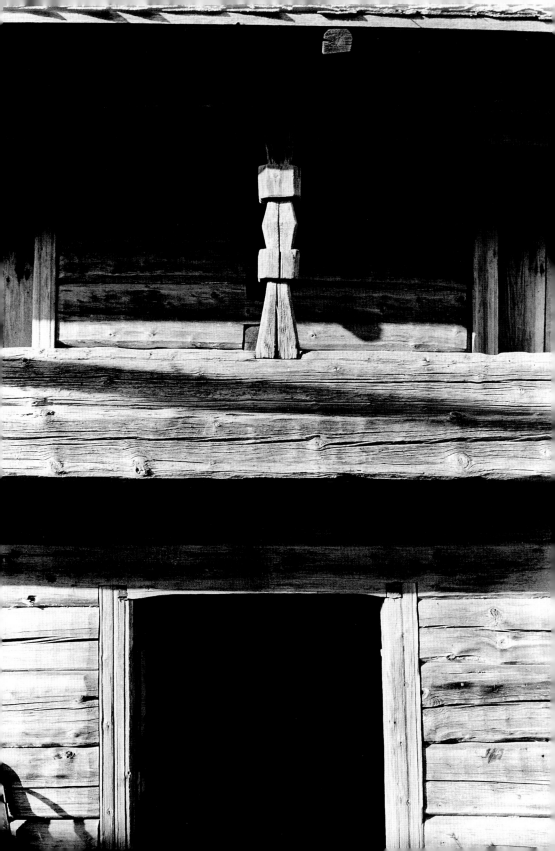

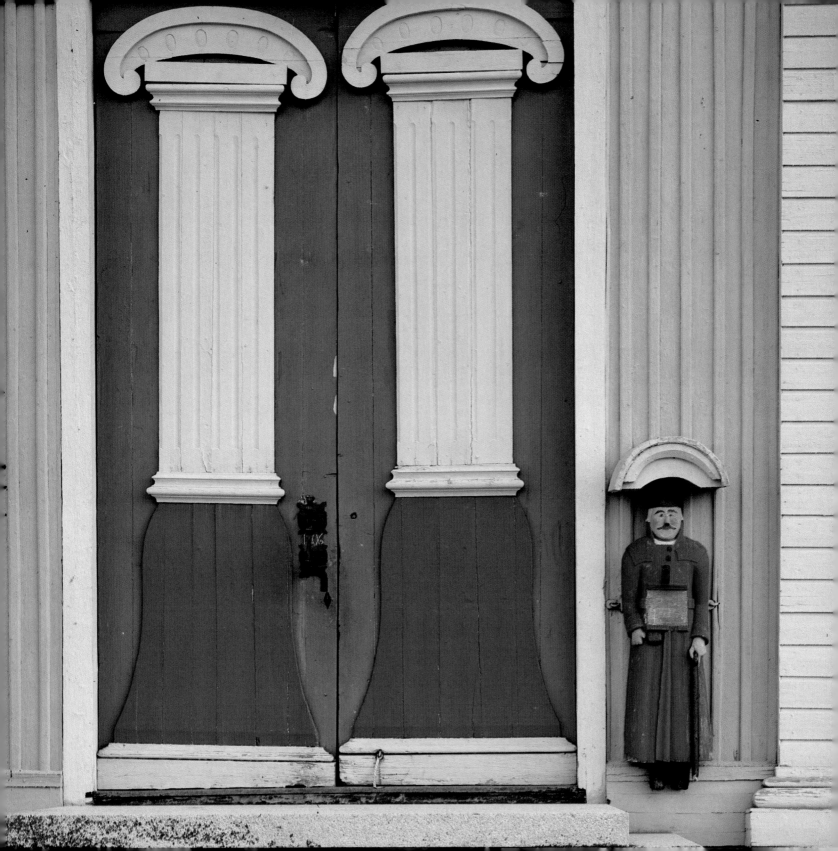

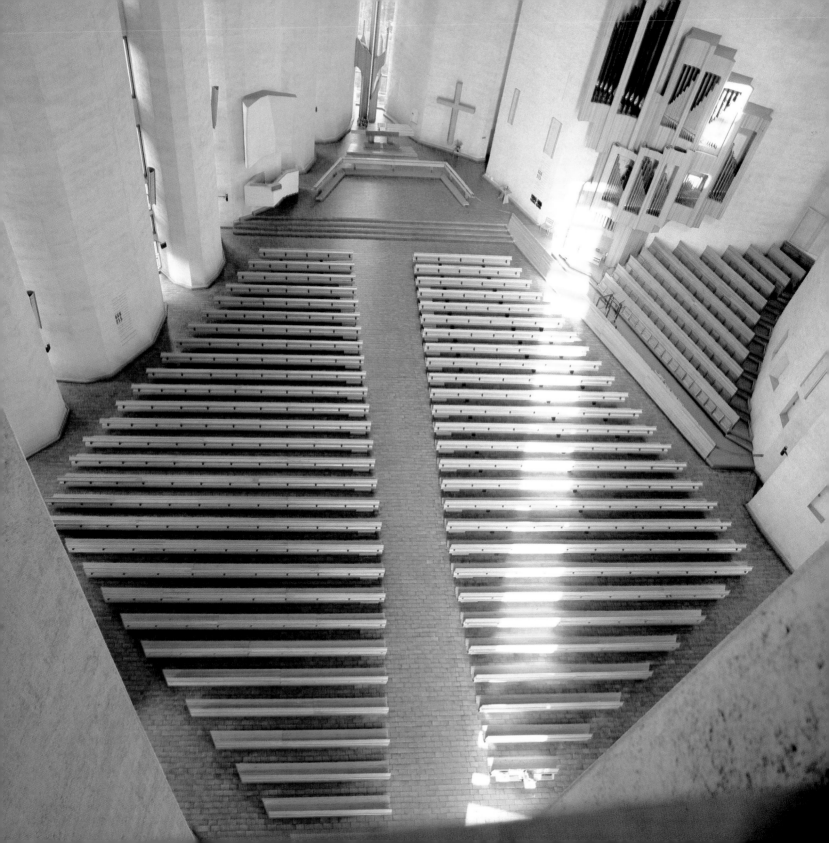

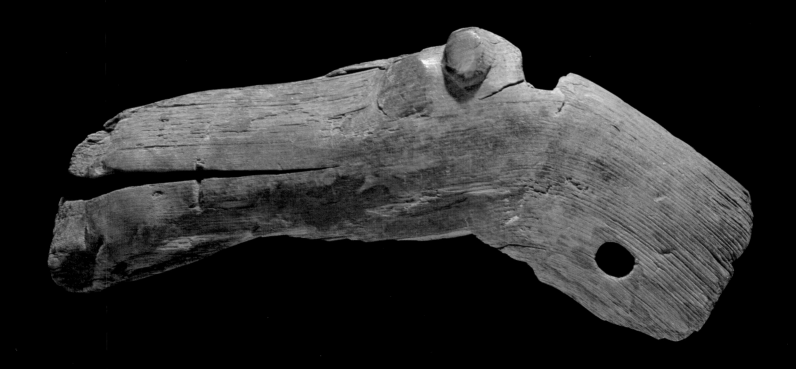

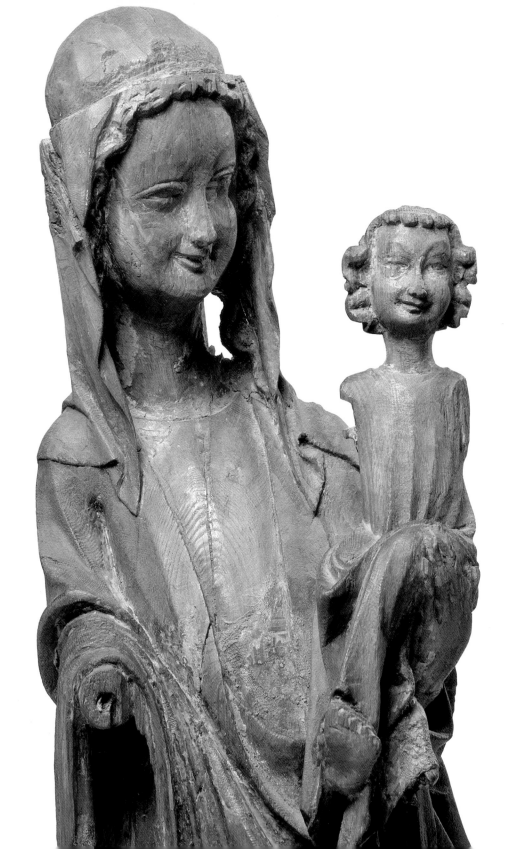

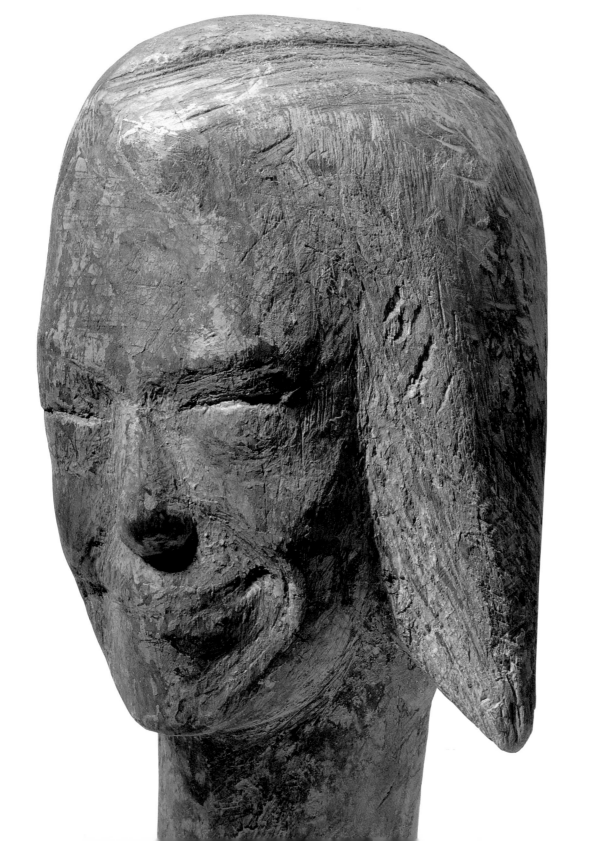

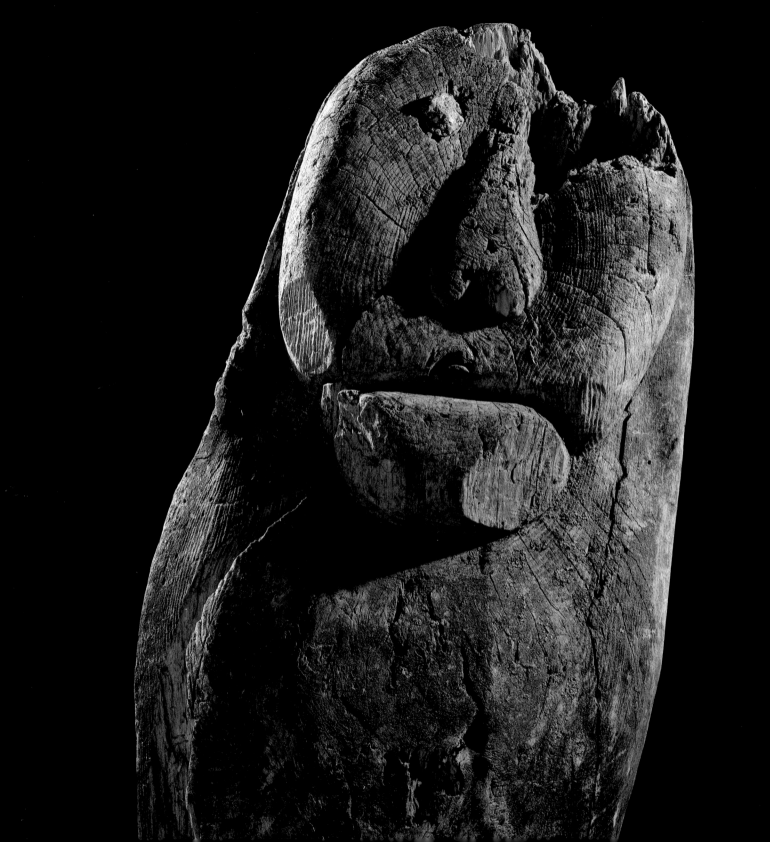

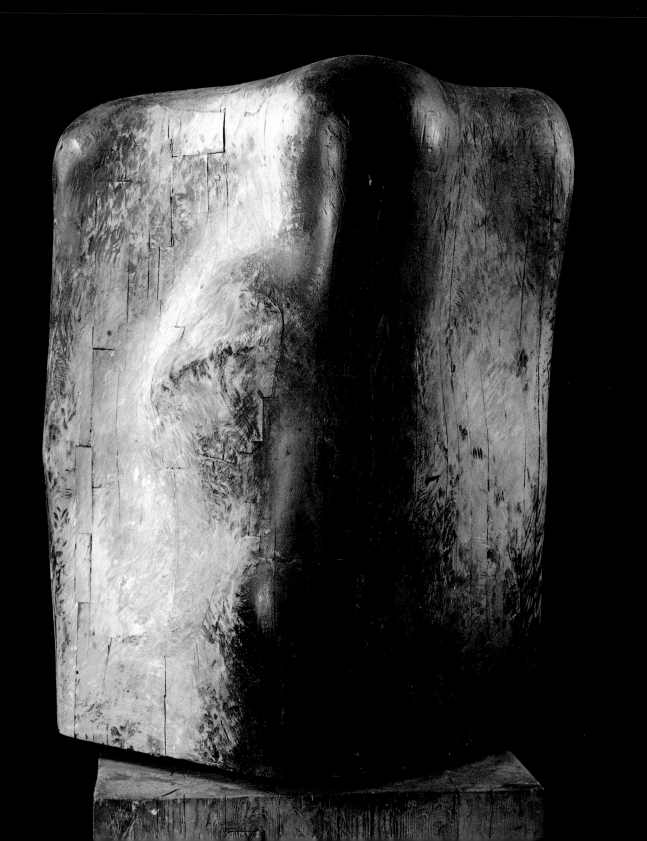

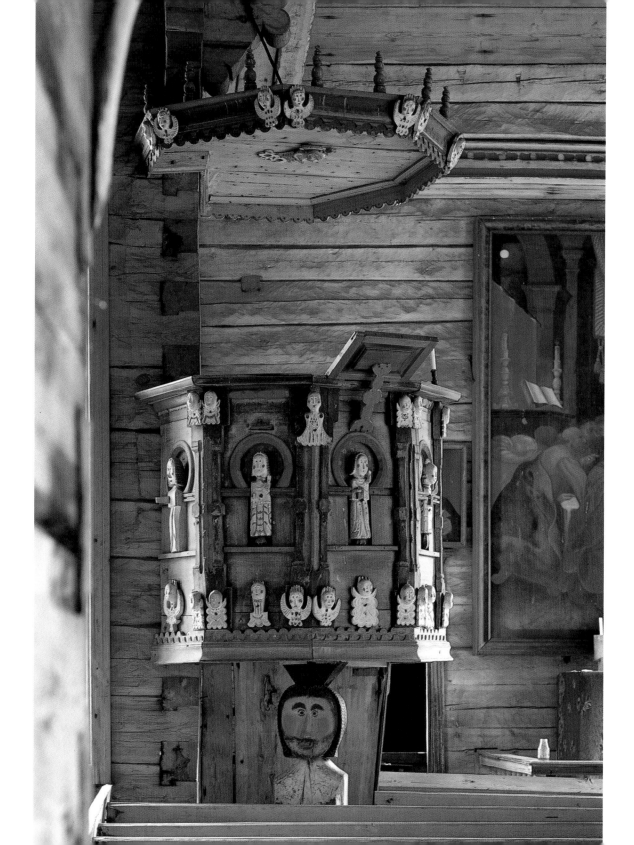

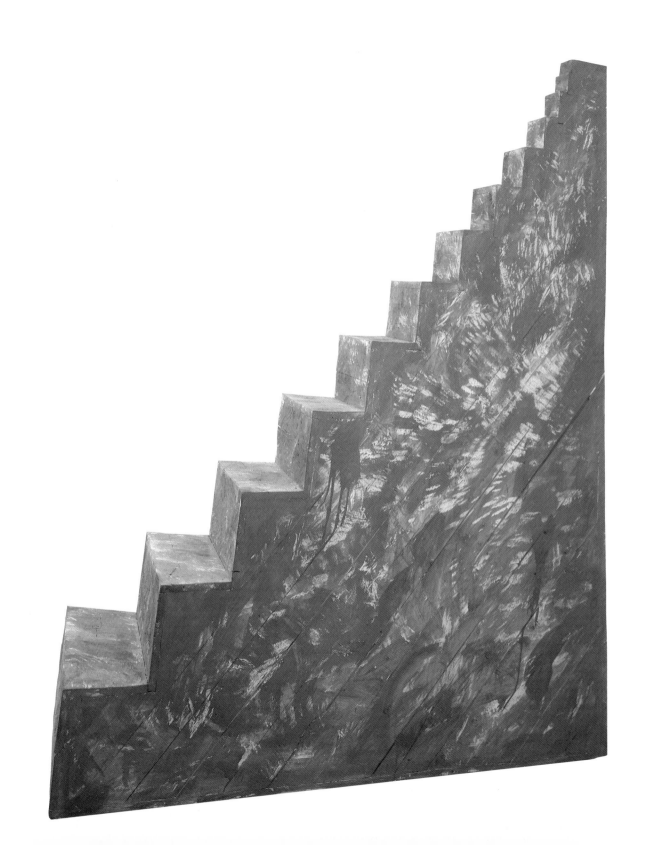

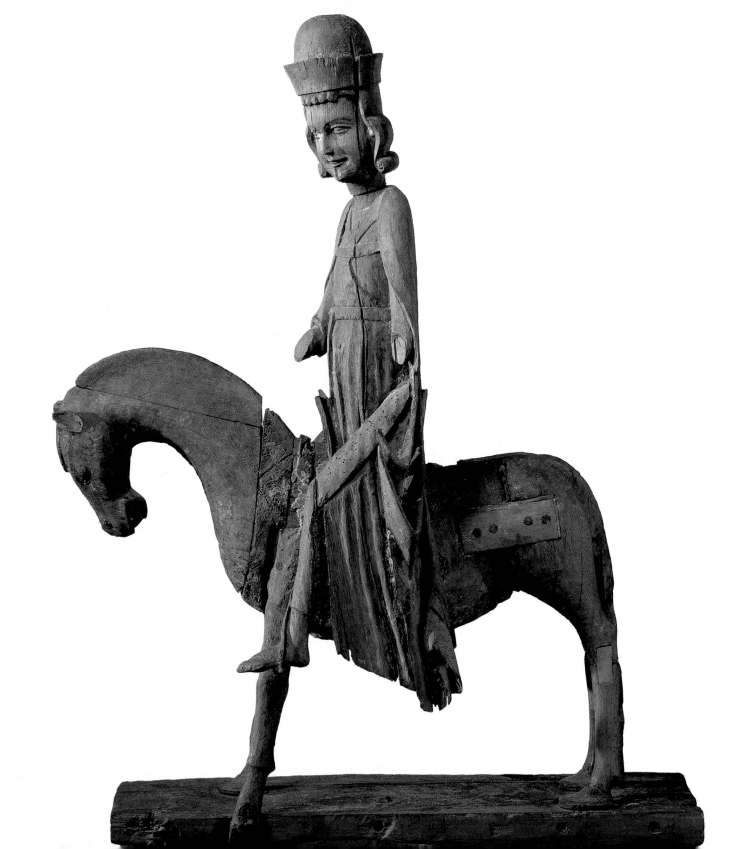

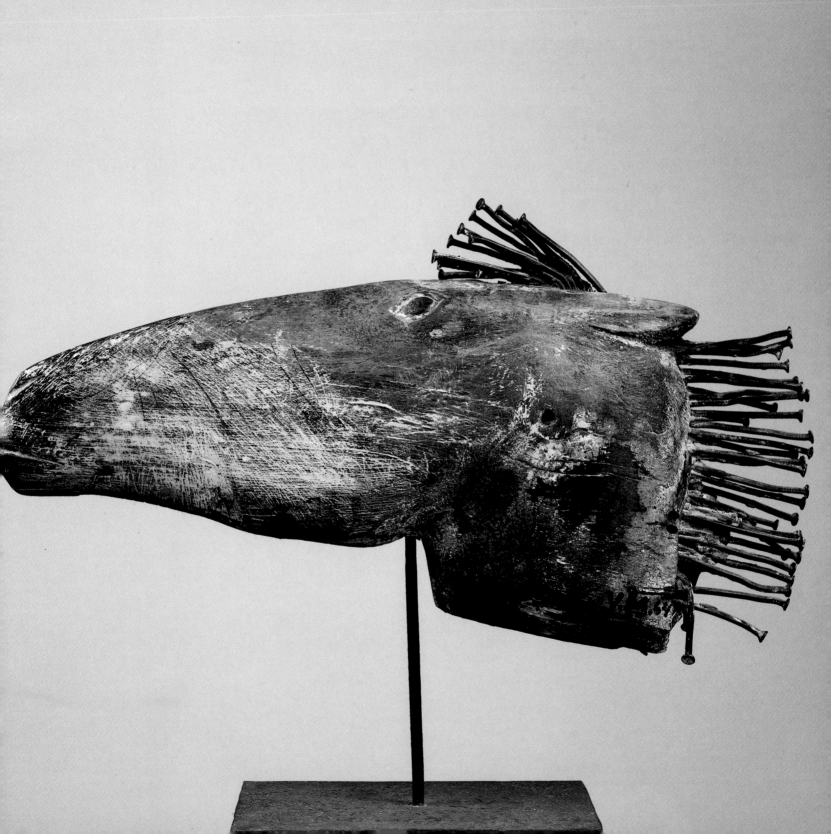

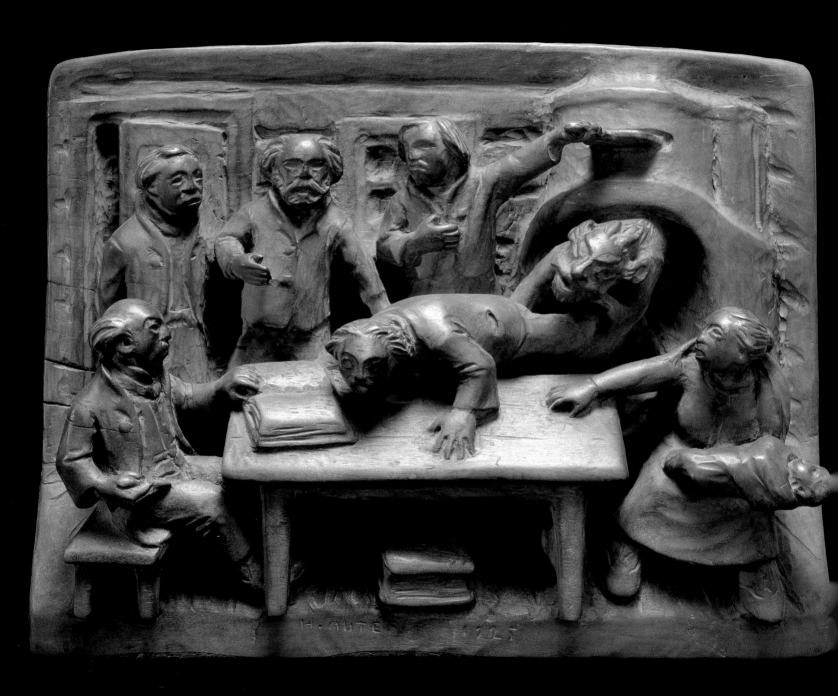

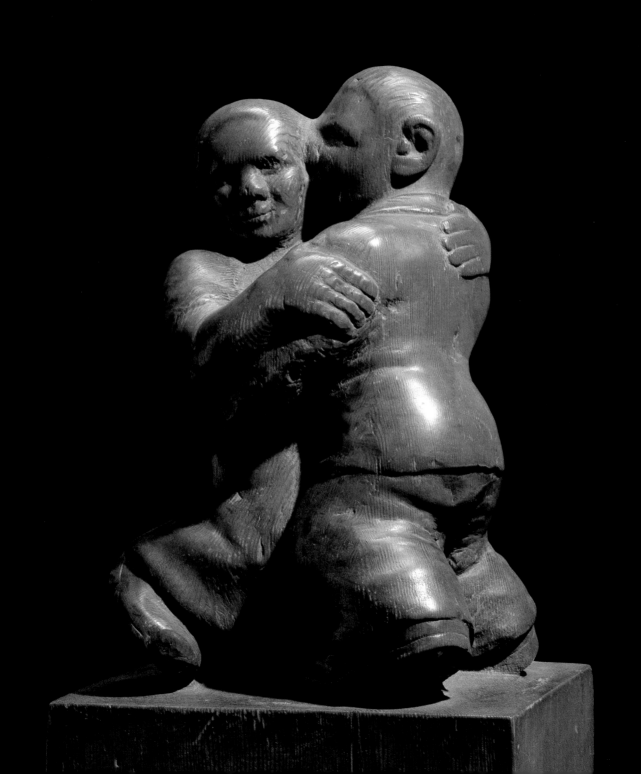

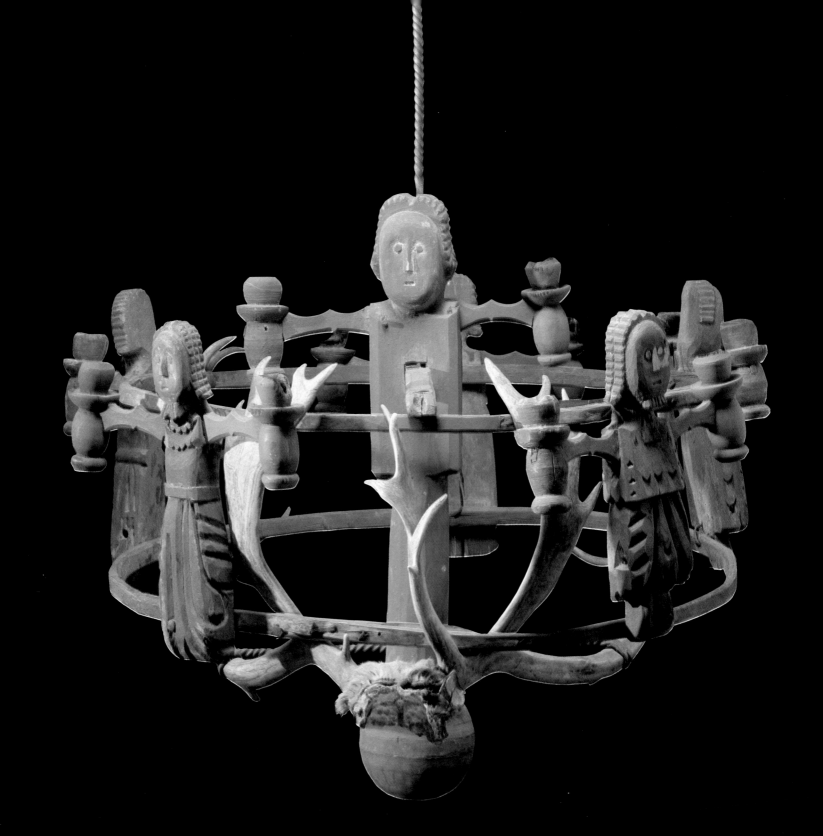

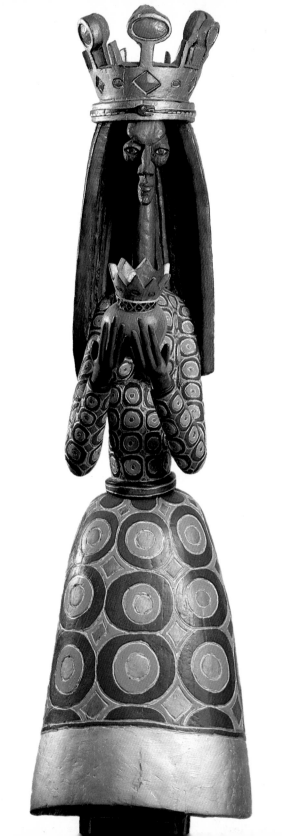

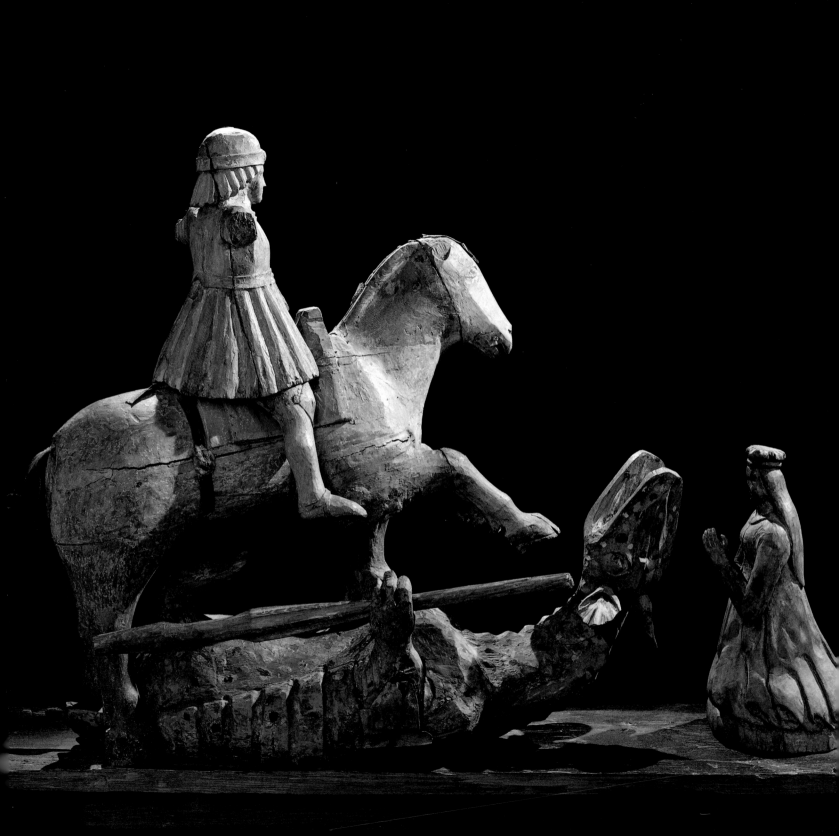

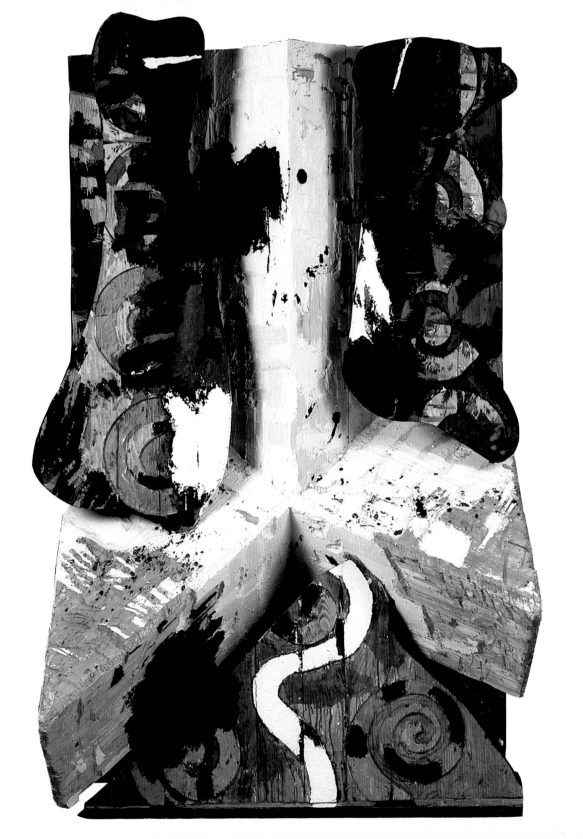

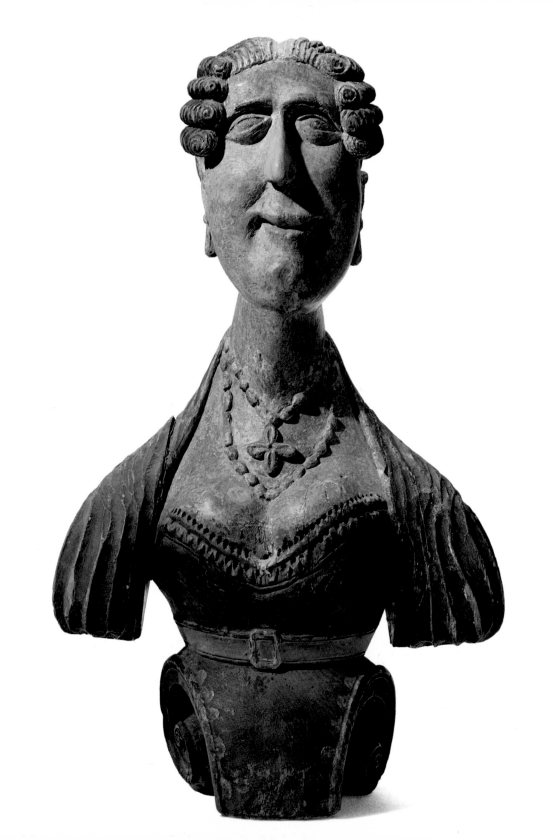

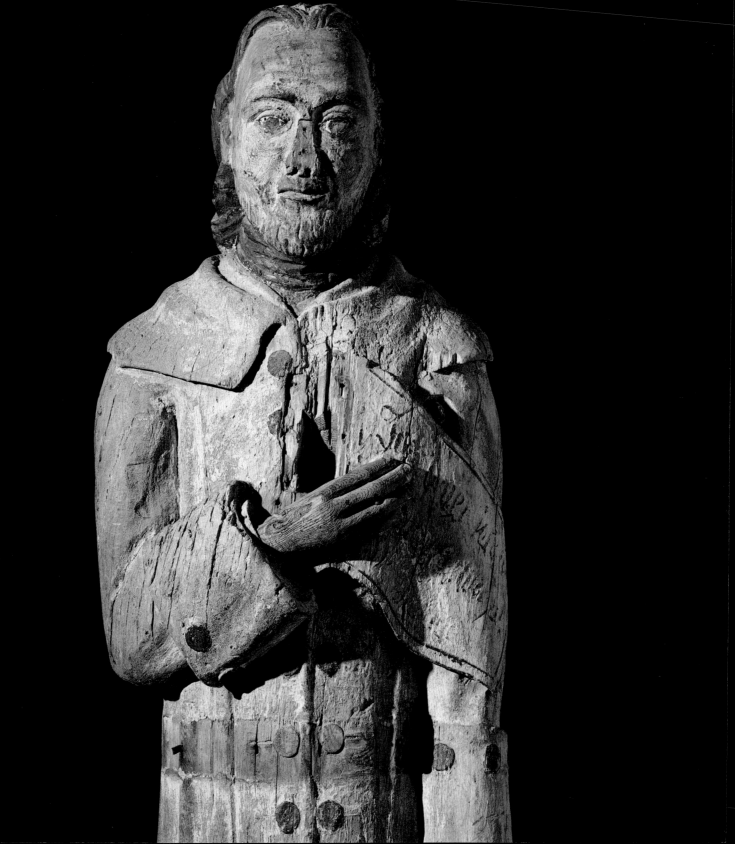

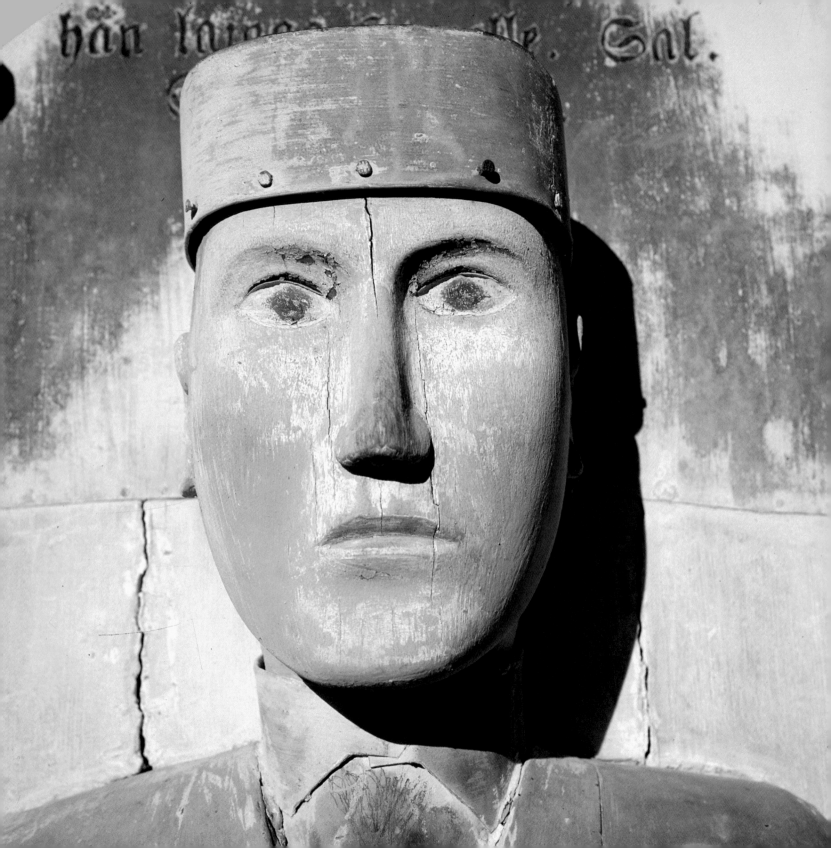

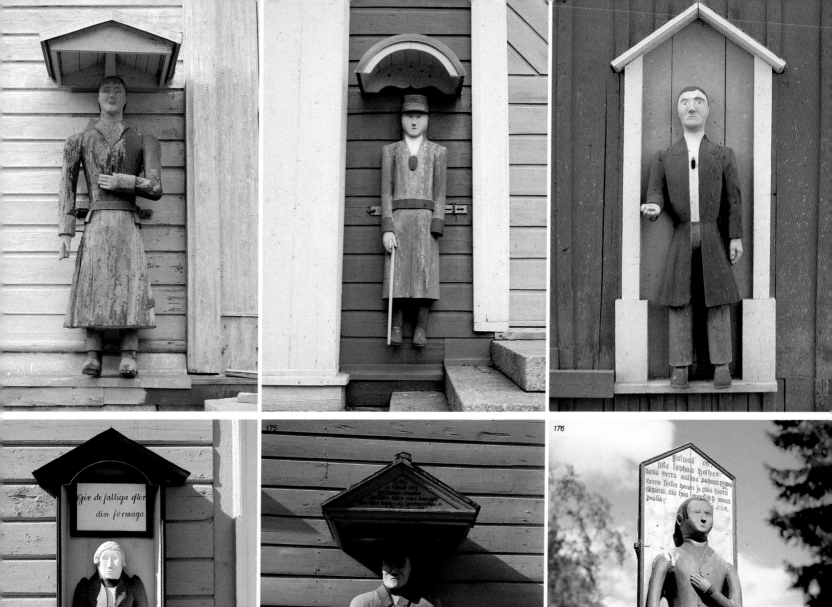

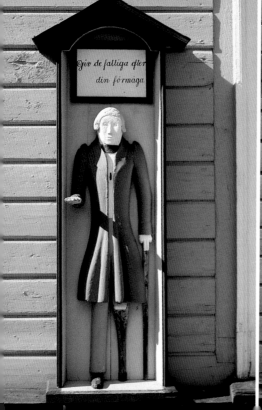

Giv de fattiga efter
din förmåga

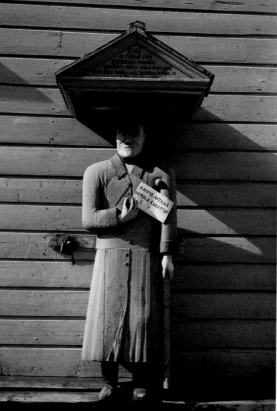

RAKITA ANTAIA
JUMALA RAKASTA

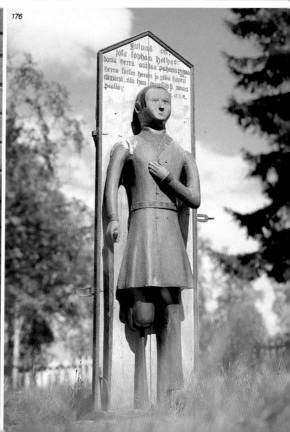

Rulluas oti,
dania Serra anttaa pahana poica
Herra fatte hänen jo kiltei haitti
(jnpäriä, etä hän menetyn maan
paällä

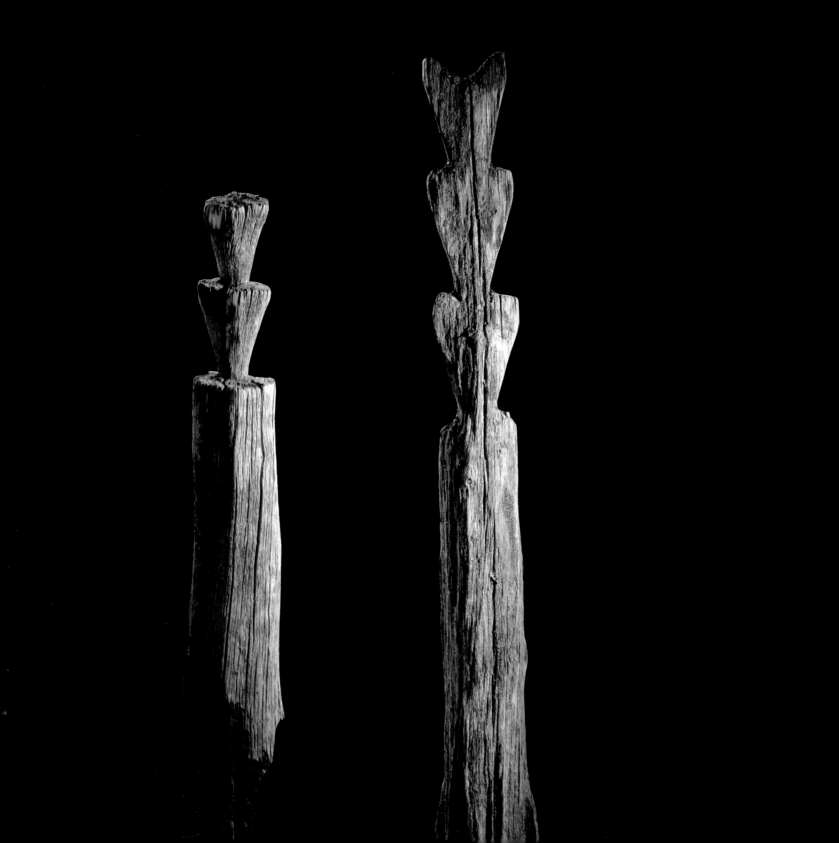

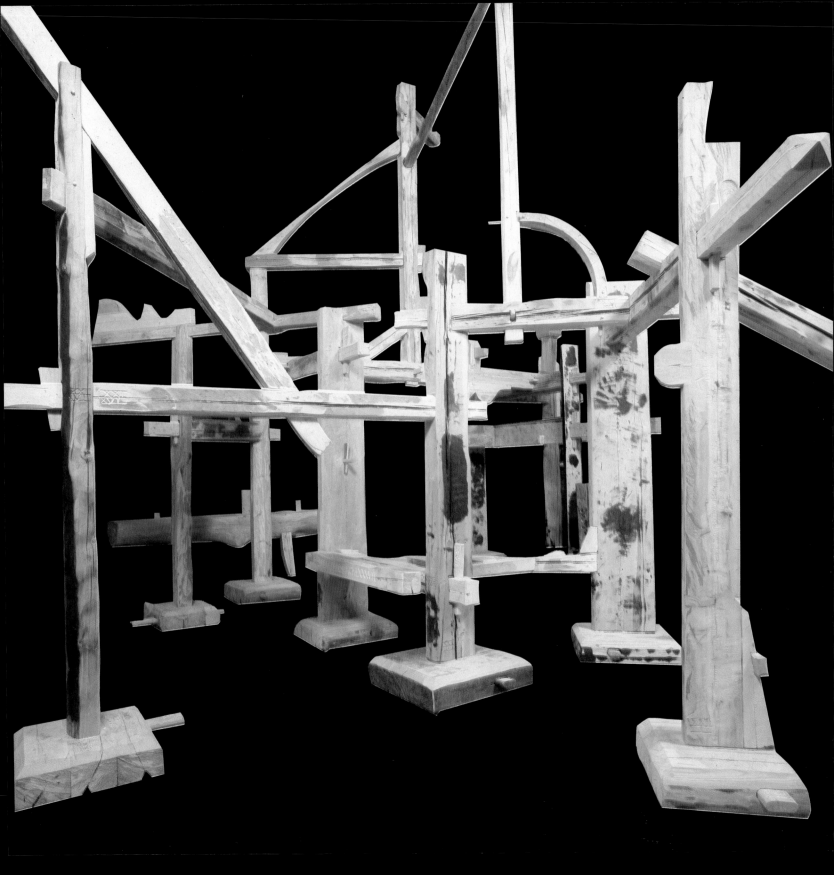

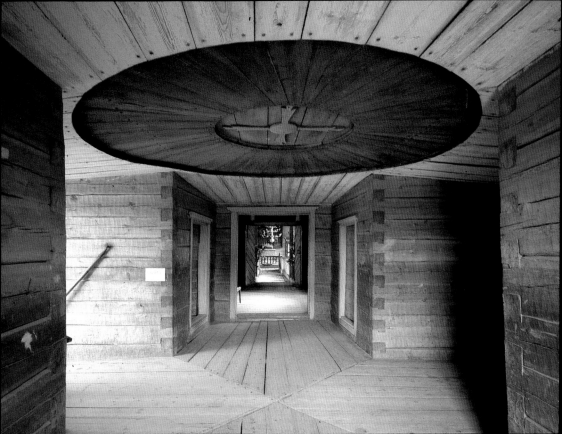

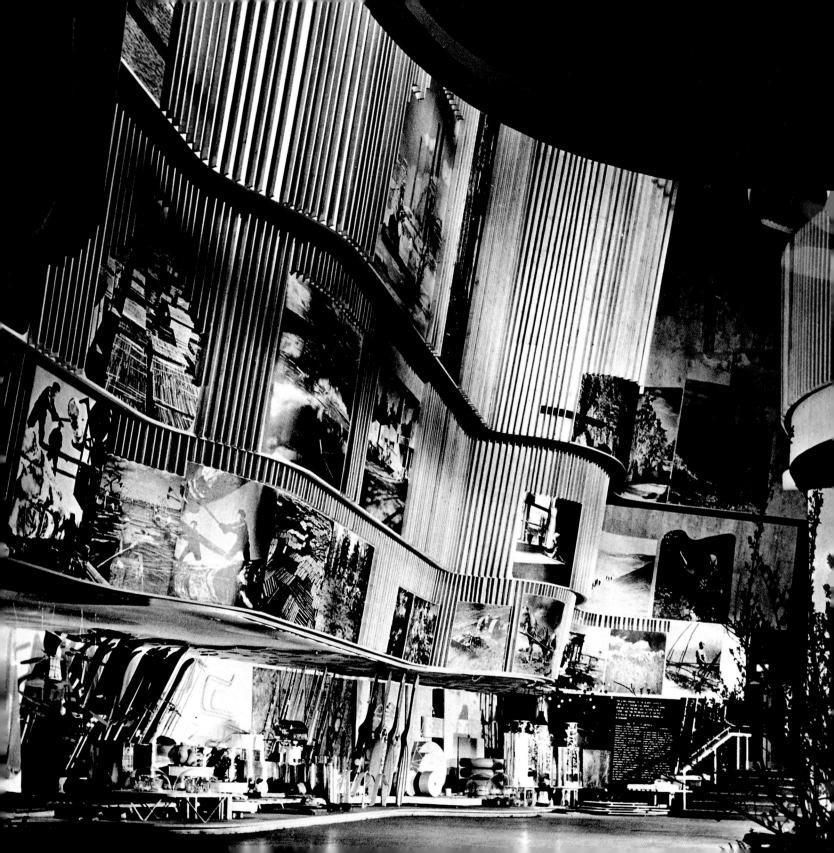

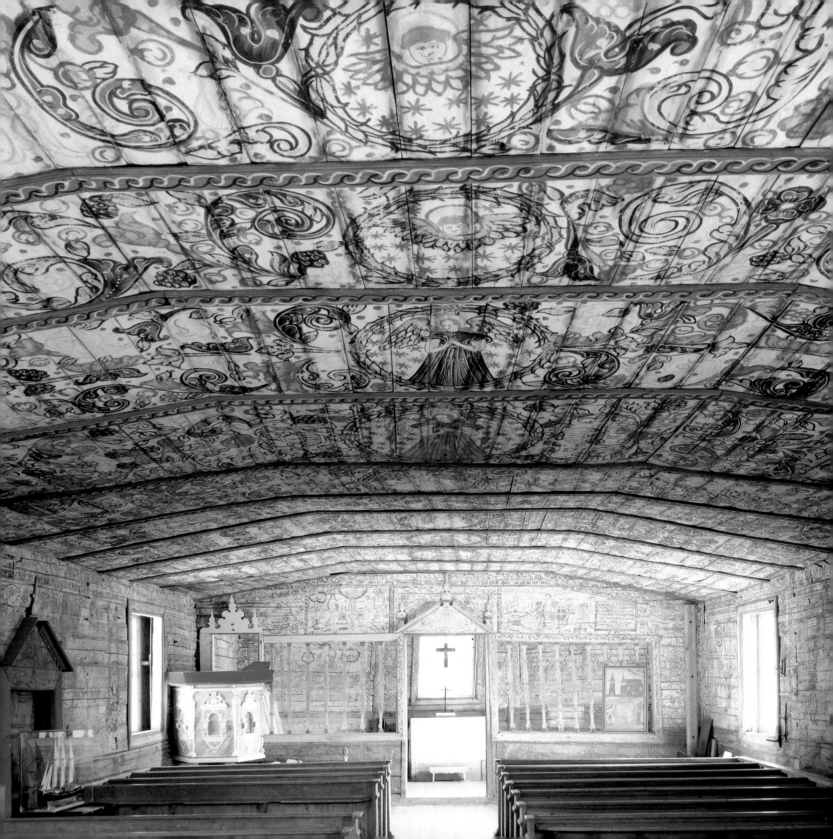

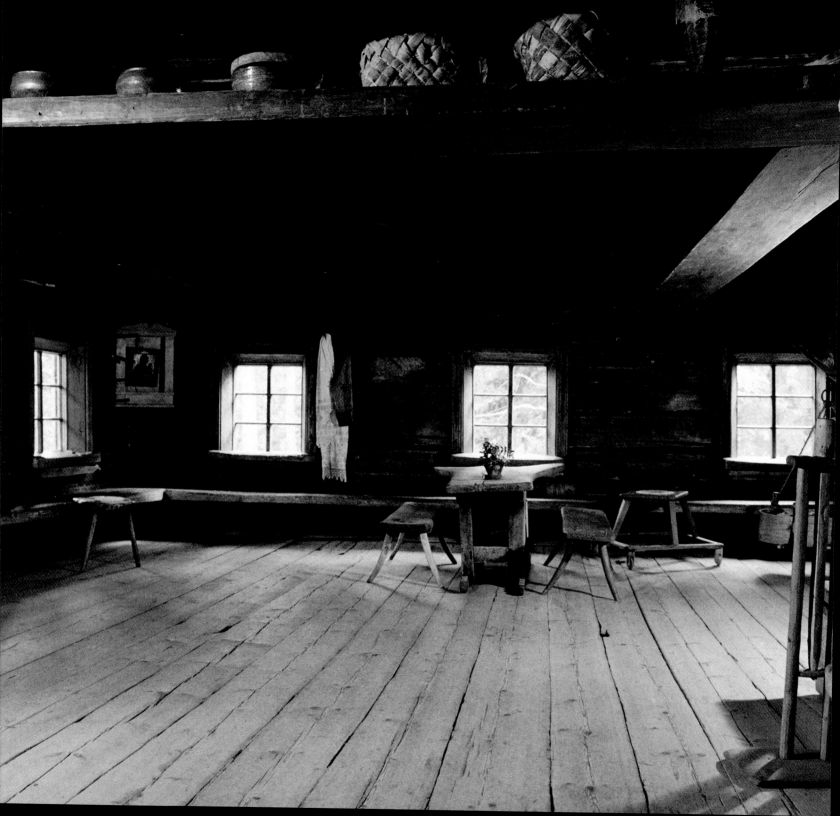

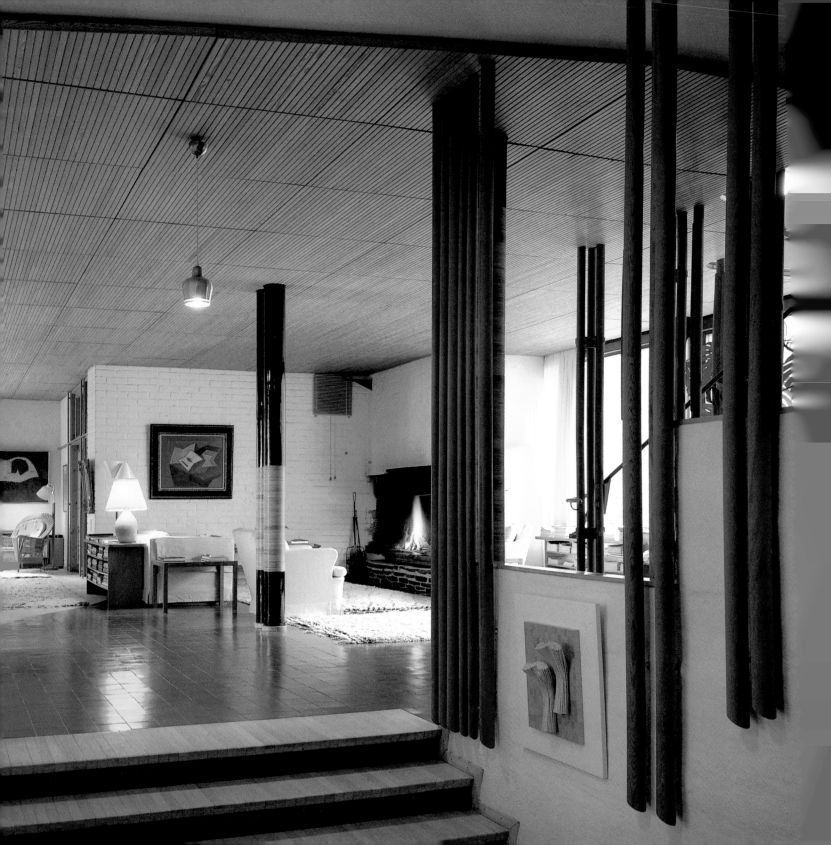

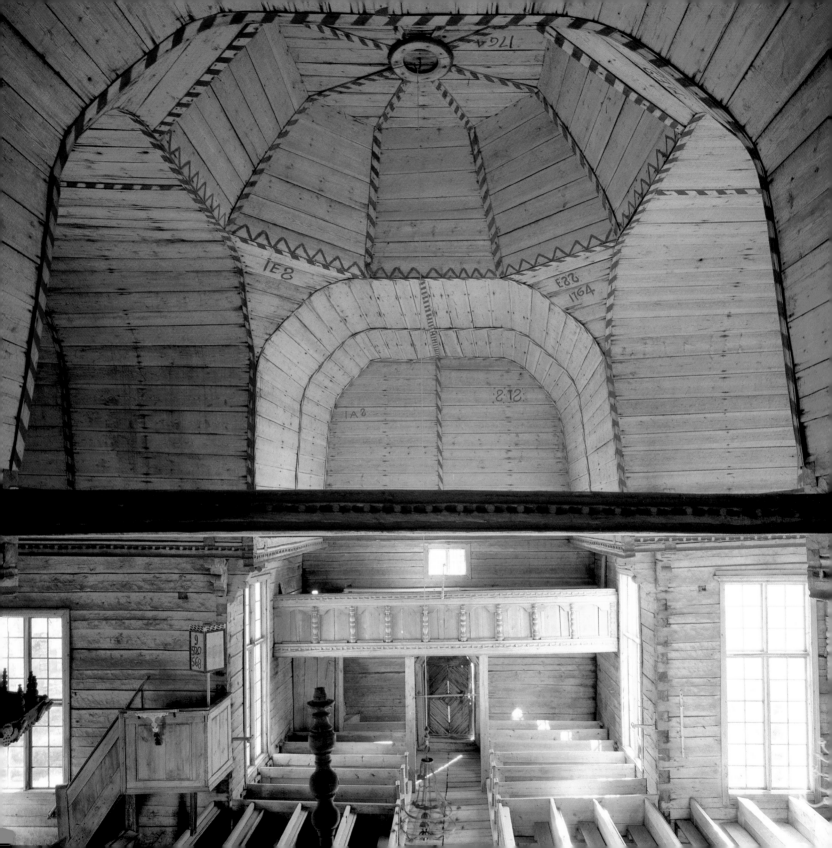

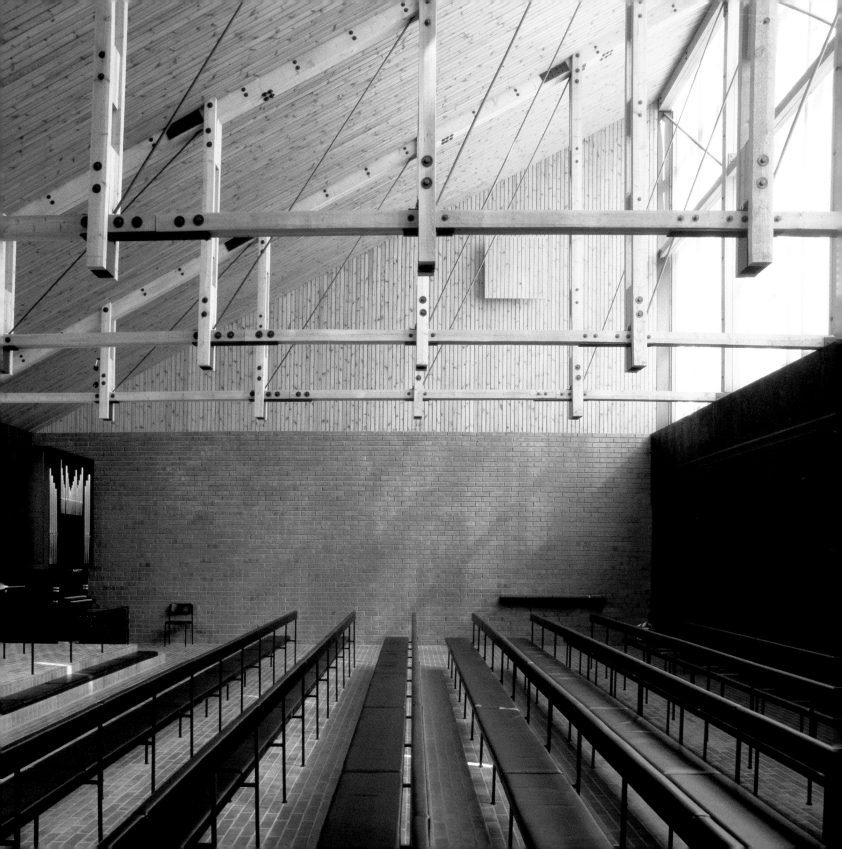

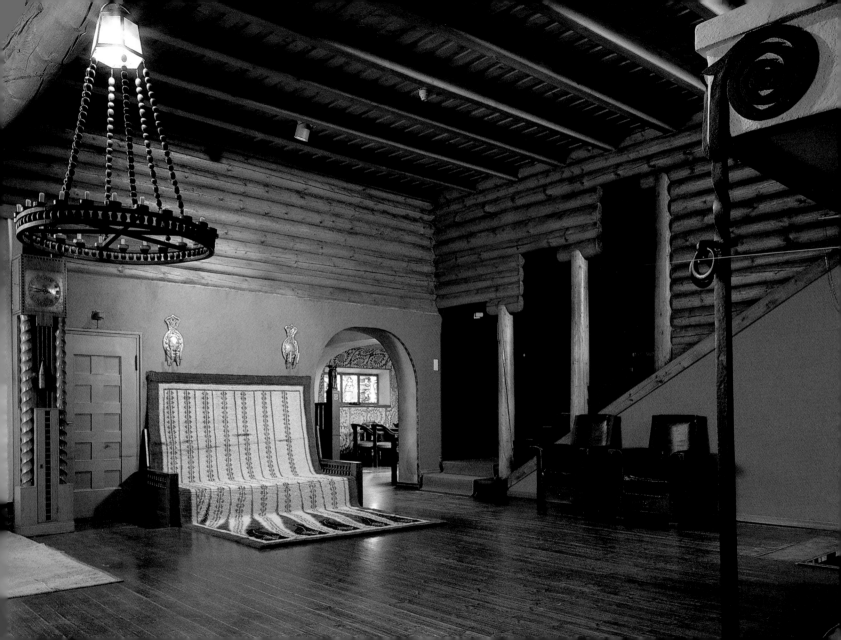

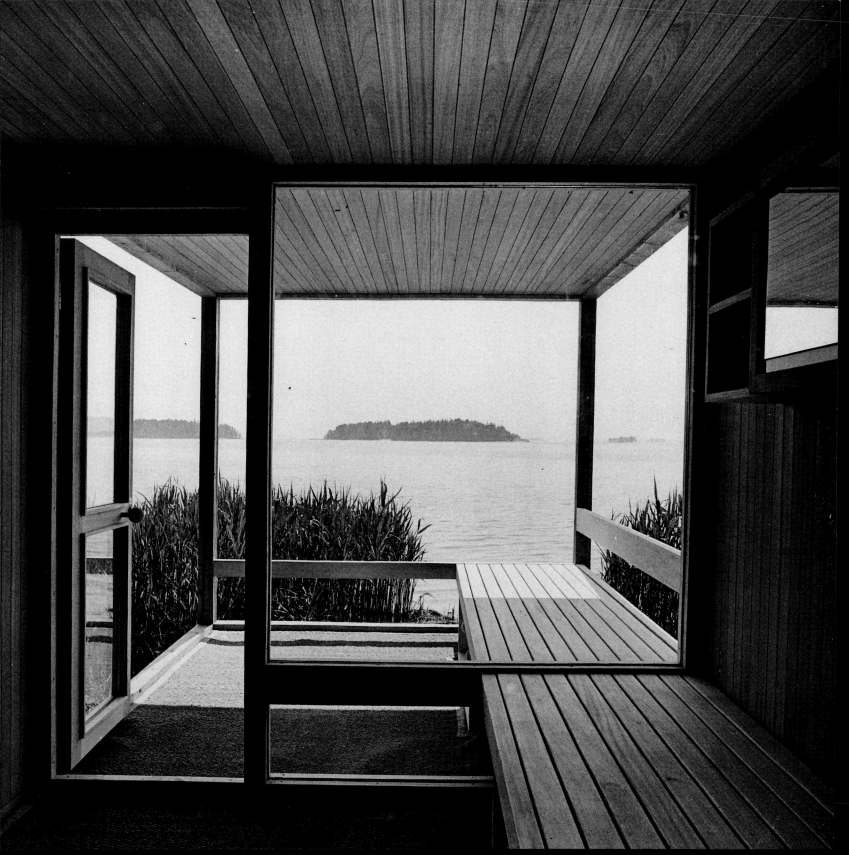

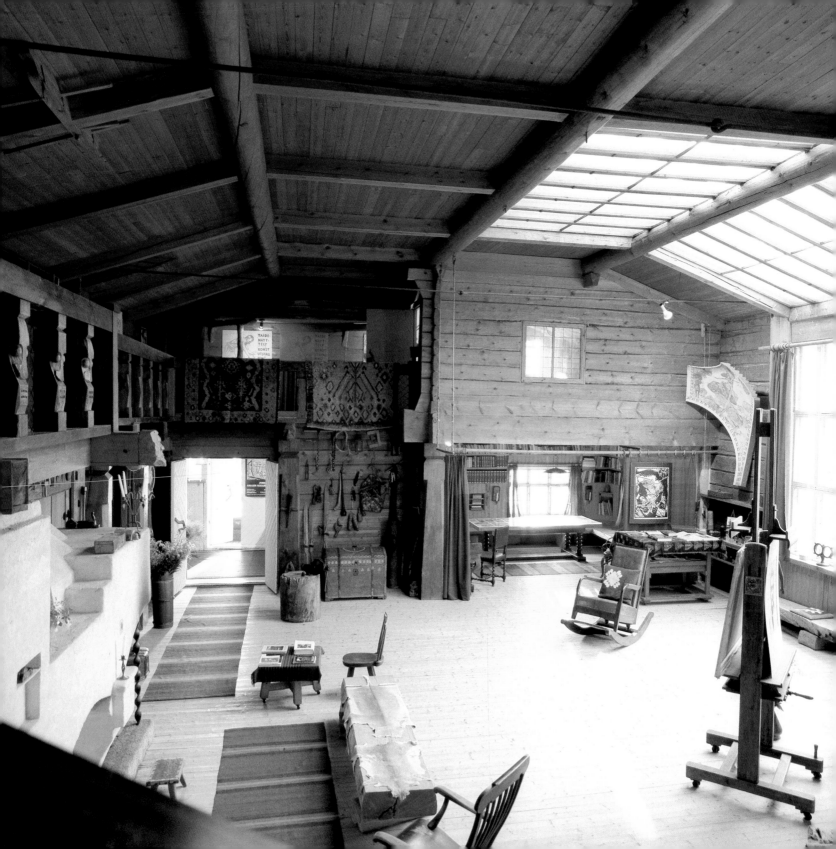

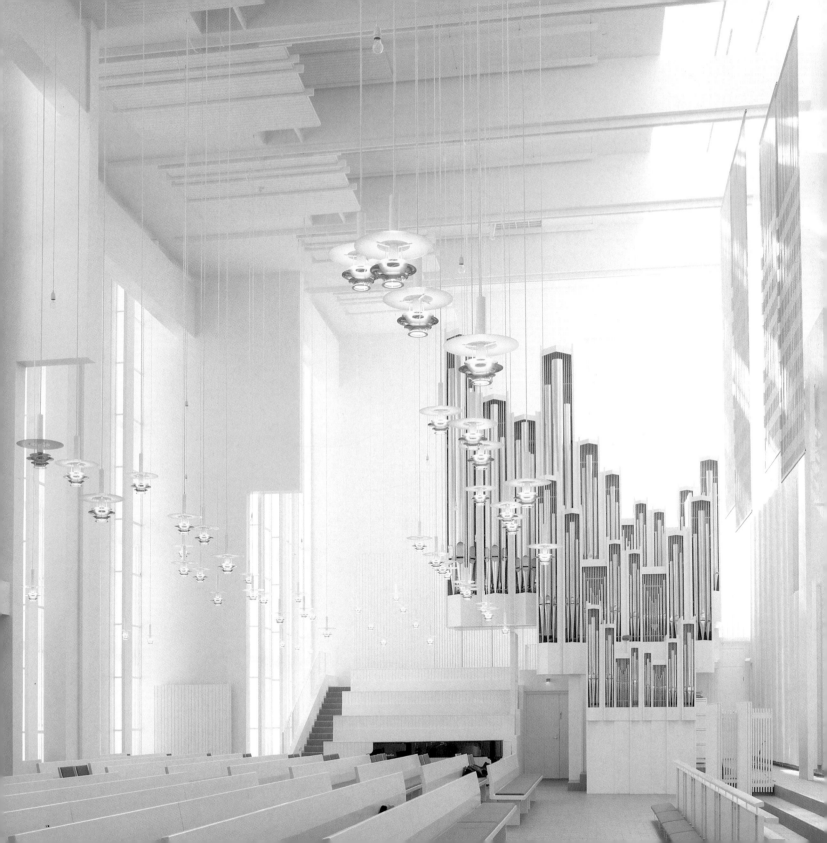

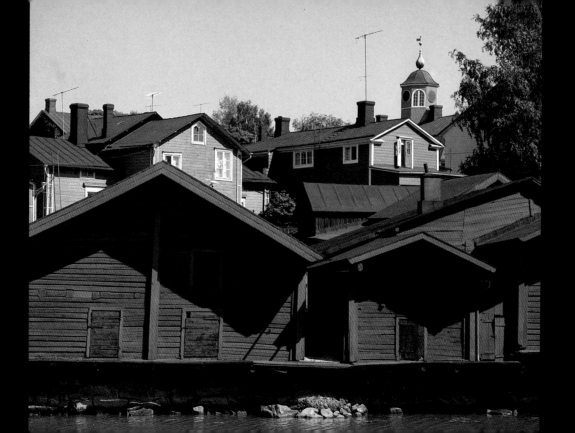

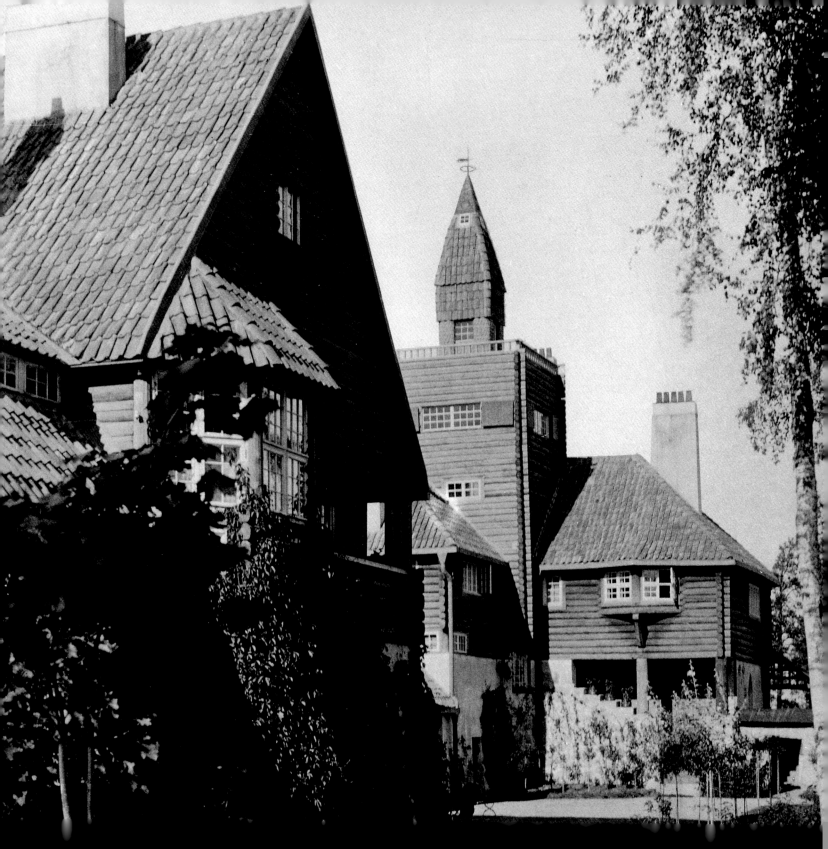

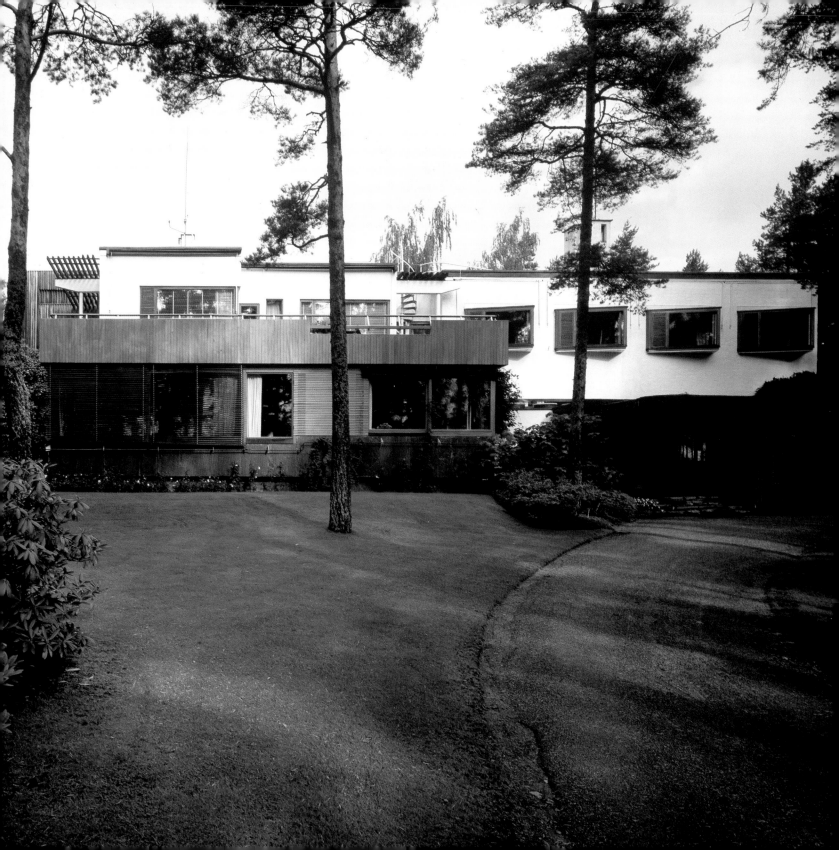

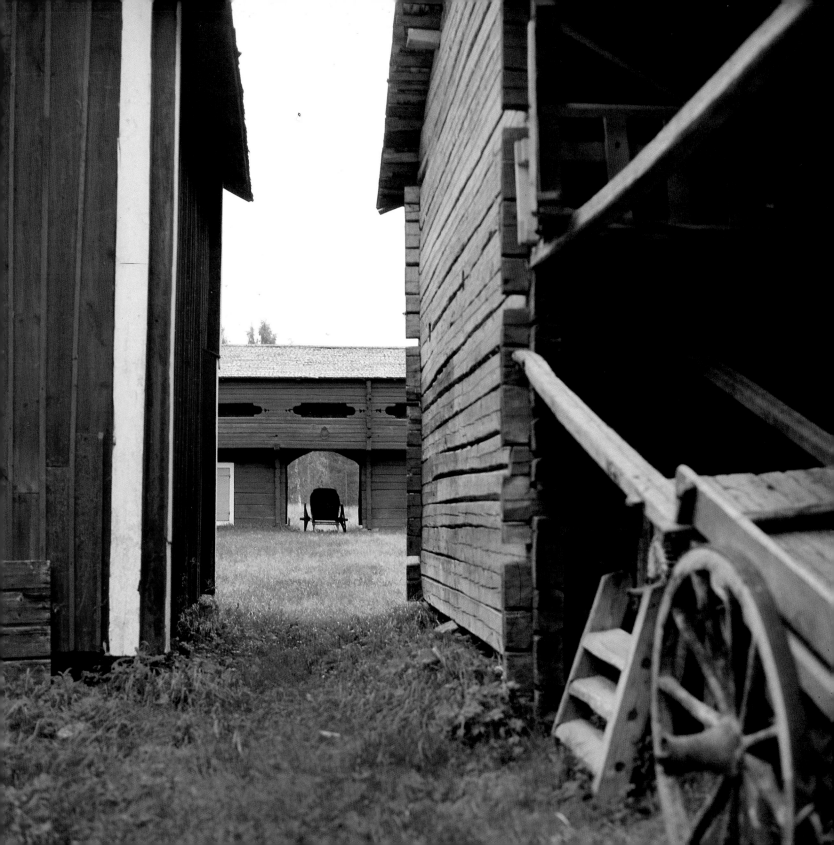

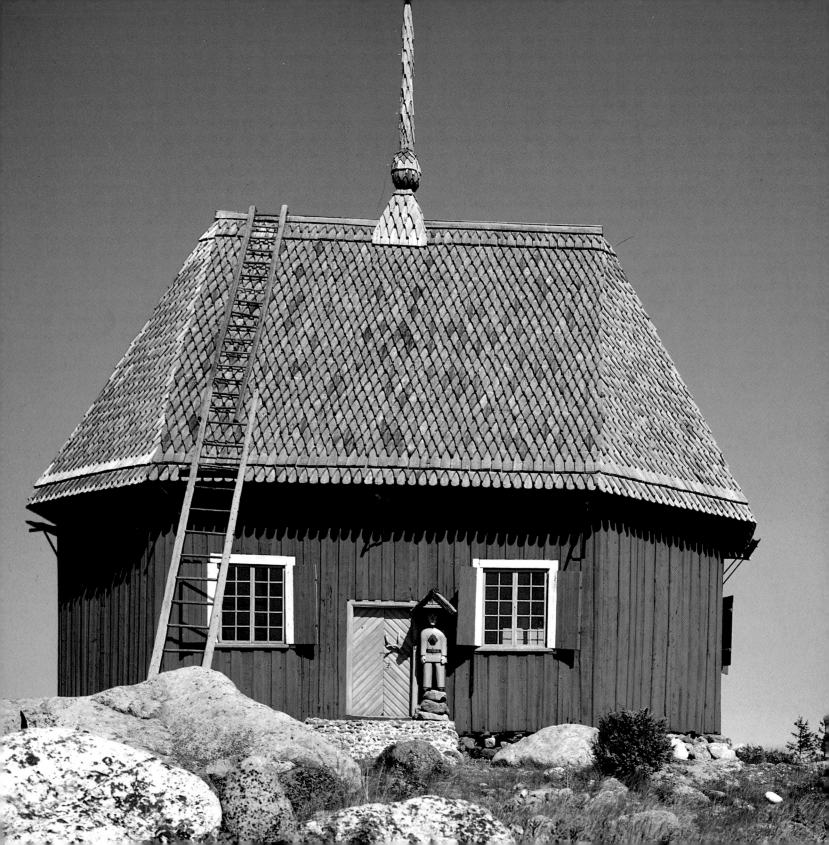

KALEVALA, CANTO 44

— — —
Steady old Väinämöinen
 trudges off homeward
his head down, in bad spirits
 helmet all askew.
He told this in words:
'No more will be that
 joy of the pike's tooth
fishbone melody!'

As he trod a glade
 skirted the edge of backwoods
he heard a birch tree weeping
 a curly birch shedding tears.
He went up to it
 drew nearer to it
he questioned it, talked to it:
'Why do you weep, lovely birch
green tree, why do you go on
white-belt, why do you complain?
You'll not be taken to war
 not be wanted for battle.'

The birch skilfully answered
 the green tree itself uttered:
'Well, some people say
 many people think
 that I live in joy
 in delight revel:
but lean in my cares_
in my longings I ring out
hum in my days of trouble
in sorrows murmur. Empty
for my silliness I weep
for my shortcomings complain
that I am hapless, wretched
utterly woeful, helpless
 in these evil spots
 on these vast pastures.
The happy and the lucky
 are always hoping
for a fair summer to come
a great summertime to warm
 but not silly me:
 woe is me, I dread
 having my bark stripped
my leafy twigs taken off!
 Often in my gloom
and often, a gloomy wretch
children of the fleeting spring
 come up close to me
 and with five knives slash
my sappy belly open.
Evil herdsmen in summer
bear off my white belt — one for
a drinking-cone, for a sheath
one for a berry basket.

Often in my gloom
and often, a gloomy wretch
 girls stand under me
 and romp beside me
 cut off foliage
and bind twigs into bath-whisks.
Often in my gloom
and often, a gloomy wretch
I am felled for slash-and-burn
 for firewood chopped up.
Three times this summer
 this great summertime
men have stood under me, have
 whetted their axes
to dispatch my luckless head
 to end my weak life.
So much for the summer's joy
the great summertime's delight;
but winter is no better
the snow season no sweeter.
 Always early on
sorrow alters my features
 my head weighs heavy
 and my face goes pale
 recalling black days
 thinking of bad times.
Then the wind brings pains
 the frost saddest cares:
the wind bears off my green coat
 the frost my fair skirt.
So with few reserves
 a poor wretched birch
I'm left quite naked
 utterly undressed
to quake in the chill
to howl in the frost.'

The old Väinämöinen said:
'Do not weep, green tree
leafy sapling, don't go on
 white-belt, don't complain!
You'll get gladness in plenty
 a new, sweeter life;
soon you'll be weeping for joy
you will peal out in delight.'

At that old Väinämöinen
formed the birch into an instrument
carved it through a summer day
hammered at a kantele
on a misty headland's tip
at a foggy island's end
carved a belly for the kantele
a soundboard for the new joy
a belly out of tough birch
a soundboard of curly birch.
The old Väinämöinen said

he declared, spoke thus:
'Here's a belly for the kantele
a soundboard for the eternal joy;
but where will the pegs be got
 the screws be fetched from?'

An oak grew in a barnyard
a tall tree at a yard's end;
on the oak were shapely boughs
on each bough was an acorn
on the acorn was a golden whorl
on the golden whorl was a cuckoo.
 When the cuckoo calls
 and utters five words
 gold wells from its mouth
 and silver pours forth
 on a golden knoll
 on a silver hill:
from there the kantele pegs
the screws for the curly birch!
The old Väinämöinen said
 he uttered, spoke thus:
'I've got the kantele pegs
 the screws for the curly birch.
But still something is missing:
five strings the kantele lacks.
Where should I get the strings from
for it, put on the voices?'
He went in search of a string.
 He steps through a glade:
a lassie sat in the glade
a young maiden in the marsh.
The lass was not weeping, nor
indeed was she rejoicing
but just singing to herself:
she sang to pass her evening
hoping a bridegroom would come
making plans for her lover.
Steady old Väinämöinen
yonder crept with no shoes on
without toe-rags he tiptoed.
 Then when he got there
he began to beg tresses
and he put this into words:
'Lass, give some of your tresses
 damsel, of your hair
 for kantele strings
voices of eternal joy!'

The lass gave of her tresses
 some of her fine hair;
gave tresses five, six
 even seven hairs:
from there the kantele strings
sounders of eternal joy.
The instrument was ready.
At that old Väinämöinen

sits down upon a flat rock
on a stepping-stone. He took
the kantele in his hands
the joy closer to himself.
The head he turned heavenward
propped the shoulder on his knees
 pitches the voices
 and checks the tuning.

He got the voices pitched, his
 instrument in a fit state
turned it till it was under
his hands and across his knees.
He let his ten fingernails
and his five fingers strike up
to clamber upon the strings
 to leap on the tunes.
Then, when old Väinämöinen
 played the kantele
with small hands, slender fingers
 thumbs curving upward
the curly birch tree uttered
the leafy sapling lilted
 the cuckoo's gold called
and the lassie's hair rejoiced.
With his fingers Väinämöinen played
with its strings the kantele rang out:
mountains thundered, boulders boomed
 all the cliffs quivered
the rocks splashed with waves
gravels in the waters swirled
 the pines made merry
stumps leapt on the heaths.

— — —

When he played at home
 in his room of fir
 the rafters echoed
 the floorboards thudded
the loft beams sang, the doors creaked
all the windows made merry
 the hearth of stone moved
the curly birch post chanted.
When he walked in the spruces
 roamed among the pines
 the spruces bowed down
the pines on the hill turned round
the cones rolled upon the lea
the sprigs showered down on the root.
When he wandered in a grove
 or tripped in a glade
 the groves played a game
the glades were glad all the time
 the flowers had a fling
the young saplings bobbed about.

— — —

But meanwhile Lauri, with his axe under his arm, wanders deep in the heart of the forest. He moves slowly, looking carefully about him, halting from time to time whenever his eye lights upon a gnarl, a knotted growth, a twisted trunk; or upon a twiggy windnest*, high among the dense branches of a birch or pine. Now he comes upon the tall stump of a fir, its top broken off by a storm. He looks at it for a while, pausing to ponder; then sets to work with his axe to notch a hole in the trunk, thinking to himself, "Who knows, next spring some rufous-tailed redstart or small, bright-coloured woodpecker may find this hole and nest in it." Thus musing, he takes careful note of the place, and passes on. But almost at once he comes upon a birch, with pendulous branches, from whose slender trunk protrudes a bulging knot, as big as a Christmas cake. Hacking it off, he takes it with him, planning to carve from it a sturdy drinking-bowl. Once

more he wanders on, but soon his sharp eye discerns, beside a small rocky outcrop, a strangely twisted juniper. "What could I make from this?" he wonders, and with two sharp strokes of his sharp axe the juniper is severed. He strips it, smilingly contemplates it for a while, picks it up, and again moves on. He hears the bells of the village cattle, gives a shrill shout to scare off the wolves. All around him, a friendly echo answers his shout. On he still goes, coming at length to a high, heather-clad ridge, where he spies a large windnest in the branches of a tall pine, swaying in the cool northeasterly breeze. He fells the tree, cuts out the bristly growth, and sits down to contemplate his find.

There Lauri sat and pondered long, studying the windnest and the knot of birch, and that strangely contorted juniper. How had Nature contrived to create them? What had twisted that juniper into so many intricate joints and bends? And he lay back, resting his head on an aban-

doned, grass-covered anthill, and looked up at the treetops and the sailing clouds, and mused upon the structure of earth and sky; and in the distance he could hear the click of his brothers' staves striking the wooden puck as they continued their game. At length he resolved to banish all thoughts from his mind and go to sleep; but sleep was loth to come. Now it was Lauri's custom, when slumber eluded him, to imagine himself a tiny mole, peacefully grubbing away in its underground mansion, until it falls asleep on its comfortable sandy bed; or else a furry bear, resting in a mossy lair in the wilds, beneath the roots of the firs, while the winter tempests rage above. And when he thought of these things, almost always a heaviness would descend upon his eyelids, and he would sink into slumber. And this is what he did now, becoming in imagination a baby mole, creeping along, deep in the womb of Mother Earth.

He fell asleep, but the fancy re-

mained with him, and was continued in his dream. It seemed to him that his whole body had suddenly contracted to the size of a smooth-furred mole: his eyes became very small, but his hands swelled up until they were like gloves; and there he was, a mole, down below the surface of the heath, burrowing among the roots of the pines. There he scratched and dug, finally tunnelling his way upward through the rotted core of a tall pine, till he reached the topmost tip of its crown and found himself sitting in a snug, moss-lined chamber in the middle of a windnest. "I like it here, I want to live here for ever", he thought, peering out with his tiny mole-eyes through the little window of his cell. Below him stretched a cheerless world, wrapped in the dismal twilight of an autumn evening.

— — —

* windnest: a nest-like growth known to English countrymen as a "witch's broom" or "witch's besom".

Aleksis Kivi (1834—1872): Seitsemän veljestä

MY CHILDHOOD'S TREES

My childhood's trees stand high in the grass

and shake their heads: what has become of you?

Rows of pillars stand like reproaches: you are unworthy to walk among us!

You are a child and ought to be able to do everything,

why are you fettered in the bonds of sickness?

You have become a human being, foreign and hateful.

When you were a child you conversed long with us,

your gaze was wise.

Now we want to tell you your life's secret:

the key to all secrets lies in the grass in the raspberry patch.

We would knock against your forehead, you sleeping one,

we would wake you, dead one, from your sleep.

Edith Södergran (1892—1923)

The sunny mass

of the Acropolis

does not frighten me.

I have seen

the Finnish knoll's

grey barn,

its temple-like

proportions

rising

weightless

towards the infinite expanse

of the spring sky.

Rabbe Enckell (1903—1974)

The river cut through the land. It was like a vein, never at rest. Otherwise, in that region, there were no signs of eager life or haste. The hills and fells, heaving up their flanks, towered sullenly; even more dour was the unblinking stare of the marshes and the bogs. It was the Northern wilderness, in which Man had not settled, because the land was barren and the climate was not kind. But trees grew even there, albeit slowly. Little by little, as a century went by and then a second and a third, their trunks grew stronger. Their branches, tuned by the wind, gave forth a powerful primeval music, and quiet, small-voiced creatures lived and died to the sound of it.

Sometimes Man passed that way, and then many of these creatures would meet with a sudden and violent death. For their flesh was good to eat and their fur was fair to look upon.

And Man's wisdom increased, and now he knew how even the trees' knotty trunks could be squeezed to produce beauty, though this was not always the result.

And squeeze them he did.

Winter approached, and a shell of ice covered the river's surging waters. But on the trunks of the forest trees on either bank, small white marks had appeared: the marks of death. The trees and their days were numbered. For half a million tree-trunks Man had planned a long-drawn-out funeral procession. Snow fell, covering their branches: think of it as a shroud.

Five-and-seventy pinewood hutments sprang up in the wildwood. Two thousand axemen and five hundred horse-handlers and measurers and torch-holders lived in them. The men set to work with their saws and their axes. The trees fell. The horses waded, the drivers shouted. Tracks, like long tentacles, groped their way through the forest. They were levelled and watered till they were smooth, so that the loads would glide easily. The venerable dead lay in their dozens, piled one upon another and firmly bound together, a mighty breastwork of timber, some smooth, some rough to the touch.

Winter set in, with snow and icy frost, starshine and northern lights. But the forest, once so peaceful, was now alive with restless activity. Smoke rose from the seventy-five camps. Five hundred draft-horses consumed their breakfasts and pulled their loads. The teeth of two and a half thousand men bit into rye bread and pork-fat, the teeth of sharpened saws bit into the timber.

Work, work, and little in the way of recreation. Yet there was jovial talk, and here and there an accordion, a mandoline; and scores of packs of cards worn down to pulp by repeated handling. The main camp even had a radio: music, news.

At night the whole settlement was wrapped in a deep, solemn silence, broken only by the plash of the dark river as it flowed beneath its shell of ice, and the crackle of the frost around the brown trunks piled along the bank.

But in the pale, frosty light of dawn the sounds began again, the hiss of a thousand skis across the snow, the clop of horses' hooves, the tinkle of the bells on their harness. Sharp blades bit into the trees; the long processions of logs slid like enormous worms along the ice-covered tracks.

Time passed, the work went on. The sun climbed higher, into the blue skies of March, its arc ever wider. Rain, sun, then melting snow. By now those half a million trunks lay in huge piles along the banks of that river in the wilds. Encouraged by the warmer weather, grey-coated timber beetles crept about in the bark of the fallen trees, their giant antennae outstretched like horns.

Sharp hatchet blows rang out as the trunks were blazed, and many millions of marks were incised on timber-ends.

At last the river ice broke up, crashed its way down the rapids, and disappeared entirely. And on the river's banks there was now a fresh stir of activity. The white shafts of a hundred timberhooks rose and fell, the trunks rolled thundering down and splashed into the water.

For this black river of the wilds was now to convey the venerable dead to places far distant from the region of their birth. Man in his wisdom had discovered that this river would serve admirably as a beast of burden, strong-backed and supple. But the river was long. There were many rocks in it. In places it widened out into a placid lake. Strong winds blew upstream. There was work in plenty for the log-men, and the white shafts of the timberhooks were soon darkened by their pitch-stained hands. They sweated, shouted "hop-heijaa" and swore. Once more the iron hooks bit into the wood, and held.

But this blue-shirted, pitch-stained log-man, who lived on rye bread and fried pork-fat, who neither expected nor received very much from life, who sinned as much as time or opportunity allowed, and diced with Death daily — this log-man, I say, was one of the most important members of society. For from those products of the vegetable kingdom, which now floated down the river in that wild and remote region, Man in his ingenuity squeezed out the finest juices, the noblest blessings, that were enjoyed in that whole country.

Before those slaughtered trees lay long and diverse journeys. Awaiting them were the saw-frames, the tall yellowing woodpiles of the timber yard, the maws of great ships, and then once again the blades of sharp tools, the bright gloss of paint, and eventually a second death from decay or consuming fire. They might find themselves deep in the ground, propping up the tunnels of some foreign mine. Or they might be taken to some factory, to be worked on by machines of various kinds, and to emerge quite changed. In the form of paper, for example, on which might be written the story of half a million tree-trunks, those very trunks that grew for a century, and then for another, and whose funeral journey was so long and eventful.

Can you hear the sighing of the winds of a hundred years and more, rising from the surface of the paper this is written on?

Peace returned to the banks of that river in the wildlands. Only the black water was still active: living, rolling, tumbling, splashing over the stones. But the hills all around were a sorry sight, like sheep clumsily shorn. Amid the drying, yellowing branches a few sparse trees still swayed in the wind. The creatures of Nature have dwindled in numbers. And clever Man, *homo sapiens*, will have no business to take him there for a long time to come.

Pentti Haanpää (1905—1955): Half a Million Tree-trunks

Such wealth:
on the board of the steps
the writing of worms occult and wise,
in front of the dull grey window
the silver curtains of the spider,
that industrious weaver.
And when you sleep
head on tired palm
the old brown wood resonates,
mellow dreams spread out
from the fragrant linen sheet
and embrace you
and behind the small windowpane
the trees are nodding
and the leaf that is I
says good night.

•

THE THRESHOLD

A child sits on the threshold of the cabin
which is old, brown, and smells of smoke.
Small finger,
small fingernail, thin, convex like a scale
 of fool's gold,
traces the knot in the threshold.

Old threshold.
The knots are hard, brown, round,
dark jewels, smooth as glass.
— — —
Small finger,
small fingernail, thin, convex like a scale
 of fool's gold,
traces the knot in the threshold . . .

Viljo Kajava (1909—)

Into the forest I went.
Humbly to the trees I bowed.
Now my bowl is full of berries.

·

THE TREE CHRIST

There was a tree. Every passer-by
picked its fingers and took them away.
Its arms were cut off and from the wounds
in its side flowed the juices of life.
And the naked trunk was cut down
for every human being's sake.

Helvi Juvonen (1919—1959)

The trees are letting their autumn burden go
and moving into the distance
(oh for clairvoyance).
A little light, dark forest, desolation
and under it all, unfathomable longing.

So let's forget, walk lightly
through peculiar times, the wavering dark,
the sighings of autumn days and the mindful forest
without carping at grief. It's ours, and still warm.

·

The trees are windblown and dropping their colours
day by day.
Only the long-boled pines encounter autumn without change,
straight and slender,
their roots clefted in rock, snow-crowned,
snow-scented; the clouds are lightly
brushing their crowns.

The path's frosted, the grass bent,
the wind bringing leaves like a sigh (the forest)
and carrying them away.

No birds. Flocking twittering over,
they've migrated to wooded dingles.
Weightless, black, the last hawks
are skimming the ground and disappearing
into the forest embrasure
and not coming back.

·

Trees, twofold: confidence in earth and day
They're disrobing already
Life will soon be over.

Eeva-Liisa Manner (1921–)

The tree,

branched

light

•

Winter trees,

brittle, their stillness

I saw, did not see

when young.

•

The air with leaves of words,

trees, speaking,

overshadowing sleep

•

Two trees enough

to define the sky

Bo Carpelan (1926—)

The trees were given those fruits, the fruit juice, I said,
so they'd flourish.
The fruits replied sharply: we're flourishing, soul exists,
flourishing's all we're about.

But no,
a soul needs its cradlesong, yes, when it's to be wakened,
but a pear's just a fruit,
it thuds out its weight, yes, but it's nothing,
and there's no fear of fruit wakening, they're dead things,
 ruddiness is all they're about,
it's like this,
soul's everything we can get moving; that's flourishing,

dawn's everything that happens, and, as for fruit, this:

the fruits are over,
they thudded to the earth that's charged with thought: it's a joy to be alive,
the fruits are over, it's a joy to be alive,
a pear has five little dwarfs in it, it's not enough to make it anything,
it's just a fruit that thuds to the earth, the earth's charged: it's a joy to be alive.

I marvel at a tree, and at all those green sprouts whose pressure the tree withstood,
a dry stock: in order to live
the tree took on sprouting, the sprouts shook it, the sprouts
 they're the women from the countryside
who got places in the branches,

 the roots lead down to the peasantry of the earth,
the women as pregnant with their goodnesses as cheeses straight from the oven,
 the men: it wasn't easy
that slow dulling, to ripen the tree with noble fruit and give wine time to ferment,

I don't mean the tree's dry fruit, of the tree's declining bough I say nothing,
 I'm remembering the wild slip: dead, lovely,
at seventeen a Folk Song was taken into the house and became three sons,
 it drowned washing the clothes;
since then the willow's meant weeping: explain all this
and how black became grey and where the houses go when they die.

Paavo Haavikko (1931—)

SUBJECT TO LAW I AM / NOT A FORMULA

1.

as buds, the imaginings, the branches, everything:
one would like to
 laughing
 spread out the whole crown of leaves
to be true
 commonly understood
 beautiful
 in its fall-colored mating costume
 the maple

2.

buds, the imaginings, the branches, everything:
approaching, gone
glows against the night:
as snow, gone
as grass, gone
as tree, gone
true, commonly understood beautiful
 in its fall-colored mating costume
 the maple

3.

as buds, the imaginings, buds of buds:
gone
 and the end, music
 everything
 speaking by speaking
 silent by being silent

Markku Lahtela (1936—1980)

Leaves in my eyes, earth

in my mouth, I love the trees my cousins

with rain in their hair, the green

open-work light in the aspen cathedral

cradles me like a polyphonic fugue of

Bach, the trees have no age, they have

visible and invisible forms, their

subterranean hands work on the dark

fields where the dead rest up after

life, photosynthesis continues polyphonically while

we get the harvest in amidst drone-scooters

and bumblebee-helicopters, with the useful

implements in our hands

Claes Andersson (1937—)

picture texts

This painting by one of the masters of the Finnish National Romantic School expresses the central role of forest and wood in peasant life. The forest was man's environment, his livelihood, his source of raw materials for building and implements. It depicts the determination and faith of a family of settlers, but death is also present in the guise of a man with an auger.

1 Axel Gallén (later Akseli Gallen-Kallela), Building, 1903. Tempera, 75×141 cm. Art Museum of the Ateneum, Helsinki.

Wood and forests have figured prominently in Finnish folklore where they possess an unlimited number of symbolic meanings. These the forest dwellers have reflected subconsciously, sometimes feeling them as secure, other times frightening and threatening. The forest has been a major theme in Finnish art, literature and music.

2 The Genealogy of Jesus. The vault and wall frescoes in the church of Lohja built in the 1480s date from the 1510s. The vault over the south aisle depicts Jesus's family tree, the Tree of Jesse. King David's father Jesse dreamed of a family tree

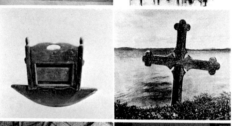

growing out of his heart on the branches of which were 22 Old Testament kings and prophets, the Virgin Mary and the infant Christ. In the high foliage of the tree is the Crucifix.

3 Aimo Kanerva, Firwood, 1952—53. Oil, 116×89 cm. Owned by Mika Waltari/Satu Waltari.

Wood is part of a peasant's life from the cradle to the grave.

4 Cradle from 1816, Suonnejoki. 57.5×97×50.5 cm. National Museum of Finland (NM). Used during many generations on the Vanha Laitila farm and probably made by a member of the family.

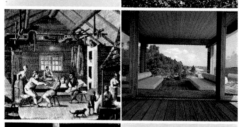

5 Grave cross, Uusi Hautuumaasaari island graveyard, Inarinjärvi. People preferred burying their dead on the island because wild animals would otherwise dig them up. The last burials were in the early 20th century.

Foreign views of Finnish life and wooden architecture — 1799 and 1984.

6 Living-room or tupa, engraving in Joseph (Giuseppe) Acerbi's "Travels through Sweden, Finland and Lapland, to the North Cape, in the Years 1798 and 1799", published in London in 1802 and extensively translated. The writer has been accused of inaccuracies: witness the national costumes, stove, window, bed and kantele in this picture. His descriptions, like those of his fellow traveller A. F. Skjöldebrand, gave rise to myths about folk runes that have persisted to this

day. They claimed that runes were sung by two people sitting opposite each other, holding hands and rocking in a rowing-like motion.

7 The architects Kaija and Heikki Siren's "sea chapel" at their island villa, 1966, featured in the American writer and journalist Elizabeth Gaynor's book "Finland — Living Design", 1984. Her book gives a close to nature, beautiful and romantic image of how Finns live.

All Finnish peasant's had to have some skill in carpentry because they built their own houses and made their own utensils. A well-made object was also proof of a man's abilities, a decorated distaff was often given as a wedding gift in Ostrobothnia. In our own time carpentry has been revived as a hobby.

8 Carpenter's bench in the corner of the artist Pekka Halonen's Halosenniemi atelier on the banks of Tuusulanjärvi lake. Halonen came from craftsman stock and appreciated handicrafts. Whilst studying in Paris in 1890—94 he longed

for the sound of a kantele and surprised his fellow artists not only by making one, but playing it.

9 Markku Kosonen, carpenter's bench, 1984. Birch, 88× 155×70 cm. Produced by Suomen Puunjalostus Oy 1984—. Although a traditional carpenter's bench in origin it has ingeneous new systems that enable both ordinary wood and boards to be worked. This craft bench has also been designed as a piece of furniture.

In old rural society a maiden was considered unfit for marriage until she could both weave and make her own clothes. Once an essential skill, nowadays weaving is a popular hobby.

10 Loom, made in South Ostrobothnia in 1768. Pine, 142× 112×131 cm. This has been made from a pine stump, the sides following its natural shape. Finnish Cottage Industry Museum, Jyväskylä.

11 Cramped living conditions forced product development. Normalo's factory in Loimaa began producing a 'collapsable American' loom in the 1930s and an improved version is still being made. They are from birch, 130×90, 110, 130 or 150×115 cm. Collapsed they take up only a 30 cm deep space.

12 Niemelä tenant's cottage from Konginkangas, Seurasaari.
13 K. Gullichsen, J. Pallasmaa, Moduli holiday cottage, 1968—74.
14 Niemelä's farmhouse from Kaukola, Seurasaari.
15 Alvar Aalto, chair 65, table 80. (Artek).
16 Baroque-style wall cabinet from Sysmä, 18th century. NM.
17 Tapio Wirkkala, set of drawers 1981. Juniper, 135×67×34.
18 Fir root sowing basket, height 17, diameter 50 cm. NM.
19 Eero Aarnio, Juttu stool, 1960. Wickerware. (Sokeva, Asko).
20 Vestry door, Sipoo medieval stone church.

21 Tapio Wirkkala, rhythmic plywood, 1958. (Soinne Oy).
22 Living-room shelf from Lappee. NM.
23 Alvar Aalto, bookcase system. (Artek).
24 Fence, Ruovesi Local History Museum.
25 Kaija and Heikki Siren, technological students' village chapel fence, 1957.
26 Curly-grained cups, Lemi and Savitaipale. Wine cup. NM.
27 Kari Virtanen, wooden bowl, 1987. Birch and coloured glue.
28 Toy reindeers carved from wood, Muonio. NM.
29 J Vennola, Pujo toy, 1967. (Aarikka Oy).

30 Snow shovel, alder, length 122 cm. Presumably from West Uusimaa. Surprisingly light which is an advantage in this kind of work. Bertel Gardberg Collection.
31 Ditch-digging spade, birch and iron, length 125 cm. Presumably from West Uusimaa. Bertel Gardberg Collection.
32 Pitchfork, birch, 163 cm. Agricultural Museum, University of Helsinki. The pitchfork used for lifting and spreading manure owes its origin to the wooden fork and shovel. The oldest ones were two-pronged and made from a single

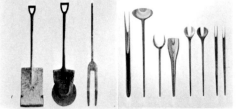

piece of wood, normally hardwearing birch. Since the middle ages the tips of the prongs have been reinforced with iron caps. In this form they reflect Roman and Gothic features.
33 Tapio Wirkkala, salad servers, 1956. Ebony, makoré and jacaranda. Lengths from the left 27.5, 27.5, 27.5, 27.5, 23, 25, 35.5 and 34.5 cm. Tapio Wirkkala Collection. A graphic motif has been derived from the different wood colours and lamination glues.

34 Grain mortar, scooped out from a block of pine, Rääkkylä. Height 72 cm, diameter 50 cm. North Karelia Museum, Joensuu. As decoration, and possibly to reduce the weight, zig-zag bands of medieval origin were carved around the sides.

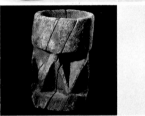
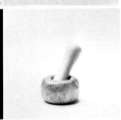

35 Markku Kosonen, mortar, 1984. Curly-grained birch, height 4.2 cm, diameter 7.8 cm. Pestle, birch, 10×3.2 cm.

Certain traditional ways of making wooden objects have been preserved up to present times. Old models and methods, especially in basketwork, are continuously repeated. The revival of handicrafts has rescued many arts from oblivion. In recent years even the traditional way of building church boats has been revived.
36 Paavo Turu, faggot basket, 1987. Miehikkälä. Pine shingles, 44×39×28 cm. Paavo Turu is the third generation of shingle makers. Shingles are made from old, slow-growing, branchless, straight pines. They are shaved off with a

puukko knife, used also for smoothing the surface. The main obstacle today is finding suitable wood as only trees growing wild can be used.
37 Sauna vihta. To Finns the sauna and vihta birch switch mean a many sided emotional link with wood. Made by Pauli Järvi, Kaivoksela.

A unique product of Finnish urban life is the wooden town. It developed from the Renaissance grid principle, combining urban and rural features with crafts and trade practised alongside farming and cattle raising. Fire posed the greatest threat and at least one wooden town was destroyed every 30—40 years. The greatest ever in Scandinavia was in Turku in 1827.
38 J. Wallin, The Fire of Oulu, 1822. Watercolour, 44×35 cm. North Ostrobothnia Museum, Oulu. Some 330 buildings were destroyed.

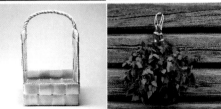

39 Joel Nokelainen, wooden birds, 1987. The artist inherited the art of carving birds from his father Ilmari Nokelainen who had in turn learned it from Russian emmigrants. He made them from one piece of wood although traditional Russian ones were from two pieces joined together. Joel Nokelainen, who makes over 2000 birds a year, says that working with the hands gives an important emotional contact with the surrounding world.

In times of distress Finns have relied on the forest and wood in many ways.
40 Bark bread, North Savo, 1st World War. Agricultural Museum, University of Helsinki. It is made from the phloem between the bark and cambium of a pine and in famine years was collected near midsummer. The poisonous lignine was removed by boiling or roasting. Dried, crumbled and ground it was baked into bread in the usual way. Although the last great famine was in 1867—68, bark bread was still being eaten in Kainuu in the 1930s. It contains about

40 % of the nutritional value of rye bread.
41 Wooden-soled paper-cloth shoes, 1940s. Paper string, cloth, leather, wood and metal, 11.5×26.5 cm. Made by Hämeen Kenkätehdas. Museum of Applied Arts, Helsinki. The wooden soles were reinforced with nails.
42 Greta Skogster-Lehtinen, birchbark wallcovering, 1942. Birchbark, paper string and greaseproof paper. Museum of Applied Arts, Helsinki. Several patterns were produced by the designer and among the users were Kestikartano restaurant.

wood shapes

When woodworking tools were primitive and glues and other fixing agents did not exist, common folk used bent tree trunks, forked branches, stumps and other naturally formed shapes. From the forest he gathered the shapes he needed at home. Sleighs, boat frames, tools and furniture made from naturally formed wood are surprisingly ingenious.

43 Juniper net gathering peg. Bertel Gardberg Collection. It is a traditional type from the islands off Tammisaari. Made from juniper, the wide part from the trunk, the curved part

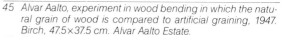

Alvar Aalto transferred the bent forms and cantilever structures of Functionalism to wood. In developing his furniture he made a considerable number of experiments with methods of bending wood. The outcome, the "plaques", are something between free art and functional design and the ideas brought forth were used in his furniture. He wrote enthusiastically of the inventiveness of Karelian peasants in using natural shapes. The bent and laminated elements in Aalto's furniture often recall the natural forms used in rustic furnishings.

Peasants in former times had to find the raw materials for the shapes and structures they required in the forest. And if the grain followed the shape of the object the result was a very durable structure. Modern laminating, pressing and glueing methods allow wood to be moulded to whatever shape desired.

47 Chair from Varsinais-Suomi, back, seat and front legs from same piece of wood. Probably late 19th century. Height 84.5/48 cm. Turku Provincial Museum. Jointing was avoided by using the natural shape of the wood. Such pieces of fur-

49 Stump leg table with plaint decoration, Loimaa, either medieval or early modern. The leg in the shape of three toes is made from the stump of a fir. Height 80 cm. Turku Provincial Museum. The oldest table legs were from the roots of firs because these gave sufficiently broad curves. The softer northern woods required greater thickness and were more simply decorated than their European prototypes.

50 Alvar Aalto, X leg, 1954. The fan-shaped X leg is produced from a normal Aalto leg sawn into 5 or 6 pieces. Alvar Aalto developed several leg types of which the X, Y and Z each

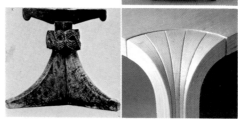

Plywood is normally used because of its physical properties, especially in bent structures. One of the Finnish pioneers was a Jyväskylä manufacturer of plywood suitcases. But plywoods layered structure also has an aesthetic potential.

51 Antti Nurmesniemi, Palace stool, 1951—52. Seat birch plywood, legs pine, 35×35×50 cm. Designed in Viljo Revell's office as a stool for the Palace Hotel saunas. Produced by G. Söderström 1952, Liljamaan puusepäntehdas 1965—70 and Oy Dalsbruks Trä och Metall Ab 1980—.

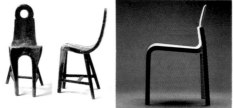

54 The furniture designed by Alvar Aalto has been perhaps the greatest success in wood furniture since Thonet in the mid-19th century. Despite their modern aesthetics and structural-element thinking, Aalto's furniture still has a free and warm character. At the turn of the thirties Aalto began his "struggle against metal in furniture design" believing that wood was a better material for following human contour than hard, shiny, cold metal. His are among the few favourites of modern design that has otherwise been condemned as elitist and pretentious. Some half-million pieces

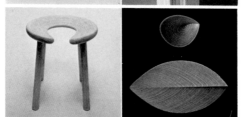

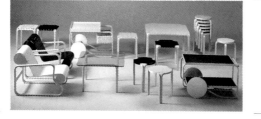

from a branch. Fishing implements often had the owner's initials on them.

44 Juniper burbot hook, Inari, average length 7 cm. National Museum of Finland. Part of a collection of Lapp objects made by I. T. Itkonen whilst on a Finno-Ugrian Society stipend in 1914.

45 Alvar Aalto, experiment in wood bending in which the natural grain of wood is compared to artificial graining, 1947. Birch, 47.5×37.5 cm. Alvar Aalto Estate.

46 Tapio Wirkkala, Hurricane (Spiral, Whirlwind), 1954. Aircraft plywood, 140×159 cm. Made by Martti Lindqvist. Tapio Wirkkala Collection. Tapio Wirkkala skillfully used in his works the natural grain of wood and the layed structured and sculptured form of plywood to achieve an overall effect of line rhythms.

niture were not the work of professionals but examples of the ingenuity of the ordinary folk.

48 Kari Asikainen, Kari 3 chair, 1981. Form-pressed birch legs, unsplit beech plywood seat, 75×47×49 cm. They are stackable and can also be joined in rows. Produced by Oy Pekka Korhonen Ltd 1982—.

became basic elements in series of multi-form furniture. "Historically, and practically, the basic problem in furniture design is the element joining the vertical and horizontal parts. I believe that it is this that gives style its real character. In being joined to a horizontal level the chair leg becomes the little sister of the architectonic pillar." (Alvar Aalto, Arkkitehti-Arkitekten 3—4/1954).

52 Tapio Wirkkala, scallop bowl, 1954. Laminated birch, height 3.5, diameter 27.7 cm. Limited production. Tapio Wirkkala Collection.

53 Tapio Wirkkala, leaf bowl, 1951. Laminated birch, length 35 cm. Limited production 1951—54. Tapio Wirkkala Collection. Tapio Wirkkala made an intensive study of the use of aircraft plywood in sculptures and utility objects. The rich patterns of his rhythmic plywood are obtained by turning layers of glued plywood at an acute angle to the surface.

of the three-legged stool have been made.

Wood has a uniquely rich texture which varies with the species, growing environment, part of the tree, age and so on. Generally speaking age and use only enrichen and beautify the surface structure. "The biological characteristics of wood, its limited thermal conductivity, closeness to man and nature, its charm and diverse finishing possibilities have preserved its commanding position in architectural interiors despite all recent experiments." (Alvar Aalto, Puu rakennusaineena, 1956.)

A wooden object or building has two tales to tell — of its growth and aging as an organic material and the workmanship of man. Industrial production has unfortunately destroyed all traces of hand and tool.
56 Kain Tapper, Wind, 1964. Wood relief, birch, 120×120 cm. Amos Anderson Art Museum, Helsinki. Sculpting marks and patina play an important part in Tapper's works.

Time, use and finish give the surface of wood its rich texture. Aged or decayed wood arouses a feeling of empathy.
58 Barn doors and wall, Keski-Kangas, Ylihärmä. Keski-Kangas farm is probably 18th century. Photograph from Markus Leppo's book "Talonpoikaistalot", 1973.

It is the warmth and grained texture of wood that makes it so pleasant to touch. Its non-conductive properties make it an ideal insulation against heat and cold alike.
60 Kaj Franck, carafe, 1954. Glass and rattan, height 22 cm. Produced by Nuutajärven lasitehdas 1954—66.

Early bell towers were simple structures of upright posts and bracing struts covered by a small roof. In the 18th century they became the original and decorative towers of professional church builders. They were a combination of mainstream European styles and local carpentry skills and traditions. The Late Renaissance came to the Finnish village or builders, inspired by the Baroque, placed a gently curving roof of shingles over the timber frame. Bell tower builders were usually skilled shingle makers. In designing the intricate pattern of the roof they took careful account of light

Wood enables archaically powerful and sophisticatedly insubstantial textural effects. It has its own ageless structural and aesthetic logic. The illustrations are based on a uniform vertical, horizontal and diagonal design.
69 Tapio Wirkkala, dividing screen, 1972. Birch, 210×520 cm. Only two of this sixteen-part screen have been produced by Käpylän Puuseppä. Tapio Wirkkala Collection.

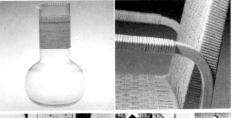

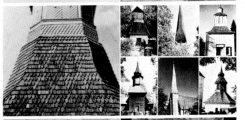

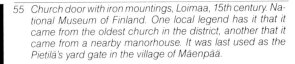

55 Church door with iron mountings, Loimaa, 15th century. National Museum of Finland. One local legend has it that it came from the oldest church in the district, another that it came from a nearby manorhouse. It was last used as the Pietilä's yard gate in the village of Mäenpää.

57 The marks left by the hatchet on the wall timbers of Petäjävesi Old Church invite one to touch them. The church, built by Jaakko Klemetinpoika Leppänen in 1763—64 and the tower by his son Erkki in 1821, has been derelict since 1897.

59 Kari Cavén, This happened, 1985. Wood and plywood, 125×175 cm.

61 Alvar Aalto, armchair 45, 1946—47. Produced by Artek 1947—. Since the late 1920s Aalto applied the bent and cantilevered structures of Functionalist furniture to wood. In criticizing tubular furniture he wrote: ". . .an object that is part of man's home should not excessively reflect light, sound, etc. Neither should an object in direct contact with man, like an armchair, be a good conductor of heat" (Rationalismen och människan, 1935.)

and the path of the sun, thus assuring a continuous change of tones throughout the day.
62 Elimäki church bell tower, 1795—97, Aatami Marttila. 63 Karinainen, 1764. 64 Pietarsaari Parish church, 15th century. 65 Vähäkyrö, 1765. 66 Pihlajavesi, 1780—82, Matti Åkerblom. 67 Kempele, c. 1695. 68 Asikainen, 1779, Mikael Piimänen.

70 Storehouse door. Photograph from "Isien työ" by Kustaa Vilkuna and Eino Mäkinen, 1982.

structure

The exceptional strength of wood coupled with its thermal insulating properties and easy working make it a versatile raw material for buildings and objects. Its tensile strength at best is almost that of steel. Essential to a wooden construction is that the joint are correctly formed and that stress and load are suitably distributed.

Finnish building tradition is based on the horizontal-log technique, the exceptions being different type of pillar-supported roofs and the East Karelian pillared cowsheds. Frame building only began in the early 20th century largely under the influence of the American balloon frame structure. With the exception of log houses post-war building has been frame structures.

72 Boathouse for church boat, Ruovesi, mid-19th century. Seurasaari Open-Air Museum, Helsinki. A horizontal-log structure is kept in place by gravity.

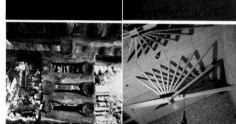

Steel parts can be used to give lighter dimensions to a wooden structure. Generally speaking the wooden parts take the load and the steel parts act as drawbeams and braces.

74 Bengt Lundsten, Orion-Yhtymä Oy's training centre, Otalampi, Vihti, 1979—80. Canteen roof structures. The roof trusses are variations of the Polonceau type in which the drawbeams are from steel and the load bearing uprights from wood. Structural design by Eero Paloheimo — Matti Ollila Engineering Office.

Two wooden structures in which the curve formed by the frame and a plywood or board surface produce a structural totality.

76 Ilmari Tapiovaara, Domus chair, 1946. Birch and birch plywood, 77/46×57×42 cm. Produced 1946—65, first by Keravan Puuteollisuus Oy, later by Wilh. Schauman.

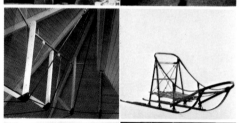

It is form that gives a wooden contruction its rigidity. Vernacular structural principles are repeated in chairs produced by modern woodworking technology.

78 Double-bow harness, Laihia, 19th century. Birch, 69× 71.5×4.5 cm. Turku Provincial Museum. Bow harnesses were used when travelling in winter and summer alike, especially in North-East Europe. The best wood to make them from was lime or bird cherry, but also birch. The bow's function was to keep the collar a suitable distance from the horse's shoulders to allow the load to be evenly distributed

80 Windmill, Louhisaari Manorhouse, Askainen, late 19th century. Pine, overall height 21.15 m, sail span 14.5 m. This practical and adjustable structure has acquired an individual and exceptional adaptation and become a work of art. The manor's huge windmill could be seen far out at sea and became a familiar landmark for sailors. Completely renovated in 1970, the mill is now painted red with tarred shafts and while sails.

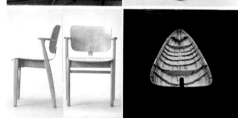

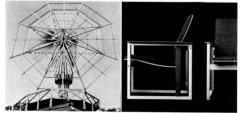

71 Hayfork, Kuutamolahti, East Karelia. Lenght 219/65 cm. National Museum of Finland. The three prongs made by splitting are kept apart with wedges. In this simple farm implement the opposing forces of wooden wedge and metal band have been used to obtain a structural form.

73 Alvar Aalto, Säynätsalo Town Hall, 1950—52, council chamber ceiling. The triangulated struts joined to a steel shoe on the main member of the ceiling are so arranged that they also support the secondary roof framing. The result is a unique solution in wood in which the primary and secondary structures are in the same direction.

75 Risto Kamunen, dog-drawn racing sleigh, 1982. Ash, runners from birch and glassfibre, 90×290×50 cm. Handmade prototype 1982. Sleighs produced in small quantities by Arktic, mainly by hand. The designer's interest in dog sleigh racing provoked the original development. Many new materials have been experimented with in making these sleighs, but the best for taking the strain of moving over uneven ground is a wooden frame joined together with flexible thongs.

77 Traditional intermediate river and lake boat, pine, built by the Salmi brothers, Rovaniemi Rural District, 1960. The frame, stem and sternpost are from naturally curved wood, the rowlocks from forked branches and plaited twigs. The sternpost has been widened to take an outboard motor. Another similar boat was given to President Kekkonen for his 60th birthday. Owner Matti Saanio.

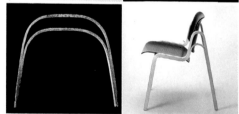

and prevent rubbing. In former days each farm stables had a bow mould on the wall. The floral-decorated bow harness was peculiar to South Ostrobothnia.

79 Ilmari Tapiovaara, Wilhelmina chair, 1959. Bent birch plywood, 73/45×52.5×45 cm. Produced by Wilh. Schauman 1960—64. Museum of Applied Arts, Helsinki. The structure is based on fontana bending whereby the leg part is made from one piece and is springy due to the special way of being fixed.

81 Simo Heikkilä, chair TZ 1, 1984. Finnish birch, 79/39× 62×68 cm. Produced by Artzan Oy, 1984—. Skillful finishing has retained the original expression of the wood. This chair combines individual craftsmanship with industrial mass production.

The measure of a carpenter's or joiner's skill is the joint. In olden days primitive tools and the absence of glues and fixing materials compelled the use of natural shapes.

82 Fisherman's anchor used for nets and baskets. Made from a forked branch with a suitably shaped stone wedged in between by a curved board. Probably 19th century or earlier, but of a type used from the 11th century onwards. Juniper and fir, height 50, width 45 cm. National Maritime Museum of Finland, Helsinki.

The traditional Finnish way of building was the horizontal-log technique. The jointing principles are the same whether for houses or jewel boxes.
83 Dovetail joint. Edge joint of an 18th century storehouse. Long-edged joints were gradually replaced in the 19th century, in some places already in the 18th century, by dovetail or corner lock joints. The dovetail joints were made by shaping the neck of the log to improve its gripping power. Photograph from "Suomalainen aitta" by A. Kolehmainen and Veijo A. Laine, 1983.

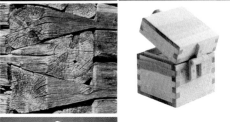

Rational joint in utility article and irrational joint in work of art.
85 Marke Niskala-Luostarinen, stool, 1952. Birch, 43×43×43 cm. Produced by Stockmann/Keravan Puusepäntehdas 1952, Arenic Oy 1985—. Museum of Applied Arts, Helsinki.

84 Bertel Gardberg, hinged box, 1987. Hoary alder, 10×10×10 cm. Bertel Gardberg Collection. This box from hoary alder heartwood was a prototype for handicraft workers in the Porkkala area who work with few tools and often no electricity. Following the break in tradition and the absence of aesthetic schooling, trained designers must develop prototypes for new production. The finish is of great importance: this box has been treated with a special oil made from natural turpentine, linseed oil and beeswax.

86 Mauno Hartman, Peepuu sculpture, 1965. Pine, 50× 200×40 cm. Art Museum of the Ateneum, Helsinki. The appeal of Hartman's sculpture lies in the ageless traditions of rural carpenters and joiners in making utility articles and the irrational language of art.

The aesthetics of plaited joints.
87 Alvar Aalto, Villa Mairea, Noormarkku, 1938—39. In his work in the late 1930s, especially for the Paris and New York world exhibitions and Villa Mairea, Aalto developed different kinds of plaited joints which were at once archaic and sensual, rustic and modern.

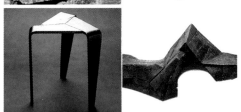

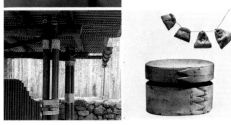

88 Net weights, woven from birch bark with a stone inside, 4.6×6.5—6.6×7.3 cm. Heikki Heikkilä Collection.
89 Box for clothes, Tohmajärvi, 19th century. 15.5×38×20.5 cm. Oval shaped box. Jointing spindles made of birch during the sap period. National Museum of Finland.

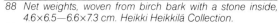

90 Chest table, Suojärvi, Karelian border type. Fluted-pillar structure, top from a single pine board with a box-like container underneath. Of a type that goes back to the middle ages. Base 53×67×35 cm, top 45—64×153 cm. National Museum of Finland.

91 Lamprey trap, willow, length 110, diameter 35 cm. Origin unknown. National Museum of Finland.

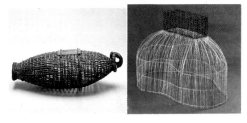

92 Martti Aiha, Dreams (Island), 1984. Bamboo trelliswork, height 105 cm. Aiha's open bamboo sculptures bring to mind ancient rituals, mythological structures, primitive huts, woven baskets or traps, but also the lyricism of nature. They also reveal a nostalgia for past culture and a concern for the future.

93 Veikko Kamunen, curly birch puukko, 1984. Lenght 20.7 cm, blade hand forged carbon steel, length 10 cm. Handle and sheath from curly birch with pewter ferrule. Produced by Lauri-tuotteet Oy, Rovaniemi Rural District, 1984—.

94 Pocket knife, 14.3 cm, blade from carbon steel, length 6 cm. Wrought pewter ferrule, handle and sheath from great sallow or curly birch. Originally designed by Johannes Lauri in the 1950s, ferrule added later. Produced by Lauri-tuotteet Oy, Rovaniemi Rural District, 1950s—.

95 Bent-handled, double-edged scythe, Kiikka. Birch, normal length 98.5, blade 93.5 cm secured with cane. National Museum of Finland. Curved handled scythe could be swung in two directions when cutting wild hay. Though common to Europe at one time it only survived into this century in Finland and Switzerland. Unsuitable for scything cultivated crops as stalks too thick.

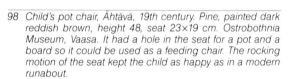

96 Tapio Wirkkala, axe, 1968. Prototype, oak and steel, 19×52.4 cm. Tapio Wirkkala Collection. The specially shaped blade enables its use in carving for then it is held just behind the head.

97 Shoulder yoke, 19th century. Naturally shaped birch, 54×8 cm. Turku Provincial Museum. Reminiscent of pail yokes used in Ålands, Satakunta and Ostrobothnia.

98 Child's pot chair, Ähtävä, 19th century. Pine, painted dark reddish brown, height 48, seat 23×19 cm. Ostrobothnia Museum, Vaasa. It had a hole in the seat for a pot and a board so it could be used as a feeding chair. The rocking motion of the seat kept the child as happy as in a modern runabout.

99 Yrjö Kukkapuro, Fysio 455v armchair, 1978. Birch, form-pressed frame, arms and foot stretcher, upholstery cloth or leather. Height 104, seat height 38—46, width 63, depth 68—85 cm. Produced by Avarte Oy 1978—.

100 Old woman's yoke, Pyhämaa, Ketteli. Length 88 cm. National Museum of Finland. Shaped to rest on the shoulders and around the neck with hooks from juniper. Once in common use in Europe they were ideal for carrying two pails of well water.

101 Sako-Valmet small-bore competition rifle. Finnish Lion Match small-bore competition rifle. Butt from walnut, length 118/74 cm. Designed in 1959, some 2600 produced between 1961—74 at Sako-Valmet Oy's Tourula factory. Sako-Valmet Oy's Tourula factory museum. International regulation heavy small-bore rifle for shooting from lying, kneeling and standing positions. Under continuous development since 1935, won Gran Praemio prize at 1969 Milan Triennial.

102 Kari Virtanen, kitchen utensils, 1976. Birch, meat board 12.2×26×25.5, rolling pins 37.5 and 41, meat mallet 32.5, masher 29. Produced by Suomen Puunjalostus Oy, 1976—83, possibly being reintroduced in 1987.

103 Seal hunter's provisions box, alder, 13.8×38.8×19.8 cm. Bertel Gardberg Collection. Bought from a junkshop in the 1950s its origin is unknown but probably 19th century and from the Finnish archipelago. Its cigar-shape derives from it being held between the legs whilst owner ate from it, also very practical as it could be seen among the mass of equipment in the boat and kept the food dry from bilgewater.

104 Three-clawed plough, West Finland, used in late 19th century. Birch, 78×135×52 cm. Agricultural Museum, University of Helsinki. A cross between a real plough and a harrow, it was used in Finland from the 18th to the turn of this century. It is one of those rare ethnological phenomena that have spread from Finland to Sweden having travelled there with the settlers from the Tornio valley.

105 Brushwood harrow from East Finland, turn of the century. Fir, 190×135×70 cm. Agricultural Museum, University of Helsinki. This type of harrow was used to mix the hand sown

seed with the ash in cut-and-burn farming and probably came to Finland in the 12th century. Branches of fir were bound to shafts and normally a new one was made each season though a well-made one would last longer if left in water. The last cut-and-burns in Finland were in the 1920s, though brushwood harrows were later used for weeding.

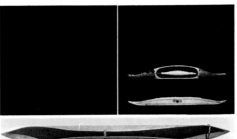

In former times all means of locomotion from skiis and skates to sledges, sleighs and boats were made from wood. All had the same streamline shape from weaver's shuttle to Lapp pulka.

106 Shuttle, wood with metal reinforcement, late 19th century. 27×3.5 cm. Grooved decoration on one side. Finnish Cottage Industry Museum, Jyväskylä.

The dugout is of great antiquity, found all over Finland and far beyond, and still in use north of the Kokemäki river in the early 20th century. Ideal for use in narrow waters, light enough to be carried by one man over short distances, a tarred dugout could outlive four ordinary boats. It was made from a healthy aspen some 100—150 years old and 15 inches thick, hollowed out with axe and adze, softened and bent by a fire to the shape of a boat, tarred inside and a few planks added to heighten the sides. The aspen dugout, which precedes the thousand year old plank boat, con-

tinued in use and the art of making them was preserved until present times.

107 Hollowed-out log, 469 cm, completed dugout, 484 cm. Built
108 by Iisakki Juhola, Ahlainen, Pirttijärvi, July 1935. The process was filmed. National Maritime Museum of Finland, Helsinki.

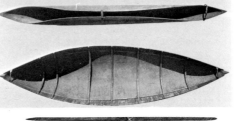

Skiis are an ancient North Eurasian invention and have been found in Old Stone Age deposits in Finland some 3800 years old and the word is among the oldest in the Finnish language. Old skiis were either of equal or varying length — the latter not being known outside Fennoscandia. Lemminkäinen used them in the Kalevala. Birch was the normal wood used in skiis, sometimes pine, and they could also have leather underneath. Skiing was at one time in danger of dying out until resurrected as a national sport in the late 19th century at which time the first cottage industries were

established in Central Ostrobothnia and Southern Lapland.

109 Skiis, Kiikka. 286×6 cm. National Museum of Finland.
110 Skiis, Sortavala, 1920s. 240×6 cm. South Karelia Museum, Lappeenranta.
111 Skiis, Himola. 252×10.5 cm. National Museum of Finland.
112 Swamp skiis, Alavieska. Pine, 161×11.5×2.5 cm. National Museum of Finland. Made from a single pine board and used during haymaking when moving over swampy or boggy ground.

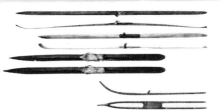

113 Rapala lures, 5—11 cm. Lauri Rapala began making wooden lures 40 years ago whilst a fisherman on Lake Päijänne and now runs an international concern. Made from balsa or apache, each one needs 25 processes. Prototypes are field tested throughout the world and few ever become mass produced. The secret lies in their uncanny resemblance to the prey of predatory fish.

114 Lapp pulka, made in Karasjoki in 1948. 58×210×45 cm. Lapland Provincial Museum, Rovaniemi. The reindeer-drawn pulka has different shapes depending on its function. That for travelling in was narrow with a high back, that for conveying being lower, wider and often with no back. The pulka for transporting provisions had a lid and doubled as the store when in camp. The shell is made from planks of pine or fir and the hoops from birch. Apparently developed at the same time as boat building in the first millenium AD.

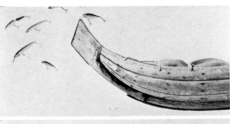

Among the ingeneous vehicles invented by peasants are the "travois" from unstripped wood made for transporting goods and the tar cart where the barrels serve as wheels. Thus all the horse needed to pull on the return journey was the axle and shafts.

115 "Travois", in use in the early 20th century. Birch, 380×125 cm. Agricultural Museum, University of Helsinki. Precursors on the haycart and used for conveying hay from distant pastures. All that was needed was a few bushy young birches, secured by a crossbar, the hay being loaded onto

the bushy platform. Still in use in the 1940s.

116 Tar cart, Kuhmo, 1920s. Pine, 430×120 cm. Agricultural Museum, University of Helsinki. Two full barrels of tar were lashed to a wooden axle and shafts and made secure with poles and ropes. In this way 125 litre tar barrels served as load and locomotion. Their origin is unknown but still used in the early 20th century.

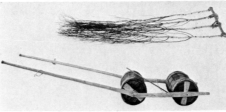

117 Traditional Lätäseno river boat, Markkina village, Kontojärvi.

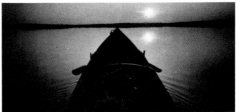

Although the shapes of peasant buildings and objects were determined by primitive working methods and hard wear, they were often quite originally decorated. Wedding and engagement gifts offered wide scope for decoration. This kind of work was done during the idle winter months. The finest works were done by coastal fishermen untied to farming and forestry. One of the main characteristics of modernism was its negative attitude towards decoration for its own sake. Many of the details and joints dictated by use or construction were traditionally given an ornamental function.

The decorative motifs in vernacular buildings and objects are usually crude yet endearing interpretations of mainstream styles. Many of the familiar classical styles of stone buildings presumably derived from wooden antecedents. In rustic hands these motifs return to their original material — wood.

119 *Chest chair with Empire features, Ylitornio, 1830. Height 76/41 cm. National Museum of Finland. The space between the legs has been turned into a box with lid and lock. Typical carving and colouration of Tornio valley furniture of this*

121 *Chair on wheels, Korsnäs, 19th century. Unpainted wood, 29.5×33.5×9 cm. National Museum of Finland. Two spinning wheels were placed in the chair when the spun thread was doubled. Finely and confidently decorated it has unintentionally acquired an expression suggestive of an African mask.*

National Romantic buildings and objects from the turn of the century are richly decorated. In place of international motifs it was also desired to draw on the mythology of the Kalevala.

123 *Gesellius, Lindgren, Saarinen, Pohjola Insurance Company building, Helsinki, 1901. The stairwell reveals a fascination with mythology and fairytales. These weird figures probably represent the bastard children of the Mistress of Pohjola in the Kalevala (Pleurisy, Colic, Gout, Scrofula, Boil, Itch, Cancer and Plague) which so horrified contemporaries.*

Decorated spinning-wheel distaffs mainly come from the coastal areas of the Gulf of Bothnia where men, in between fishing and seal hunting, spent their time carving. The oldest ones date from the early 18th century and by the beginning of this century they were no longer made. Meant as a wedding gift or indication of intent, they were a measure of the worth of the carver. Although all men carried a puukko few could carve a distaff. They were also made by master carpenters and mass production is not unknown.

126 *Flax distaff, probably alder. Height 38 cm. Ostrobothnia*

Details from Hollola Church built in the 1480s.

135 *Part of the front of the choir stall. Of the rich medieval interior only the panel boards and front and back ends of the choir stalls have survived. This fragment is carved from oak, presumably by a master craftsman in Turku. The shields of the Sture and Posse families date from the 1480s. National Museum of Finland.*

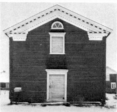

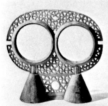
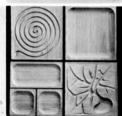

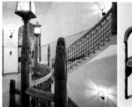
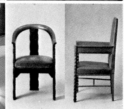

118 *Heddle, 1811. Woodcuts on both sides. 31.5×6 cm. Vaasa Provincial Museum.*

period.
120 *Viitala grain store, Kuortane. An ordinary storehouse has been given a temple-like expression. Photo from Markus Leppo's book "Talonpoikaistalot", 1973.*

122 *Ilmari Tapiovaara, trays, 1960. Teak, 40×40 cm. Like many other Finnish experts who worked on overseas projects, Tapiovaara worked for ILO in Paraguay in 1959—60 developing products for the woodworking industry. After furniture and turned objects came cutting blocks and trays with both a functional and decorative purpose. When not in use they were hung on the kitchen walls, a kind of "utility relief". Tapiovaara has also designed similar objects to be made from domestic pine.*

• *Eliel Saarinen's chairs for Hvitträsk (1901—03). Both made by N. Bomanin Höyrypuuseppätehdas, Turku.*
124 *Dining-room chair, 1918. Oak, upholstered in reddish-brown split leather. Height 85/46 cm.*
125 *Living-room chair, 1906. Oak with ebony inlay, upholstered in mottled green leather. Height 110/46 cm.*

Museum, Vaasa. Intended as a gift for the bride of Anders Andersson Bäck (1817—1901) from Kruunupyy and carved by him whilst a ship's carpenter.
• *Distaffs from the National Museum of Finland's collection. 127 Vimpeli, 1853. 128 Lemi. 129 Uusikaarlepyy, 1775. 130 Alaveteli, 1857. 131 Vöyri, 19th century. 132 Paavola, 1862. 133 Vöyri, 1878. 134 Geta, 19th century.*

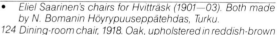

136 *Hollola Church west end gableboard. The roof was last repaired in 1906. Possibly a copy of the original made in 1640.*

d e t a i l

137 Rocking chair for two, Kylmäkoski, 19th century, detail of armrest. Features of both Biedermeyer and Gustaf styles. National Museum of Finland.
138 Antti Nurmesniemi, walking stick, 1987. Designed for the London Victoria & Albert Museum's "New Design for Old" exhibition of objects for elderly people. Made by Kari Virtanen.

139 Olli Tamminen, pendant, 1983. Steatite, silver and bockenholz, 11×8 cm. Plaited silk cord by Satu Tamminen. Bockenholz is an extremely hard, heavy and resinous wood from the jungles of South America. Tamminen acquired a piece from Wärtsilä who use it for bearings in ship's propellers. In this pendant it has found an aesthetic expression.

140 Timo Sarpaneva, castiron dish, 1959. Teak and castiron, height 12.9, diameter 19.6 cm. Produced by W. Rosenlew & Co. Oy, Pori Factory, 1960—67.

141 Bertel Gardberg, necklace, 1985. Ebenholz and silver, 10×6.5 cm. People knowing of Gardberg's interest in experimenting with new materials often bring him their finds: the ebenholz came from a journalist returning from Africa. It is extremely hard, oily and heavier than water and is the focal point of this necklace. The toning cotton cord was plaited on a traditional pirta frame by Gardberg's wife.

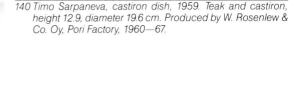

142 Tuija Hietanen, doll, 1984. Pine, brass, Kittilä jasper, 33×8×3 cm. The doll was the outcome of a practical at the Ylämaa School of Stoneworking. Although the task was to make a utility article, Hietanen's original intention of a doll for children developed into a piece of sculpture.

143 Bertel Gardberg, tongs, 1987. Teak and silver, 25.1×3.1 cm. Inspired by a pair of French tongs for olives in tall, narrow jars. The Gothic-like circular design is not mere ornamentation as it helps make the tongs more flexible.
144 Bertel Gardberg, wooden box with stone lid, 1960. Larch and steatite, height 8.9, diameter 10.2 cm. Gardberg began working with steatite whilst making things for churches. Both the lid and box are turned, but the finish is by hand as a machine finish, according to Gardberg, does not bring the same living effect to the surface.

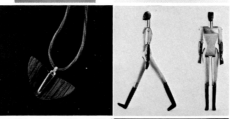

145 Axel Gallén (later Akseli Gallen-Kallela), Kalela atelier, Ruovesi, 1894—95.
146 Martti Välikangas, Käpylä Garden City, 1920—25.
147 Erik Adlercreutz, Nils-Hinrik Aschan, Marine Motel, Tammisaari, 1972.

148 Mauno Hartman, Preface, 1967. Pine, 67×147×40 cm. Art Museum of the Ateneum, Helsinki. Hartman's massive sculptures are reminiscent of rural carpenters' log cabins, the smaller ones joiners' finer objects and hunters' traps. He converts the pure functionalism of vernacular woodwork into an artistic message. Preface brings to mind the work benches of traditional cobblers and felters.

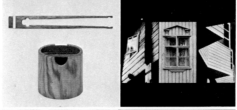

149 Outhouse, Äyhkyri farm, Juuka, North Karelia, early 19th century. Juuka is an old settlement and this type of two-storey outhouse is thought to have originated in the 16th century. The pillars are fine examples of rural carpentry. Photo from "Suomalainen talonpoikaistalo" by Alfred Kolehmainen and Veijo A. Laine, 1979.

150 Bell tower door and pauper figure, Kälviä. The tower was built in 1769 by Jaakko Rijf. Beside the door with its massive Ionic pillar decorations is a 166 cm pauper figure said to have been made by a local farmer Erkki Lassila born 1826.

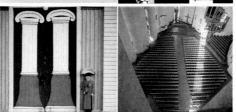

151 Raili and Reima Pietilä, Kaleva Church, Tampere, 1966. Contrasting with the concrete structure and surfaces are the wooden furnishings, organ loft and the architects' own Broken Reed altarpiece.

image

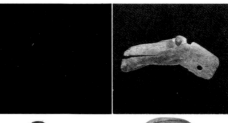

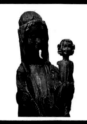

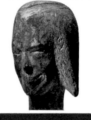

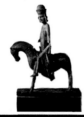

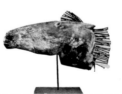

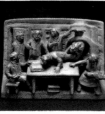

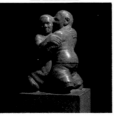

152 An elk's head of pine from Lehtojärvi, Rovaniemi, 39 cm. National Museum of Finland. Radiocarbon dating gives its age as 5800 BC. It may possibly have come from a Stone Age elk-head decorated boat of the type that appear in rock drawings in Scandinavia, East Karelia and also in Sarakallio, Laukaa. The mandible has unfortunately been lost.

and beaklike mouths.

154 Kain Tapper, Smile, 1957. Alder, height 35 cm. Owned by Markku Reunanen, Helsinki. Tapper's earlier carvings of people and animals are associated with his rural childhood. In later years they become abstractions of natural phenomena.

156 Kain Tapper, A Feeling for Nature II, 1981. Birch and pine, 105×80×80 cm. Owned by Orion-yhtymä Oy, Espoo. The rustle of aspen leaves, the sun's halo, rising mists, thundery weather and other natural phenomena have had a profound influence on Tapper. The living versatile surfaces on his works are evidence of tools, touching-up and patination with various fillers and colours.

158 Radoslaw Gryta, Path to Heaven, 1985. Wood, 210×86 cm. Privately owned. This Polish-born sculptor has acquired the Finnish way of using wood, combining a simple form with an artistic surface treatment.

160 Viljo Mäkinen, Horse's head, 1964. Aspen and iron nails, 37×50 cm. Turku Art Museum. Mäkinen's sympathetic works reflect the humorous content of Finnish folk art. He is as much interested in portraying people as animals, and his coloured works bring to mind the folk craftsmen's pauper statues and saints. The bits of planks and iron nails in his otherwise folkish works give them a Pop Art touch.

162 Ben Renvall, Polkka, 1932. Wood, height 41 cm. Antell Collection, Art Museum of the Ateneum, Helsinki. Renvall's small sculptures convey humour and plasticity. In his earlier works humour comes from his short, squat figures. Though normally working in bronze and ceramics, Renvall has also produced some folkish works in wood. Polkka pokes fun at the endearing awkwardness and deadly seriousness of a village barn dance.

153 Raisio Madonna by the Master of Lieto, c. 1340. Oak, height 88 cm. National Museum of Finland. The Master of Lieto was an unknown craftsman working in Turku in the middle ages and his most famous work is in Lieto Church. Carvings of saints by him or his apprentices are to be found in churches in the Turku area. He was trained in Gotland in master Bunge's school where he attained the high local standard of proficiency. His works, which represent the Gothic in Finland, are characterized by deep vertical pucking on garments, long slender fingers, short sharp noses

155 Lake Lagoda stone eyed god, probably early 19th century, height 70 cm. National Museum of Finland. This good luck statue for fishermen was first near Valamo Monastery on Vossinoy island on the site of a burned tsasouna church. The story goes that a monk, plagued by bad luck, threw it into the lake. There it floated ashore and was found by fisherman who, enjoying a good haul, placed it on the roof of Sidorov's farm in Peltoinen on the island of Mantsi.

157 Petäjävesi Old Church pulpit. The church was built by Jaakko Klemetinpoika Leppänen in 1763—64. The pulpit is decorated with saints and angels and supported by a bulging-eyed, grim-faced St. Christopher whose fur hat has slipped backwards. Here Renaissance forms have been given a folkish twist. Local belief says it is older than the church and comes from Jämsä, but it is not impossible that this clumsy yet endearing pulpit is the work of Leppänen himself.

159 St. Matthew of Raisio by the Master of Lieto, c. 1340. Oak, height 125 cm. National Museum of Finland. St. Matthew performed miracles for the poor and sick and the church cared for their poor with alms left at his altar.

161 Hannes Autere, A Guardian for the Child, 1925. Wood relief, 29×39 cm. Art Museum of the Ateneum, Helsinki. Autere revived traditional wood carving and the humour of the common people. His themes are humorous folk tales and customs and the stories of Aleksis Kivi. In place of classical figures, Autere's are clumsy countryfolk in their natural milieu. He skillfully used grain, colour and patina to achieve a balance between theme and material.

163 Kain Tapper, Alder skull II, 1977. Alder, 110×60×60 cm. Art Museum of the Ateneum, Helsinki. Tapper once found a horse's skull near his home and this soon became a favourite theme, simplifying in time into almost purely geometric squares and triangles. He has also included in his skull themes elements of the Finnish landscape.

164 Deer antler candelabra, late 18th century. Wood and horn, height 75/123, diameter approx. 100 cm. Korpilahti Local History Museum. Figures, presumably of the apostles and the Virgin Mary, holding candlesticks and a double-faced figure in the centre were carved from wood and painted red. Most original in shape, this antler candelabra was used in Korpilahti Old Church built in 1753. Possibly made by Jaakko Klemetinpoika Leppänen who worked on the interiors in 1763—64.

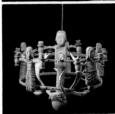

166 St. George, the dragon and a princess, late-medieval and locally made, from Hinnerjoki Church. Wood, 102×140×56 cm. National Museum of Finland. St. George was the guardian saint of crusaders, the protector and comforter of lepers, and alms left at his altar were given to the poor. More than a dozen statues of St. George survive in Finland, most of them late 15th century and locally made.

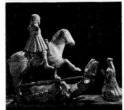

168 Ship's figurehead, probably the work of a folk craftsman. Height 55 cm. The Empire dress and hairstyle place it in the first decade of the 19th century. Ostrobothnia Museum, Vaasa. Local belief says it represents Queen Christine and that it may have come from the old townhall in Kristiinankaupunki.

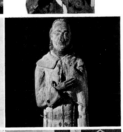

170 Vaivaisukko, Kuru, 1855. Maker unknown. The Reformation forbade images of saints, but the origin of the vaivaisukko can be found from the Bible in the blind beggar Bartholomew and the poor and sick Lazarus. Invalids from the 1808—09 war also influenced their appearance. These crude and comical figures today arouse quite opposite feelings. More than 120 still exist, mainly in Ostrobothnia and 19th century in origin. Though little is known about who made them there appear to be the work of skilled countryfolk, carpenters and builders.

177 Deer statues, left from Kuirujärvi village, Sodankylä, height 108 cm, right from Tanhua village, Savukoski, height 125 cm. National Museum of Finland. The practice of sacrificing part of the fish catch, game bag or reindeer to a seita idol continued into the last century. Statues of deer and fish were a kind of seita and were carved on the stump of a tree near a favourable hunting place. The last such statues were made by Finns in South Lapland who had acquired the custom from the Lapps.

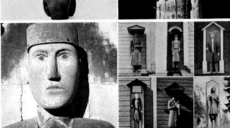

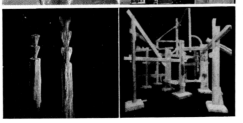

165 Heikki W. Virolainen, Marjatta, 1965. Painted wood, 238× 56×60 cm. Art Museum of the Ateneum, Helsinki. Virolainen's works possess a feeling for Finnish folklore and legend, with interpretations of the Kalevala in many of them. There is also a religious message with his national themes, as in his Väinämöinen Crucified. Primitive African sculpture and the cultures of Egypt, Mexico and the East have also influenced him. He uses the bright colours so beloved in olden times.

167 Pauno Pohjolainen, Alfa and omega, 1984. Wood and colour pigments, 220×130×80 cm. Harkonmäki Collection, Espoo. Pohjolainen's works are based on the dual effect of sculpture and painting. In his early works he tried to free himself from his religious background, as in his Death on the Cross series. His expressionist works combine the movement in the 1980s to break down traditional borders in the arts and the simplicity and solemnity of folk carving.

169 Vaivaisukko pauper statue, possibly from Luoto. Its dress indicates that it is pre-1755. Height 166 cm. Ostrobothnia Museum, Vaasa. These carved wooden costumed figures holding collecting boxes for the poor outside churches are unique and the first purely social art form in Scandinavia, possibly in the world. Originating in Ostrobothnia in the late 18th century when the care of the poor was transferred to the parish. Possibly derive from medieval sacrificial posts.

171 Veteli, 19th century, maker unknown.
172 Ullava, 19th century, maker unknown.
173 Sulva, 1868, Johan Bergman.
174 Siipyy. Donated to the parish by sea captain Johan Appelö. Some maintain he made it and sold it in 1849.
175 Kaustinen, 1832, possibly made by the smith Abraham Jakobinpoika Björk (1807—62).
176 Pylkönmäki, c. 1880, possibly made by Taavi Pajunen.

178 Mauno Hartman, Amos, 1987. Pine, 460×1060×770 cm. Hartman uses timbers from demolished wooden buildings to create a cottered element structure with the traditional carpenters marks on the joints. He carves and burns the logs, often leaving them outside in the elements to bring out their texture, colour and patina. Over the years a log cabin could be dismantled and re-erected many times, and this has become part of the message of Hartman's constructions.

Throughout the ages Finnish architecture has converted the great European styles into simple wooden forms. The enclosed farmhouse yard was originally Renaissance and many of the decorative features of the red ochre house reflected classical motifs. But modern Finnish architecture has also softened and vernacularized the International Style through the use of wood. Today's architecture is characterized by areas and slats of wood for lighting or acoustic purposes and the enlivenment of surfaces.

180 Alvar Aalto, Finnish Pavilion, New York World Exhibition, 1939. Aalto's pavilions at the Paris and New York world exhibitions are masterpieces of the use of wood. Wood was then Finland's green gold and a part of its national identity. The building and exhibits show all the things that can be made with wood. The New York pavilion is still probably the finest example of a free, plastic space form.

182 To Finns, the simple peasant tupa or living room is the archetype of all that is cosy and peaceful. Its nobility of size, human dimensions, spartan detail and scarce furnishings are a perfect blend of tradition and hard wear. Pertinotsa was brought from Suojärvi on the Karelian border to the Seurasaari Open-Air Museum in Helsinki. The house was inhabited in 1884. In this large room the family lived, laboured, ate and slept. The furniture was unpainted though sometimes carved. The dining-table was the most important item, placed one end towards the wall as was the custom in

184 Petäjävesi Church, 1763—64, built by Jaakko Klemetinpoika Leppänen. When the original, primitive plans were submitted for approval they were rejected in favour of the Kiukainen Church design. However, this decision took so long that the church had been built and now remains one of the most touching architectural structures in Finland. The round-cornered barrel vaults on the bar of the cruciform join a cupola in the middle with triangular pendants and an octagonal, flat-topped calotte. The lathes covering the seams and joints of the adzed planks are decorated with slanting Introverting and opening space.

186 Herman Gesellius, Armas Lindgren, Eliel Saarinen, Hvitträsk atelier home, 1901—03. At midday light enters the high, log-walled living room from two corner windows. The room has a massive fireplace. It was some years before the furniture designed for the room was made. Loja Saarinen apparently made the wooden chandelier and the Flame bench rya was one of Axel Gallén's (later Akseli Gallen-Kallela) designs.

188 Axel Gallén (later Akseli Gallen-Kallela), Kalela atelier home, Ruovesi, 1894—95. In the wake of the Karelian Movement at the end of the 19th century foremost Finnish artists wished to return to the common people, to a Kalevala idyll. The first of these famous ateliers was Emil Wikström's Visavuori in Sääksmäki, built in 1893. Gallén had begun working on the design of Kalela already in 1889, but it was five years before building began. He had made two expeditions into Russian Karelia with Louis Sparre in 1890 and his atelier includes both East Karelian and Central Finnish features. But the in-

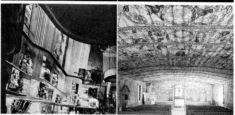

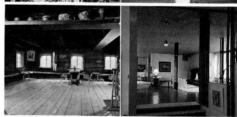

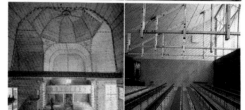

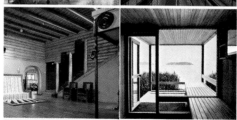

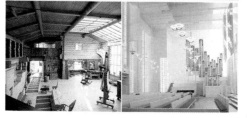

179 The entrance to Petäjävesi Church was through a corridor from the bell tower. The bell tower was of cruciform shape with narrowing ends. This false perspective of apparently Baroque origin enhanced the passage-like character of the space. The ceiling has a round shape covered with boards intended for a cupola. Petäjävesi Church was built by Jaakko Klemetinpoika Leppänen in 1763—64 and the bell tower by his grandson Erkki in 1821.

181 Pyhämaa island church, 1647—52. Christian Wilbrandt's distemper paintings on the log surfaces date from 1667. He was probably the leading church decorator of his time in Ostrobothnia but fire and rebuilding have destroyed all his other works. The low, intimate form of the church brings to mind an upended boat, the lush foliage in his paintings a feeling of space penetrating between the leaves, rather as in the medieval church of Hattula.

this area.
183 Alvar Aalto, Villa Mairea, Noormarkku, 1938—39, living room. Here Aalto transferred to the private villa of a rich client the idea of the all-embracing tupa. His use of wood was versatile and inventive, ranging from the traditional sauna, rough hewn log structures and a porch of unstripped fir branches to elegant interior details in the Japanese spirit. Aalto considered this villa a kind of utopian prototype for social housing.

lines in red ochre in the same style as medieval ribbed vaults.
185 Kaija and Heikki Siren, chapel for the University of Technology students' village, Otaniemi, 1957. This is one of the most impressive interiors in post-war Finnish architecture. The altar scene with its primitive and powerful materials brings to mind Pantheist nature. The chapel burned down in 1976 but is now faithfully restored.

187 Aarno Ruusuvuori, element sauna, design and prototype 1968. A constructivist tendency appeared in Finnish architecture in the 1960s. Wood is the only structural and insulating material that can be used uncovered both inside and outside in Finnish climatic conditions. Wood constructivism developed in the 1960s and early 1970s. Ruusuvuori designed the Mari Village for Marimekko Oy with its small wooden houses and element sauna.

terior was influenced by the English hall and the outside by the Swiss saddle roof.
189 Juha Leiviskä, Myyrmäki Church, 1984, east wall. Painted wood surfaces and slats have been used to produce a rich rhythmic effect and light play on the walls and ceiling.

190 Due to fire most Finnish wooden towns are no older than the 19th century. The oldest are Porvoo where the buildings around the cathedral date from the middle ages and old Tammisaari which still retains its Renaissance town plan. In the medieval part of Porvoo the houses go down to the river, the banks of which are lined with the wharfs of the town burghers. The 1832 plan for the new part of the town provided for a promenade so beloved by Classicist designers.

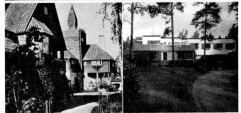

191 Herman Gesellius, Armas Lindgren, Eliel Saarinen, Hvitträsk atelier home, 1901—03. The mansion-sized home of these three architects is the largest of the atelier homes built under the influence of Karelianism at the turn of the century. Although the National Romantics aimed to create an architecture based on vernacular traditions, Hvitträsk also displays English and American influences. The upper part of the main building was originally a log structure. However, the log castle effect disappeared when the sides were covered with shingles and the tower and north wing were

destroyed by fire in 1922.

192 Alvar Aalto, Villa Mairea, Noormarkku, 1938—39. This villa is among the finest private houses built in this century. Aalto at this time had already produced his own local version of modernism with its versatile use of wood. Artistically, Villa Mairea is a combination of international modernism and the Finnish tradition of wooden house building.

193 Museum storehouses from Kuortane. The origin of the enclosed farmhouse yard is Renaissance in style. Photograph from Markus Leppo's book "Talonpoikaistalot", 1973.

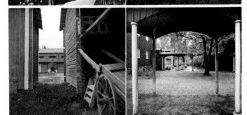

194 Martti Välikangas, Käpylä Garden City, Helsinki, 1920—25. This is now one of the finest residential areas in Finland. Originally designed as a working-class community, it was planned to be replaced by new buildings in the 1960s but instead was renovated and is now one of the most sought after areas in the capital. The log element houses within a simple town plan have been enlivened with elegant classical pillars and decorations.

195 With their tree-lined avenues designed to limit the spread of fire Finnish wooden towns are like parks. With its well at the end Aleksanterinkatu street in Porvoo is a fine example of an Empire boulevard. The buildings with their Classic and Neo-Gothic details represent the "shattered Classicism" of mid-19th century Finland.

196 Kaija and Heikki Siren, terrace houses in Kontiontie street, Tapiola, 1955. In the decade following the war Finnish architecture showed a harmonious and expressive mixture of the International Style and local traditions. Tapiola Garden

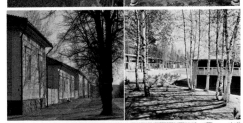

City was a superb example of the social ideals and architectonic sensitivity of that period. Although lacking an overall plan, certain areas and groups of buildings within it offer the most delightful milieus. These terrace houses are an early example of industrial building, the long facades being constructed from wooden elements. These simple structures, with their fences and sheds, create the image of a traditional Finnish wooden town.

197 Axel Gallén (later Akseli Gallen-Kallela), Kalela atelier home, Ruovesi, 1894—95. Gallén built Kalela immediately after Emil Wikström built his Sääksmäki home in 1893, although his designs were ready in 1889. These are probably the first largely based on traditional Finnish folk building, but even Swiss elements have crept into Kalela. The back-to-nature ideals of artists at that time can be seen in Kalela, rising as it does from the lake, surrounded by forest, and bringing to mind the Kalevala themes so beloved by Gallén himself.

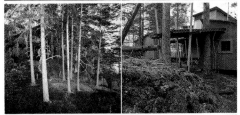

198 Georg Grotenfelt, Ararat Housing Association summer cabin, Juva, 1986. Alongside the urbanism and intellectualism of Finnish architecture today there is a new sensitivity and aesthetic appreciation of the natural milieu. Grotenfelt's design blends with the East Finnish landscape, consciously recalling childhood images and memories and the tradition of country building.

199 Church stables, Närpiö. This group of buildings form a unique wooden milieu in minature. Built next to the church of medieval origin, they were intended to house travellers coming to church from afar. The horses were stabled under a lean-to in the yard. Their age is uncertain and many have been demolished and moved to make way for the churchyard and road. In the 1940s there were still 342, though nowadays only about 150.

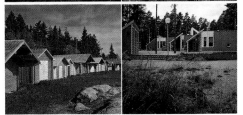

200 Timo Airas, Kari Järvinen, Kindergarten, Säkylä, 1980. In the wake of industrialized, massive building in the 1970s came a move towards a smaller scale, richer form and a commitment to local environment and tradition so difficult to express. As wood is a typical Finnish material when new architecture aims at a national expression it almost always uses it.

201 Kalla Church, Kalajoki, 1780. Built by Simon Jylkkä-Silven from the same parish. This wooden octagonal church has a shingle roof and is painted with a mixture of train oil and red ochre. The vaivaisukko beside the door is new, made by a local wood carver Ville Orell in 1967. It has unboarded log walls and vaulting. It was built on a rocky island outside Kalajoki where the annual fishing began. Around the church are grey huts where the fishermen lived, sometimes with their families, the womenfolk salting the fish in barrels for the winter. The priest went along and was paid in fresh

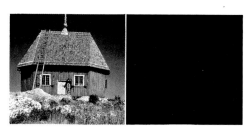

fish. The church could be seen from far out at sea and served as a landmark. Apart from the Ålands, Kalla is the only place in Finland with limited self-government and decisions are taken at a village meeting. A decision was taken in 1778 to build a new church and anyone who failed to deliver building materials as ordered was "banned for life from this fishing place for being uncooperative and harmful".

SOURCES

WOOD IN FINNISH LITERATURE, SOURCES, TRANSLATORS

The Birch kantele. *Kalevala,* canto 44. The *Kalevala,* the Finnish epic based on oral tradition, tells how the first kantele, the Finnish psaltery, was made from the jawbone of a giant pike. When this was lost, the wise man Väinämöinen made a replacement of wood — the material which has been used ever since.

Translated from the Finnish by Keith Bosley, whose complete translation of the *Kalevala* will be published in The World's Classics of Oxford University Press in 1989.

Aleksis Kivi (1834—1872) — *Seitsemän veljestä (The Seven Brothers),* Chapter V, 1870. — Translated from the Finnish by David Barrett.

Edith Södergran (1892—1923) — *Landet som icke är,* 1925. Schildts. — Translated from the Swedish by David McDuff.

Rabbe Enckell (1903—1979) — *Vårens cistern,* 1931. Söderström & Co. — Translated from the Swedish by David McDuff.

Pentti Haanpää (1905—1955) — *Karavaani ja muita juttuja,* 1930. Kustannusosakeyhtiö Kansanvalta. (Otava). — Translated from the Finnish by David Barrett.

Viljo Kajava (1909—) — *Hyvästi muuttolintu,* 1938. Gummerus. *Tuliteema,* 1957. Otava. (*Wind, Ligth, Sea: Poems 1935—82,* 1984. Otava.) — Translated from the Finnish by Anselm Hollo.

Helvi Juvonen (1919—1959) — Puukristus. *Kuningas Kultatakki,* 1950. WSOY. Metsään menin . . . *Pohjajäätä,* 1952. WSOY. (*Collected Poems,* 1960. WSOY.) — Translated from the Finnish by Anselm Hollo.

Eeva-Liisa Manner (1921—) — Puut luovuttavat . . . *Orfiset laulut* (So let's forget. *Orphic Songs*), 1960. Tammi. Puut ovat täynnä tuulta . . . *Niin vaihtuivat vuoden ajat* (The trees are windblown . . . *See How the Seasons Change*), 1964. Tammi. Puut, kahtalaiset . . . *Paetkaa purret kevein purjein* (Trees, two-fold . . . *Flee the Sails with Light Sails*), 1971. Tammi. — Translated from the Finnish by Herbert Lomas.

Bo Carpelan (1926—) — Trädet . . . and Vinterträd . . . *73 dikter,* 1966. Schildts. Luften . . . and Två träd . . . *Marginalia,* 1984. Schildts. — Translated from the Swedish by David McDuff.

Paavo Haavikko (1931—) — *Synnyinmaa (Homeland),* 1955. Otava. — Translated from the Finnish by Herbert Lomas.

Markku Lahtela (1936—1980) — *Rakastan sinua, musta tuuli (I Love You, Black Wind),* 1975. Gummerus. — Translated from the Finnish by Anselm Hollo.

Claes Andersson (1937—) — Löv i mina ögon . . . *Trädens sånger,* 1979. Söderströms. — Translated from the Swedish by David McDuff.

SOURCES OF PICTURE TEXTS:

Acerbi, Giuseppe, Resa i Finland 1799. Helsingfors 1953.

Amberg, Anna-Lisa, Saarisen sisustustaide — Saarinen's interior design 1896—1923. Museum of Applied Arts publication. Helsinki 1984.

"The bird-whittler". Form-Function-Finland 1/1982.

Blaser, Werner, Holz Haus — Maisons de bois — Wood Houses. Basel 1980.

Enäjärvi-Haavio, Elsa, Pankaamme käsi kätehen, suomalaisten kansanrunojen esittämistavoista. Porvoo 1949.

Gaynor, Elizabeth, Finland — Living Design. New York 1984.

Kolehmainen, Alfred & Laine, Veijo A., Suomalainen talonpoikaistalo. Keuruu 1979.

Kolehmainen, Alfred & Laine, Veijo A., Suomalainen aitta. Keuruu 1983.

Leppo, Markus, Vaivaisukot — Finnish Pauper-Sculptures. Porvoo 1967.

Leppo, Markus, Talonpoikaistalot — Bondgårdar — Peasant Houses. Porvoo 1973.

Lilius, Henrik, Suomalainen puukaupunki — Trästaden i Finland — The Finnish Wooden Town. Rungsted Kyst 1985.

Linnilä, Kai, Suomalaisia taiteilijakoteja. Jyväskylä 1982.

Mantere, Heikki (toim.), Hollolan kirkko, asutuksen, kirkon ja seurakunnan historiaa. Hämeenlinna 1985.

Nordman, C.A., Suomen keskiaikaista kuvanveistoa. Porvoo 1951.

Pallasmaa, Juhani (ed.), Tapio Wirkkala. Essay by Pekka Suhonen. Finnish Society of Crafts and Design publication. Helsinki 1981.

Pallasmaa, Juhani (ed.), Alvar Aalto furniture. Essays by Elissa Aalto & Marja-Riitta Norri, Igor Herler, Marja-Liisa Parko and Göran Schildt. Museum of Finnish Architecture publication. Espoo 1984.

Pallasmaa, Juhani (ed.), Hvitträsk, koti taideteoksena — Hvitträsk, the home as a work of art. Essays by Anna-Lisa Amberg, Marika Hausen and Tytti Valto. Museum of Finnish Architecture publication. Keuruu 1987.

Peltonen, Jarno, Ilmari Tapiovaara — sisustusarkkitehti — inredningsarkitekt — interior architect. Museum of Applied Arts publication. Helsinki 1984.

Pettersson, Lars, Petäjäveden vanha kirkko. Keski-Suomi 18. Museum of Central Finland publication. Saarijärvi 1986.

Rácz, István, Suomen keskiajan taideaarteita. Helsinki 1960.

Rácz, István, Suomen kansantaiteen aarteita. Helsinki 1971.

Salokangas, Sakari, Kirkkojemme vanhat tapulit. Porvoo 1967.

Sihvo, Pirkko (koonnut), Mull on kourat kontiolta. Loitsuja ja taikoja. Rauma 1986.

Suomalaisia Kansanhuonekaluja — Old Finnish Furniture. Teksti Jorma Heinonen. Helsinki 1969.

Valkonen, Markku & Valkonen, Olli, Suomen taide. Varhaiskaudet. Porvoo 1982.

Valkonen, Markku & Valkonen, Olli, Suomen taide. Nykyaika. Porvoo 1986.

Vallinheimo, Veera, Rukinlapa — Käyttöesine ja kihlalahja. Porvoo 1967.

Vilkuna, Kustaa & Mäkinen, Eino, Isien työ. Keuruu 1982.

Vuorela, Toivo, Suomalainen kansankulttuuri. Porvoo 1975.

PHOTOGRAPHERS

Avec Audiovisual Ky 99
Luis Baudrand 19
Werner Blaser 72, 80
Ritva Bäckman 152
Arno de la Chapelle 189
Georg Grotenfelt 198
Kari Haavisto 7, 46, 48, 138
Kari Hakli 24, 57, 66, 184
Erkki Helamaa 64
Seppo Hilpo 59, 92, 156, 158, 160, 163, 167, 178, 181, page 6
Lauri Kanerva 190
Johnny Korkman 9, 179
Ilmari Kostiainen 15, 23, 50, 54, 61
Veijo A. Laine 83, 149
Markus Leppo 58, 120, 150, 170—176, 193, 201
Kaj G. Lindholm 13
Museokuva 3, 135, 155
Eino Mäkinen 70
Joel Nokelainen 39
Ilpo Okkonen 145—147, 151, 185, 188, 194, 197, 200
Otso Pietinen 67, 196
Matti A. Pitkänen 5, 199
István Rácz 12, 14, 26, 28, 182
Simo Rista 74, 187, 195
Matti Saanio 77, 117
Sakari Salokangas 62, 63, 65, 68
Asko Salokorpi 136
Esa Santakari 20
Douglas Sivén 1, 8, 192
Ezra Stoller 180
Studio Rajala / Erik Pääkkönen 11
Studio 10 Oy 38
Lauri Toivanen 114
Rauno Träskelin 4, 10, 17, 18, 21, 25, 27, 29—37, 40—45, 47, 51—53, 55, 56, 60, 69, 71, 73, 75, 76, 78, 79, 81, 82, 84—91, 93—98, 100—113, 115, 116, 118, 119, 121—134, 137, 139—144, 148, 153, 154, 157, 159, 161, 162, 164—166, 168, 169, 177, 183, 186, cover
Uuskuva / Ragnar Damström 16, 22, 49
Per-Olof Welin 2

ARCHIVES

Artek 15, 23, 50, 54, 61, 192
Finnish Film Archive 70
Museum of Applied Arts 19, 75
Museum of Finnish Architecture 6, 57, 62—68, 136, 180, 184, 186, 187, 191, 196
National Board of Antiquities 28, 152, 179
Q-studio 16, 22, 49

LENDERS OF EXHIBITS

Agricultural Museum, University of Helsinki.
Aiha, Martti. Helsinki.
Alavus Parish. Alavus.
Alvar Aalto Estate. Helsinki.
Amos Anderson Art Museum. Helsinki.
Artzan Furniture factory. Helsinki.
Art Museum of the Ateneum. Helsinki.
Avarte Oy. Helsinki.
Cavén, Kari. Helsinki.
Finnish Cottage Industry Museum. Jyväskylä.
The Finnish Handicraft Organization. Helsinki.
Gardberg, Bertel. Pohja.
Hartman, Mauno. Helsinki.
Heikkilä, Heikki. Hämeenlinna.
Heikkilä, Juhani. Helsinki.
Helsinki City Art Museum. Helsinki.
Hietanen, Tuija. Imatra.
Hvitträsk Foundation. Helsinki.
Juho Jussila Oy. Jyväskylä.
Kaarlela Parish. Kaarlela.
Kalustetalo Tauno Korhonen Oy. Helsinki.
Kamunen, Risto. Rovaniemi Rural District.
Kodisjoki Parish. Kodisjoki.
Kosonen, Markku. Helsinki.
Kymenlaakso Provincial Museum. Kotka.
Lantto, Pirkko. Helsinki.
Lapland Provincial Museum. Rovaniemi.
Laurema, Esa. Helsinki.
Lauri-tuotteet Oy. Rovaniemi Rural District.
Lindgren, Jouko and Liisa. Helsinki.

Mentula, Perttu. Helsinki.
Merz, Rudi. Lohja.
Museum of Applied Arts. Helsinki.
Museum of Central Finland. Jyväskylä.
Museum of Finnish Architecture. Helsinki.
National Maritime Museum of Finland. Helsinki.
National Museum of Finland. Helsinki.
Nokelainen, Joel. Helsinki.
North Karelia Museum. Joensuu.
Ostrobothnia Museum. Vaasa.
Prykäri Glass Museum. Nuutajärvi Glass.
Pöytyä Parish. Pöytyä.
Raahe Museum. Raahe.
Rapala Oy. Vääksy.
Reunanen, Markku. Helsinki.
Ristomatti Ratia Art Collection. Helsinki.
Sako-Valmet Oy, Tourula Factory Museum.
South Karelia Museum. Lappeenranta.
Sport Museum of Finland. Helsinki.
Tamminen, Olli. Helsinki.
Tapiovaara, Ilmari. Espoo.
Tulonen, Ritva. Hamina.
Turku Art Museum. Turku.
Turku Provincial Museum. Turku.
Turu, Paavo. Suurmiehikkälä.
K and Y Wiherheimo Ky. Helsinki.
Tapio Wirkkala Collection. Helsinki, Riihimäki.
Virtanen, Kari. Nurmo.
Ylämaa Local History Museum. Ylämaa.

DONATORS OF EXHIBITION BUILDING MATERIALS

flooring materials:
The Finnish Sawmill Owners' Association/
Enso-Gutzeit Oy
Kymmene Oy
Metsä-Serla Oy
Oy Wilh. Schauman Ab

planks:
The Finnish Builders' Merchants Association

plywood and boards:
Association of Finnish Plywood Industry
Finnish Particle Board Association

turned logs:
Honkarakenne Oy

**WOOD
IN FINNISH
ART**

HISTORY

General works:
Ahtola-Moorhouse, Leena, "Katsaus suomalaiseen kuvanveistotaiteeseen 1910—80" — "Review of Finnish Sculpture 1910—80". Suomalaista veistotaidetta — Finnish Sculpture. Porvoo 1980.
Jäntti, Yrjö A., Suomalaisia pienoisveistoksia. Porvoo 1980.
Meinander, K. K., Medeltida altarskåp och träsniderier i Finlands kyrkor. Helsingfors 1964.
Nordman, C. A., Suomen keskiaikaista kuvanveistoa. Helsinki 1951.
Nordman, C. A., Medeltida skulptur i Finland. Helsingfors 1964.
Peltola, Leena, Puupiirros Suomen taiteessa. Näyttelyluettelo, Suomen taideakatemia 1981.
Rácz, István & Pylkkänen, Riitta, Suomen keskiaikaisia taideaarteita. Helsinki 1959.
Riska, Tove, "Naantalin luostarikirkon Kristuksenpää". Taidehistoriallisia tutkimuksia 4 — Konsthistoriska studier 4. Helsinki 1978
Schildt, Göran, Suomalaisia kuvanveistäjiä. Helsinki 1969.
Schildt, Göran, Skulptur i Finland. Köpenhamn 1970.

Monographs:
Kojo, Viljo, Albin Kaasisen puinen kääpiökansa. Helsinki 1929.
Wennervirta, Ludvig, Hannes Autereen taidetta. (Introd. på svenska). Helsinki 1958.

Folk art:
Leppo, Markus, Vaivaisukot — Finnish Pauper-Sculptures. Porvoo 1967.

MODERN TIMES

General works:
Harkonmäki kokoelma — Harkonmäki Collection. Suomalaista 80-luvun taidetta — New Painting in Finland. Espoo 1985.
Kuvanveisto 1983. Suomen kuvanveistäjäliiton vuosijulkaisu 1983.

Monographs and studies:
Berg, Maria, Mauno Hartman—Kain Tapper. Keuruu 1980.
Nurmela, Kari, Kolme matkaa Kain Tapperin elämästä. Helsinki 1987.
Takasuo-Raippalinna, Päivi-Marjut, Kain Tapperin puunveisto. Pro gradu -tutkielma. Jyväskylän yliopisto 1979.
Tapio, Marko, "Kain Tapperin taiteen lähtökohdista". (Engl. summary). Taide 6/1976.
Wennervirta, Ludvig, Hannes Autereen taidetta. (Introd. på svenska). Helsinki 1958.

Joint exhibition catalogues:
Attityder/Tretten individer fra Finland. Nordjyllans Kunstmuseum, Aalborg. Suomen Taiteilijaseura 1986.
Facettes de Finlande. 10 ans d'art finlandais. Paris 1975.
Finsk kunst nå. Henie-Onstad kunstsenter 1983.
Kuuntelua. Taidemaalariliiton näyttely Helsingin Taidehallissa 1986.
Metsän kuva. Näyttely Pyynikinlinnassa. Tampere 1987.
Muutosten vuosikymmen. Lahden taidemuseo 1985.
Mythes et Formes de Finlande. Centre Culturel de la Communanté Francaise Wallonie-Bruxelles le Botanique 1984.
Sculptor 85. Suomen Kuvanveistäjäliiton näyttely Helsingin Taidehallissa 1985.
Siirrettävä Tuonela. Helsingin kaupungin taidemuseon julkaisuja n:o 12. Helsinki 1983.
Suuntana Kuopio. Näyttely Kuopion taidemuseossa 1985.
Trä — finskt element. Skulptur av Mauno Hartman och Kain Tapper. Göteborgs kunstmuseum 1977.

Vuoden nuori taiteilija 1985. Kristian Krokfors, Kari Cavén, Markku Kivinen, Tero Laaksonen, Taisto Rauta. Tampereen Taidemuseo 1985.

Vuoden nuori taiteilija 1986. Tero Laaksonen, Martti Aiha, Chris af Enehjelm, Kuutti Lavonen, Tapani Mikkonen.

Vuoden nuori taiteilija 1987. Radoslaw Gryta, Pekka Kauhanen, Tuula Lehtinen, Harri Leppänen, Teemu Saukkonen.

Private exhibition catalogues:

Martti Aiha. Galleria Krista Mikkola 1986.

Hannes Autere 1886—1967. Prins Eugens Waldemarsudde. Stockholm 1979.

Kari Cavén—Raili Tang. Galleria Krista Mikkola. Helsinki 1986.

Mauno Hartman. Biennale di Venezia 1968.

Mauno Hartman. Helsingin Taidehalli 1972.

Mauno Hartman. Helsingin Taidehalli 1980.

Mauno Hartman. Amòs Andersonin taidemuseo 1987.

Kain Tapper. Vuoden taiteilijan näyttely, Helsingin Taidehalli 1981.

Kain Tapper. Biennale di Venezia 1984.

Kain Tapper. Millesgårdens utställning 1985.

Einklang mit der Natur. Skulpturen von Kain Tapper. Dortmunder Museumsgesellschaft 1986.

Heikki W. Virolainen. Amos Andersonin taidemuseo 1980.

(compiled by Marjatta Levanto)

●

WOOD
IN FINNISH
APPLIED ARTS

Alvar Aalto furniture. Editor: Juhani Pallasmaa. Essays by Elissa Aalto & Marja-Riitta Norri, Igor Herler, Marja-Liisa Parko and Göran Schildt. Helsinki 1984.

Aav, Marianne, "Gunnel Gustafsson-Nyman som möbelritare" — "Gunnel Gustafsson-Nyman huonekalupiirtäjänä". Gunnel Nyman. Suomen lasimuseon tutkimusjulkaisu — The Bulletin of the Finnish Glass Museum. Riihimäki 1987.

Amberg, Anna-Lisa, "Luettelo Eliel Saarisen asunnon sisustuksista" — "Catalogue of the interiors in Eliel Saarinen's home". Hvitträsk, koti taideteoksena — Hvitträsk, the home as a work art. Toimittaja: Juhani Pallasmaa — Editor: Juhani Pallasmaa. Helsinki 1987.

Amberg, Anna-Lisa, Saarisen sisustustaide — Saarinen's interior design 1896—1923. Taideteollisuusmuseon julkaisuja 10 — Publications of the Museum of Applied Arts 10. Helsinki 1984.

Appelgren, Arne, "Mästerprov och ritningar till mästerstycken i Vasa snickarskrå". KHÅ 1933. Ekenäs 1933.

Asikainen, Kari, "Kari-tuoli paras huonekalu 1982". Muoto 8, 1/1983.

Boulton-Smith, John, The Golden Age of Finnish Art. Helsinki 1985.

Finch, A. W., "Utvecklingen af smaken för dekorativ konst i hemmen". Ateneum 1901.

Gardin, Piero Berengo, Tapio Wirkkala. Milano 1984.

Kallio, Marja, Korhonen 75. Huonekalutehdas Korhonen Oy. Turku 1985.

Klemetti, Heikki, Kansan sana taiteessa. Porvoo, Helsinki 1948.

von Konow, Walter, "Huonekalutyyleistä". Ensimmäiset museopäivät Helsingissä v. 1923. Helsinki 1923.

Laine, Yrjö, "Suomalaiset huonekalut". Keksintöjen kirja 1. Puu, sen käyttö ja jalostus. Porvoo, Helsinki 1933.

Lindberg, Carolus, Koristetaide. Porvoo 1927.

Matilainen, Erkki, Kansallista kauneutta uusissa muodoissa. Mallikokoelma puisia käyttö- ja koruesineitä. Porvoo 1949.

Meinander, K. K., Suomen huonekalutaide. Porvoo 1928.

Meinander, K. K., "Taideteollisuus Suomessa uskonpuhdistuksen jälkeen". Oma maa III. 2. uud. p. Porvoo 1922.

Miestamo, Riitta, Suomalaisen huonekalun muoto ja sisältö — The form and substance of Finnish furniture. Lahti 1980.

Munch, Marita, "Irisfabriken och Sparres möbelkonst". Osma 1960—61. Helsinki 1961.

Nikander, Gabriel, "Åbosnickarnas mästerstycken under 1700-talet". Svenska kulturbilder. NF 1: 1—2. Stockholm 1934.

Pajastie, Eila, "Arttu Brummerin huonekaluja ja niiden ajallista taustaa". Suomen Taideteollisuusyhdistys Vuosikirja 1969 ja toimintakertomus vuodelta 1968. Helsinki 1969.

Peltonen, Jarno, "Ilmari Tapiovaara, sisustusarkkitehti". Muoto 14, 3/1984.

Peltonen, Jarno, Ilmari Tapiovaara, sisustusarkkitehti — Ilmari Tapiovaara, inredningsarkitekt — Ilmari Tapiovaara, interior architect. Taideteollisuusmuseon julkaisuja 11 — Konstindustrimuseets publikation nr 11. Helsinki 1984.

Reutersvärd, Oscar, "Finlands medeltida dopfuntar, vigvattenskålar och piskinor samt dopfuntar av medeltida typ". Taidehistoriallisia tutkimuksia 4 — Konsthistoriska studier 4. Helsinki 1978.

Siimes, F. E., "Puusepänteollisuus". 50 vuotta Suomen teollisuutta ja taloutta. Teknillinen Aikakauslehti. Erikoisnumero 4A 1946.

Sirelius, U. T., "Kansanomaisesta koristeleikkauksesta Suomessa". Nuori Suomi 22. 1912.

Suhonen, Pekka, Artek — alku, tausta, kehitys. Helsinki 1985.

Suhonen, Pekka, Artek — start, bakgrund, utveckling. Helsingfors 1985.

Suhonen, Pekka, Artek 1935—1985. Taideteollisuusmuseon julkaisu no 15 — Konstindustrimuseets publikation nr 15. Helsinki 1985.

Susitaival, Paavo, Suomen puusepänteollisuuden vaiheita. Suomen Puusepänteollisuuden Liiton julkaisu N:o 7. Lahti 1950.

"Talonpojan käsityöt". Suomen kulttuurihistoria 2. Jyväskylä 1934.

Taskinen, Rita, Kodin huonekalu- ja sisustusvuosikirja 1985—86. Helsinki 1985.

Ullberg, Uno & Tavaststjerna, Alarik & Kekkonen, Jalmari, Kansanomaisia rakennustapoja ja koristemuoto-ja Karjalasta kahden puolen rajaa. Helsinki 1929.

Wennervirta, L., Finlands konst. Helsingfors 1926.

Wennervirta, L., Suomen taide. Helsinki 1927.

Vesara, Timo, "Tapaus Tarzan". Muoto 14, 3/1984.

Tapio Wirkkala. Catalogue editing and graphic design Juhani Pallasmaa. 2nd ed. Helsinki 1985.

Vuorela, Toivo, Suomalainen kansankulttuuri. Porvoo, Helsinki 1975.

Zilliacus, Benedict, "Alvar Aalto teollisena muotoilijana". Suomen Taideteollisuusyhdistys Vuosikirja 1977 ja toimintakertomus vuodelta 1976. Helsinki 1977.

Zilliacus, Benedict, "Suomen käyttötaide". Kotien käyttötaidetta. Pohjoismainen taidekäsityö ja taideteollisuus. Porvoo 1961.

(compiled by Eeva Viljanen)

WOOD
IN FINNISH
ARCHITECTURE

DESIGN AND BUILDING

Lehtovuori, Olli, Hyvin suunniteltu pientalo. Helsinki 1984.

Puurakennustaito. Käsityön kirja. Helsinki 1946.

Vepsäläinen, Jussi, Puutalon suunnittelu. Helsinki 1974.

PROTECTION AND IMPROVEMENT

Härö, Elias & Kaila, Panu, Pohjalainen talo. Vaasa 1976.

Härö, Elias & Kaila, Panu, Österbottensgården. Vasa 1978.

Kaila, Panu & Vihavainen, Tuija & Ekbom, Pehr, Rakennuskonservointi. Suomen museoliiton julkaisuja 27. Helsinki 1983.

Puurakennukset. Historia, tutkimus ja suojelu. Julk. Seurasaarisäätiö. Helsinki 1977.

HISTORY

Wooden churches:
Klemetti, Heikki, Suomalaisia kirkonrakentajia 1600- ja 1700-luvuilla. Porvoo 1927.
Klemetti, Heikki, Suomalaisia kirkonrakentajia 1800-luvulla. Porvoo & Helsinki 1936.
Pettersson, Lars, "Utajärven kirkko ja tapuli". Utajärven vaiheita. Helsinki 1962.
Pettersson, Lars, Hailuodon palanut puukirkko ja sen maalaukset. Suomen Muinaismuistoyhdistyksen Aikakauskirja 73. Helsinki 1971.
Pettersson, Lars, "Haapaveden kirkot". Haapavesi ennen ja nyt II. Haapaveden kirja. Pieksämäki 1973.
Pettersson, Lars, "Joutsan kirkko". Joutsan kirja. Jyväskylä 1976.
Pettersson, Lars, "Limingan kirkot ja kellotapulit". Liminka 1477—1977. Oulu 1977.
Pettersson, Lars, Kaksikymmentäneljäkulmaisen ristikirkon syntyongelmia. Suomen Muinaismuistoyhdistyksen Aikakauskirja 79. Helsinki 1978.
Pettersson, Lars, "Kansainvälisiä ja kansallisia aineksia Suomen vanhassa puukirkkoarkkitehtuurissa" — "National and international features of the old wooden church architecture in Finland". Abacus, Suomen rakennustaiteen museon vuosikirja — Abacus, Yearbook. Museum of Finnish Architecture. Helsinki 1979.
Pettersson, Lars, "Karjalaismalliset puupyhäköt". Ortodoksinen kirkko Suomessa. Lieto 1979.
Pettersson, Lars, "Kristiinankaupungin puukirkot ja kellotapulit". Kristiinankaupungin historia I. Vaasa 1984.
Pettersson, Lars, "Sodankylän vanha kirkko". Suomen kirkot 12. Helsinki 1984.
Pettersson, Lars, "Kyrkor och klockstaplar i svenska Österbotten". Svenska Österbottens historia V. Vasa 1985.
Pettersson, Lars, "Petäjäveden vanha kirkko". Keski-Suomi 18. Jyväskylä 1986.
Salokangas, Sakari, Kirkkojemme vanhat tapulit. Porvoo & Helsinki 1967.
Santakari, Esa, Kansanrakentajien puukirkot — Allmogemästarnas träkyrkor — The wooden churches of Finland. Helsinki 1977.
Wendeler, Rolf & Helvi, Alte Holzkirchen in Finnland. München 1981.

Folk architecture:
Bresson, Thérèse & Jean-Marie, Maisons de bois. Paris 1978
Bresson, Thérèse & Jean-Marie, Frühe skandinavische Holzhäuser. Düsseldorf 1981.
Kirkinen, Heikki, Karjalantalo. Helsinki 1981.
Kolehmainen, Alfred & Laine, Veijo A., Suomalainen talonpoikaistalo. Helsinki 1979.
Kolehmainen, Alfred & Laine, Veijo A., Suomalainen aitta. Helsinki 1983.
Kolehmainen, Alfred & Laine, Veijo A., Murtovaara, talomuseo Valtimolla. Lappeenranta 1976.
Leppo, Markus, Talonpoikaistalot, talonpoikaisarkkitehtuurin katoavaa kauneutta — Bondgårdar, bondarkitekturens försvinnande skönhet — Peasant houses, the vanishing beauty of peasant architecture. Porvoo & Helsinki 1973.
Moley, Christian, Les structures de la maison. Example d'un habitat traditionnel finlandais. Lille 1984.
Paulaharju, Samuli, Suomalainen sauna. Suomalaisen Kirjallisuuden Seura, Kansanelämän kuvauksia 17. Helsinki 1982.
Paulaharju, Samuli, Suomalainen talo. Suomalaisen Kirjallisuuden Seura, Kansanelämän kuvauksia 22. Helsinki 1983.

Urban wood architecture:
G. T. Chiewitz, lääninarkkitehti 1815—1862 — G. T. Chiewitz, länsarkitekt 1815—1862. (Olof Holmberg . . . et al.). Turun maakuntamuseo, Näyttelyesite 10. Turku 1986.
Gardberg, Carl Jacob, Stadsplan och byggnadsskick i Borgå intill år 1834. Folklivsstudier II. Helsingfors 1950.
Lilius, Henrik, Joensuu 1848—1890. Tekstiosa. 2. p. Joensuu 1984.
Lilius, Henrik, Joensuu 1848—1890. Kuvaosa. 2. p. Joensuu 1984.

Lilius, Henrik, Suomalainen puukaupunki — Trästaden i Finland — The Finnish wooden town. Rungsted Kyst 1985.

Meilahden huvila-alue. Julk. Helsingin kaupungin kaupunkisuunnitteluvirasto, Yleiskaavaosasto. Helsinki 1977.

Okkonen, Ilpo & Ritva, Pilvilinnoja ja vesiposteja. Oulu 1985.

Soiri-Snellman, Helena, Ruissalon huvilat — Runsala villor. Turun maakuntamuseo, Raportteja 8. Turku 1985.

Suominen, Renja, Salon puiset asuinrakennukset 1887—1920. Salo 1978.

Valanto, Sirkka, Rautateiden arkkitehtuuri — Järnvägarnas arkitektur. Helsinki 1984.

Valjakka, Sirkka, Jyväskylän kaupungin rakennukset ja asukkaat 1837—1880. Jyväskylä 1971.

Wickberg, Nils Erik, "Byggmästarfamiljen Andsten". Empirestudier. Helsingfors 1945.

Wooden architecture at the turn of the century:

Hvitträsk, koti taideteoksena — Hvitträsk, the home as a work of art. Toimittaja: Juhani Pallasmaa — Editor: Juhani Pallasmaa. Essays by Anna-Lisa Amberg, Marika Hausen and Tytti Valto. Helsinki 1987.

Kivinen, Paula, Tampereen jugend. Helsinki 1982.

Kivinen, Paula & Korvenmaa, Pekka & Salokorpi, Asko, Lars Sonck, arkkitehti 1870—1956 — Lars Sonck, architect 1870—1956. Helsinki 1981.

Tuomi, Ritva, Erämaa-ateljeet — Studios in the wild. Helsinki 1979.

Tuomi, Ritva, "Kansallisen tyylin etsimisestä" — "On the search for a national style". Abacus, Suomen rakennustaiteen museon vuosikirja — Yearbook. Museum of Finnish Architecture. Helsinki 1979.

MODERN WOODEN ARCHITECTURE

Ahmavaara, Anna-Liisa, Asumme lähellä luontoa — We live close to nature. Helsinki 1966.

Ahmavaara, Anna-Liisa, Asumme omassa talossa. Helsinki 1969.

Helamaa, Erkki, 40-luku, korsujen ja jälleenrakentamisen vuosikymmen — 40-talet, korsurnas och återuppbyggandets årtionde. Helsinki 1983.

Paavilainen, Simo, "Martti Välikangas ja 1920-luvun klassismi Käpylässä" — "Martti Välikangas and the Classicism of the '20s in Käpylä". Arkkitehti 1/1981.

Suomalainen pientalo — Finnish house. (Tore Tallqvist . . . et al.). Helsinki 1986.

Yksilöllisiä puutaloja. Toim. Jussi Vepsäläinen. Helsinki 1987.

See also:

Alvar Aalto. Band I 1922—1962. Redaktionelle Bearbeitung: Karl Fleig — Co-Editor: Karl Fleig. Zürich 1963.

Alvar Aalto. Band II 1963—1970. Redaktion: Karl Fleig — Editor: Karl Fleig. Zürich 1971.

Alvar Aalto. Band III Projekte und letzte Bauten — Projects and final buildings. Redaktion: Elissa Aalto, Karl Fleig — Editors: Elissa Aalto, Karl Fleig. Zürich 1978.

Raportti rakennetusta ympäristöstä — Aarne Ervin arkkitehtuuria. Toim. Pertti Solla. Helsinki 1970.

Pietilä, modernin arkkitehtuurin välimaastoissa — Pietilä, intermediate zones in modern architecture. Toimitus: Marja-Riitta Norri . . . (et al.). Helsinki 1985.

Quantrill, Malcolm, Reima Pietilä. Helsinki 1985.

Kaija+Heikki Siren, arkkitehdit — Kaija+Heikki Siren, arkitekter. Toim. Erik Bruun & Sara Popovits — Red. av Erik Bruun & Sara Popovits.

Kaija+Heikki Siren, architects. Editor: Erik Bruun, Sara Popovits. Helsinki 1977.

Arkkitehti-lehti. Julk. Suomen Arkkitehtiliitto — Arkkitehti, finsk arkitekturtidskrift. Publ. av Finlands Arkitektförbund — Arkkitehti, Finnish architectural review. Publ. by the Finnish Association of Architects.

Puu. Julk. Puuinformaatio ry.

(compiled by Anna-Liisa Alho)